The Fascination of Egypt
Selected works from the
Dresden Skulpturensammlung

SANDSTEIN

The Fascination of Egypt

Selected works from the Dresden Skulpturensammlung

Editors:
Staatliche Kunstsammlungen Dresden
Stephan Koja
Saskia Wetzig

Staatliche
Kunstsammlungen
Dresden

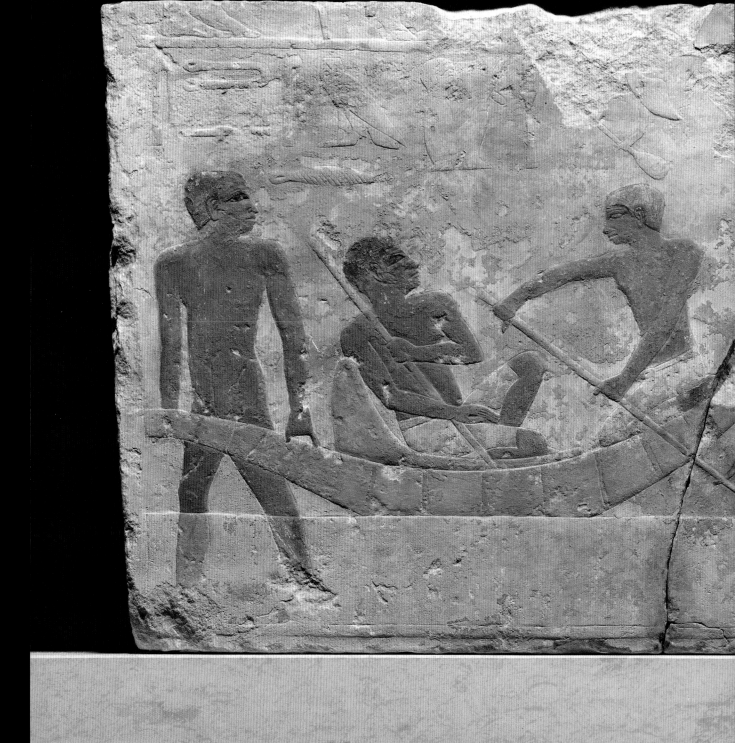

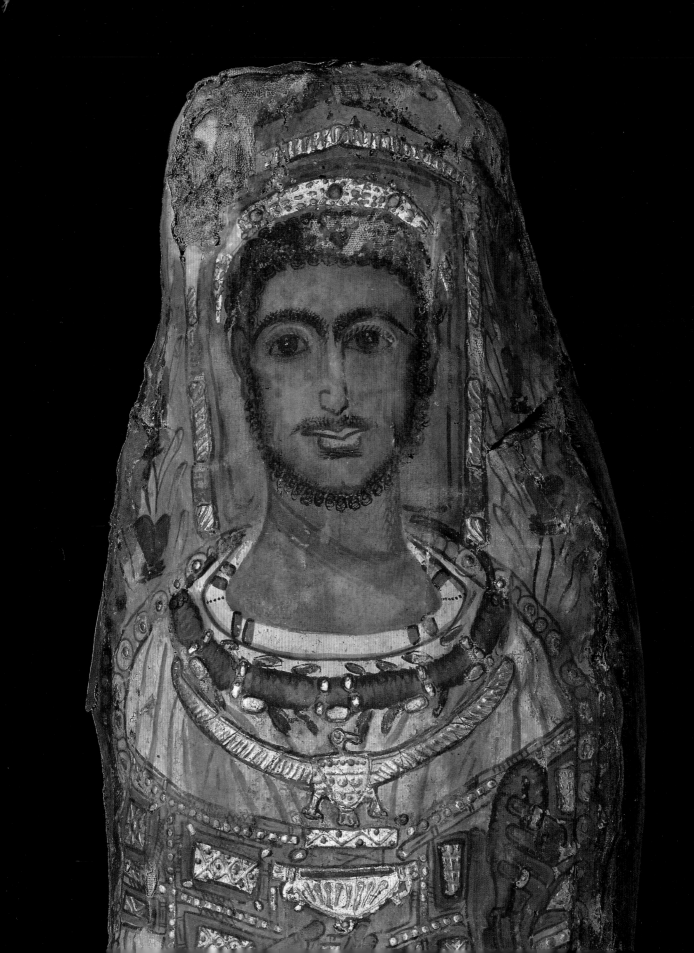

Contents

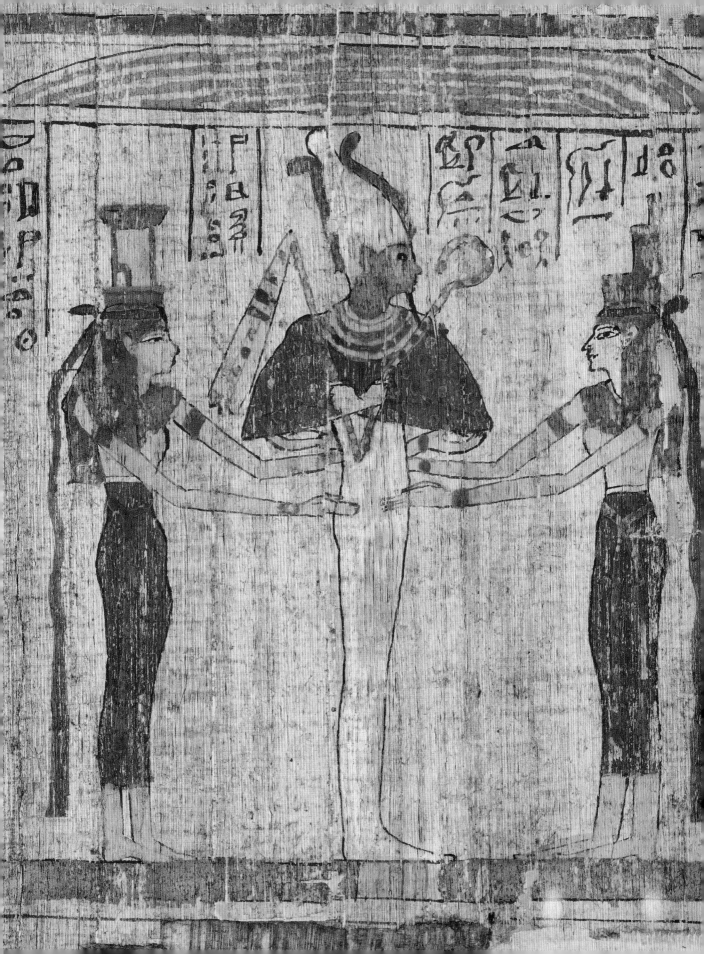

Foreword

Stephan Koja

Few sculpture collections are as diverse and multifaceted as the Dresden Skulpturensammlung. Ever since its inception during the reign of Elector Friedrich August I, known as Augustus the Strong, in the early 1720s, it has brought together sculptural works from a wide range of art historical periods and cultural spheres. It is evident from the first inventory, drawn up in 1726, as well as the list of works displayed in the Palace in the Great Garden in 1730, that even at that time Ancient Egyptian objects stood side by side with Roman sculptures and Greek vases, and masterful bronze statuettes from the Renaissance were just as much a part of the collection as contemporary Baroque sculptures. Since then, the collection has been continuously expanded: in the nineteenth century, significant holdings of medieval wood sculpture and the cast collection were added, and throughout the centuries works of contemporary art have also been collected. It was the archaeologist Georg Treu (dir. 1888–1915) who, more than any other director of the collection, championed the concept of an encyclopaedic sculpture museum. Under his aegis, it seemed possible to achieve what nowadays poses a considerable challenge: namely, to do justice to all the different groups of works among the museum's holdings within a single building, the Albertinum. That this was, and still is, very difficult can be seen from the fact that parts of the collection are currently only exhibited in changing, temporary exhibitions and many objects are held in museums and storerooms in various locations.

Hence, it is all the more gratifying to be able to present selected Egyptian objects to a broader public in the special exhibition "Journey to the Afterlife. Egyptian Funerary Art from the Dresden Skulpturensammlung" in the Semper Cabinet from 13 August 2022 to 16 April 2023. Since the festive reopening of the Gemäldegalerie and the Skulpturensammlung in the Semper Building at the Zwinger in February 2020, a small exhibition area featuring mummies and funerary masks is already on show in the immediate vicinity of the Classical Antiquities and the Old Masters. The larger-scale special exhibition will enable visitors to gain deeper insights into Ancient Egyptian culture, which continues to exert an unbroken fascination to this day. The appeal of these artefacts lies, among other things, in their great antiquity and good state of preservation, in their vibrant colours, the formal clarity and distinctiveness of their iconography, as well as the monumental impact of even the smallest objects.

This is also strikingly evident from this catalogue. It presents around 170 highlights of the collection: artefacts relating to the royal cult of the gods, items used in private religious practice, and objects testifying to Pharaonic ideology, along with funerary decorations and monuments of the cult of the dead, as well as mummies and grave goods. All these are discussed and elucidated in well-researched scholarly essays supported by numerous colour photographs. Thirty years after the publication of the previous collection catalogue on the subject, these holdings are thus once again being given the attention they deserve, including among specialist circles. The catalogue also features essays on the history of the collection and on Egyptomania in Saxony during the Baroque Period, as well as on the Ancient Egyptian pantheon and the concepts of the afterlife, as reflected in the Dresden Egyptian collection.

I am especially grateful to Manuela Gander and Marc Loth for their scholarly research and expert curatorship of the Egyptian collection. The catalogue authors also benefited from the enthusiastic support and assistance of their fellow Egyptologists Jana Helmbold-Doyé, Asja Müller, Jan Moje, Hans-Ulrich Onasch and Torsten Renner, to whom I am likewise much obliged. In their knowledgeable and stimulating essays, Friederike Seyfried and Dirk Syndram shed light on the fascination surrounding Egyptian art and contribute towards our understanding of it. Thanks are therefore also due to them, as well as to the colleagues from the German Mummy Project in Mannheim – Stephanie Zesch, Stephanie Panzer, Albert Zink and Wilfried Rosendahl – for their expertise in conducting the scientific analyses of the Dresden mummies.

I would also like to thank the photographers of the Staatliche Kunstsammlungen Dresden, Elke Estel and Hans-Peter Klut, for the brilliant new photographs of many of the objects, and Saskia Wetzig for her judicious supervision of the project. Finally, the publishing house Sandstein Verlag has, with great dedication, also turned this project into a wonderful book in the publication series of the Dresden Skulpturensammlung, thus once again impressively testifying to the extraordinary importance of the collection. I would like to take this opportunity to thank all those involved.

Of Gods and Tombs – the Aegyptiaca in Dresden as a reflection of Ancient Egyptian culture

Friederike Seyfried

The enduring fascination of Ancient Egyptian culture is ultimately the reason why the Dresden Skulpturensammlung (Sculpture Collection) has owned a sumptuous collection of art objects and artefacts from this early advanced civilisation since the 18th century. The long and multifaceted history of the collection of Aegyptiaca and the phenomenon of Egyptomania are expertly addressed in the corresponding essays in this volume. In addition, the catalogue section provides a meticulously researched and Egyptologically sound survey of the Dresden collection, enabling readers to immerse themselves in the diverse array of ancient Egyptian objects in the Skulpturensammlung. Through their detailed descriptions and explanations, the catalogue contributions provide key insights into the cultural contexts of the objects; this not only situates them both historically and chronologically, it also helps us to understand their cultural purpose. The aim of the present contribution, therefore, is to supplement these essays by broadly outlining selected aspects of Ancient Egyptian culture and highlighting, as it were, which of its cultural facets are best reflected by the Dresden holdings. It should be emphasised, however, that a comprehensive survey cannot be presented in just a few pages, and interested readers are referred to the wide-ranging writings of expert colleagues in groundbreaking monographs on the history of Ancient Egyptian art, culture and religion.[1]

The material remains of Ancient Egyptian culture are much better preserved than those of other cultural regions, above all due to the arid climate in Egypt's river oasis (fig. 1); these valuable resources provide a vast amount of information about a cultural history that spanned more than 4,000 years, beginning with the Early Dynastic Period and the formation of the

Pharaonic state (c. 2900 BCE) and ending in Late Antiquity (5th century CE). An examination of the surviving cultural assets, however, reveals an imbalance in the state of preservation and the quantitative distribution of these artefacts across the different cultural realms: in the field of architecture, for example, monumental temples and tombs made of stone are extremely well preserved (fig. 2), whereas it is relatively rare for their likewise attested equivalent buildings made of mud bricks to have survived. The same applies for residential buildings and palaces, whose stone components have survived better than the bulk of the brick walls, which are also often buried beneath modern settlements or covered by fertile farmland. Therefore, by comparison, temples and tombs now have a greater presence than the Ancient Egyptian settlement structure. The asymmetry becomes even more apparent with regard to the respective original furnishings. In temples, it is almost exclusively the decorated walls and monumental stone sculptures that have been preserved or uncovered, with the exception of depot finds of numerous votive offerings and figurines (cf. cat. nos. 3, 6–9) or foundation deposits. The preservation of furnishings in settlements is also dependent upon the local geomorphological environment. It is a completely different situation, however, with the furnishings of tombs: here, the abundance of remains of Ancient Egyptian material culture that have been handed down to us is revealed and seems to compensate, as it were, for what has not survived in the temples and settlements. Because apart from the utensils that were produced specifically for the purposes of interment and mummification – such as the embalming materials, the coffins (fig. 3, cat. no. 21) and canopic jars (cat. no. 26), the shabtis (cat. no. 28) and the Books of the Dead written on papyrus (cat. no. 29) – most of the grave goods refer to earthly life, and can therefore be regarded as authentic evidence and a reflection of contemporary cultural life (cat. nos. 30 b, 31–34). This observation must be qualified, however, by the fact that the majority of the grave goods almost exclusively reflect the living environment of the social

Fig. 1 Hervé Champollion, *West bank of the Nile below Esna (Upper Egypt)*, 2006

Fig. 2 Mortuary temple of Pharaoh Ramesses III
in Medinet Habu, Western Thebes

elites. On the other hand the depictions of craftsmen at work
or of agricultural scenes – either in relief (cat. no. 14), paintings
or three-dimensional models – and the surviving literary ref-
erences to other social groups offer important insights into the
lives of all social strata in Ancient Egypt.

The abundant material deriving from tombs and burial
sites range from the royal interments in the pyramids and the
later rock-cut tombs in the Valley of the Kings, to the monu-
mental cemeteries of associated officials, priests and military
personnel, and the burial sites of their servants and clientele,
to the important tombs of outstanding craftsmen and artists.
These archaeological references have shaped our view of a cul-
ture dominated by a cult of the afterlife, with the result that
Ancient Egyptian culture perhaps best represents and elucidates
what Jan Assmann summarised in his pertinent and universal
claim that "death is the origin and the centre of culture."[2]

This theory, which is convincingly verified by Assmann
in his book *Tod und Jenseits im Alten Ägypten* (Death and
Salvation in Ancient Egypt), expressly refers to the very be-

ginning of human history and the earliest signs of human
culture. Reflecting on one's own mortality, burying one's
relatives, wishing to maintain in contact with one's ancestors,
assuming the existence of an afterlife, and believing that
numina and deities control the universe and the forces of
nature – all of these practices and beliefs revolve around the
cultural factor of death.

In hardly any other society does the cultural driving force
of death assume such diverse forms as it does in Ancient
Egypt. At the same time, it becomes apparent that the Ancient
Egyptians in no way had a death wish; instead, their adher-
ence to a firmly established and meaningful divine cult, cou-
pled with a mortuary cult, meant that they were to a certain
extent reconciled with death, or "overcame" it with their con-
cepts of the afterlife. The fascination with Ancient Egypt that
gradually took hold of Europeans in the 17th and 18th centu-
ries and has since become an enduring global phenomenon,
probably stems not only from admiration for this culture's
artistic and artisanal products and their specific aesthetic, but

also from precisely this sense of being reconciled with one's physical death.

This brings us back to the Dresden Aegyptiaca, the large majority of which can be assigned to the divine cult and/or the mortuary cult; these holdings can therefore be used to identify and explain the core elements of Ancient Egyptian ideas of the afterlife and theological concepts. The following sections will concentrate first of all on some fundamental theological principles, then on the mortuary cult. The sociopolitical development and history of the Pharaonic state will, on the other hand, not be outlined in detail here; this approach corresponds to the focus of the collection of Egyptian antiquities in the Dresden Skulpturensammlung.

Observations on the polytheistic religion of Ancient Egypt

The religions of all early cultures are characterised by the fact that they evolved rather than being founded; they were, therefore, completely in harmony with the natural environment in the respective cultural region, and were indeed primarily determined by natural phenomena. Cosmic manifestations and astronomical observations, the alternation of day and night, the changing seasons, climatic influences on local living conditions, flora and fauna, and human life with its continual exposure to danger from birth to death: all of these elements shaped the distinctive forms of religious concepts and actions in early cultures. A multitude of divine influences were perceived, and each culture met these with its own cultic practices and religious ideas. Gods and goddesses, demons and spirits were thereby mainly associated with the forces of nature and celestial bodies, as well as with particular animals and plants and their attributes.

In terms of their origins, religious beliefs in Ancient Egypt also followed these conventions, but over the course of millennia they evolved into a dense network of deities in varying constellations. The wealth of connections and correlations inevitably seems confusing at first glance, but going back to the beginning of the history of these cults makes it easier to understand how each early settlement along the Nile developed its own cults, and at least one city deity (cf. cat. no. 6)

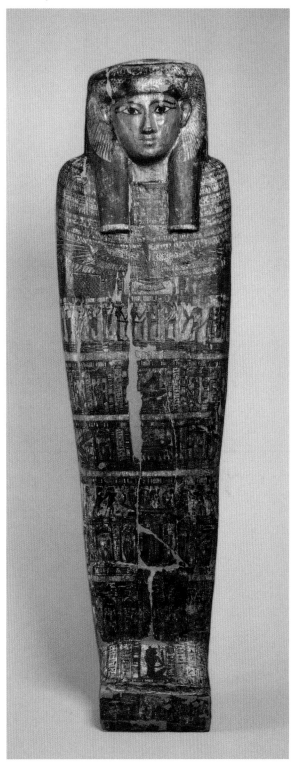

Fig. 3 Lid of a coffin, Late Period, wood, clay, plaster/chalk ground, painted, h. 172 cm, Staatliche Kunstsammlungen Dresden, Skulpturensammlung, Inv.-no. Aeg 784

could be assigned to each of the cities that grew out of these settlements. The deity resided in the city temple. This sacred district, which was surrounded by walls, was a condensed embodiment of heaven and earth; it marked the domain over which the deity ruled, and at the same time it was the economic centre of the city, as the surrounding agricultural land and business enterprises were linked to the temple, and thus to the deity. As Jan Assmann notes in his unsurpassed survey of religious beliefs in Ancient Egypt, "an Egyptian city was always the city of a deity"[3].

Given these prerequisites, it was almost inevitable that several deities with comparable or similar attributes would be worshipped in different places along the Nile, and also that different creation myths could exist simultaneously without mutually excluding one another. For example, there were several gods associated with the moon, such as Thoth (fig. 4) and Khonsu, one of whom resided in Hermopolis, while the other belonged to the Theban triad. There were also various mother goddesses, such as Isis and Hathor, and a number of primordial and creator gods, such as Nun, Atum (fig. 5) or Amun (fig. 7). Over time, the similarities between various deities could lead to their becoming merged, and certain theological concepts could also gain greater acceptance compared to other constellations of deities, but the close connection between gods and their respective cities was never relinquished. This link between the deities and their cities was particularly evident in the Greek renderings of the names of Ancient Egyptian settlements. "City of Thoth" became Hermopolis (after Hermes, the Greek messenger of the gods), while "City of (the crocodile god) Sobek" (cat. no. 8a) became Crocodilopolis, to give just two examples.

Besides the huge number of Ancient Egyptian gods, the incredibly diverse manifestations of these deities have always held a strong fascination, but also caused confusion and amazement. A deity can be represented in purely anthropomorphic or purely animal form, or be depicted as a hybrid form, whereby the head of an animal is combined with a

◀ Fig. 4 Statuette of god Thoth as an ibis, Late Period, bronze, h. 9.8 cm, Staatliche Kunstsammlungen Dresden, Skulpturensammlung, Inv. no. Aeg 821

Fig. 5 Relief of god Atum, Mortuary temple of Pharaoh Ramesses III in Medinet Habu, Western Thebes

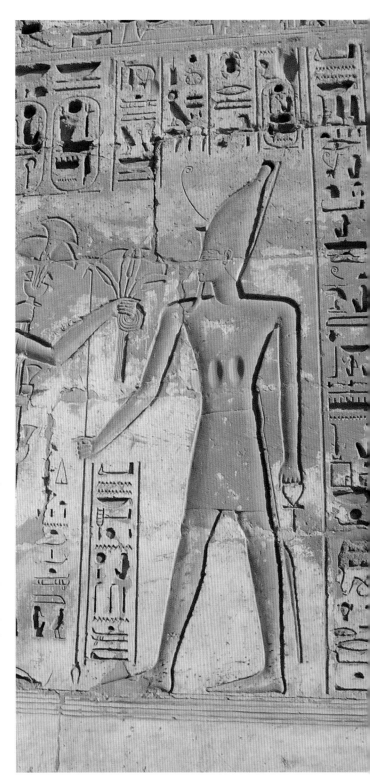

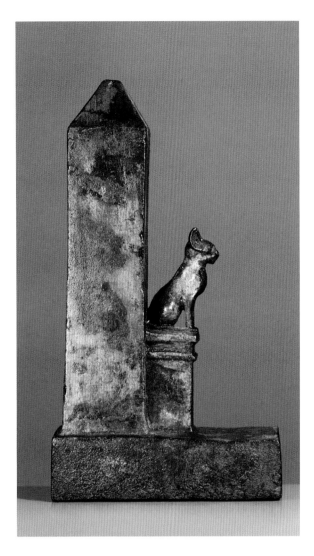

Fig. 6 Statuette of goddess Bastet in form of a cat, sitting in front of an obelisk, Late Period, bronze, h. 15.8 cm, Staatliche Kunstsammlungen Dresden, Skulpturensammlung, Inv. no. Aeg 823

warrior goddess Sekhmet is depicted as a lioness (cat. no. 4); this reflects the pack behaviour of lions, where the females are the main hunters. The (male) lion in the depiction of the sphinx, on the other hand, is associated with the king (cat. no. 11). The goddess Bastet, one of several goddesses of love, is mainly depicted as a cat (fig. 6, see also cat. no. 6 b), while another mother goddess, Hathor, is depicted as a cow suckling the young king. Some gods also had several sacred animals associated with them, which embodied different aspects of the deity's character. Amun, the creator god and state god who is mainly depicted in purely human form (fig. 7), is associated with both the goose and the ram (cat. no. 25 aq), and Thoth, the god of writing, scribes and the moon, is depicted both as a baboon and as an ibis (fig. 4, cat. nos. 21, 23 c, 25 ab, 29). In the respective cult centres, the sacred animals of the deities were worshipped in the temples and also kept there, and when they died they were mummified and buried in their own grave-yards. Viewed from today's perspective, this custom assumed quite bizarre proportions during the Graeco-Roman Period: not only was the most sacred temple animal in which the deity was incarnated and "indwelled" (einwohnte) later mummified and buried (cat. no. 6 e), but also every one of the animals that were kept, or even just parts of them (cat. no. 8). In the case of the ibis necropolises dedicated to Thoth at Tuna el-Gebel near Hermopolis in Middle Egypt, mummified parts of wings and even the eggs of birds were found in the ceramic vessels made for this purpose. Similar evidence of baboon burials is attested at the same site as well as for the cat mummies associated with the goddess Bastet at Bubastis and Saqqara (fig. 6).

Animals and plants were not the only things assigned to the deities, however; crowns and other accessories also defined a deity's characteristic appearance (for examples, see cat. no. 25). The above-mentioned goddess Hathor, for example, is depicted wearing a headdress of cow horns and a sun disk (cat. no. 25 s) when she appears as a woman. The same headdress could also be worn by Isis, as both goddesses were syncretistically merged into a composite deity called Isis-Hathor (cf. cat. nos. 6 d, 7 c, 9 b). In many places, however, people worshipped not only a single god, but also divine triads, families or groups of deities. The following examples may be given: at Thebes Amun (fig. 7) was worshipped together with the goddess Mut (fig. 8, see also cat. no. 4) and their common child Khonsu, – or at Memphis, the god Ptah in a triad with the goddess Sekhmet and the young god Nefertem (cat. no. 6). In addition, many gods were worshipped at different places as "visitors" during divine festi-

human body, and the join is skilfully concealed by a collar or wig. There are, however, also examples of the opposite convention, such as in the depictions of sphinxes (cat. no. 3 c), which usually have a lion's body and a human face. The attributes and responsibilities of the gods that are portrayed in animal form can often be derived from the observable biological features or behaviours of the respective species. For example, the fierce

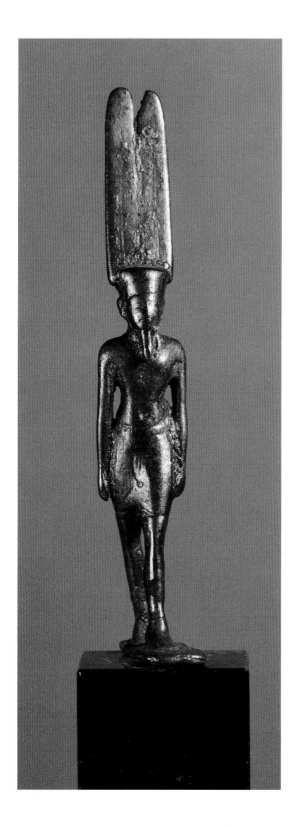

vals when they participated in the ceremonies. This practise results in the construction of many smaller temples and sacred places for those "guest gods" at the main religious centres of Ancient Egypt. In the holy complex of Karnak at Thebes not only the main local deities were worshipped, but likewise the god Ptah and the goddess Ipet (cat. no. 2).

The previous sections have briefly outlined the diverse manifestations of Egyptian gods and goddesses, with only marginal reference being made to existing structures that reveal a meaningful order within this country inhabited by gods. At this point I would like to address one of the most important creation myths in Ancient Egypt, which non only deals with the emergence of the cosmos and the genealogy of the gods concerned, but also legitimises the institution of Egyptian kingship and leads on to the final section of this essay, which focuses on the Ancient Egyptian mortuary cult: it is the creation myth of Heliopolis.

In this myth, the development of the cosmos from pre-existence to primeval time to historical time[4] is represented with the aid of a genealogical sequence of nine deities. Atum, the All-Lord, is the god of pre-existence: "His name means both 'to be nothing' and 'to be everything'."[5] Atum (fig. 5) produces from himself the first divine couple: the male air god Shu and his female counterpart Tefnut, whose name is often translated as "moisture" – probably in reference to her having been "spat out" or "excreted" by Atum (cf. cat. no. 6b). Shu and Tefnut are the first couple to be distinguished as male and female. They in turn produce the god Geb ("earth"), and the godess Nut ("sky") (cat. no. 23 a). This divine couple then creates four deities who form pairs of siblings: Osiris and Isis, Nephthys and Seth. In primeval times, according to the myth, the male gods ruled on earth in the genealogical sequence outlined above, before withdrawing into the heavenly sphere, whereby their presence on earth was always guaranteed through the process of "indwelling" (*Einwohnung*) in the temples. The Osiris myth that takes up from this point leads seamlessly into the historicity of Egypt by establishing Egyptian kingship ideology as fundamental to the Pharaonic state: Osiris, who was murdered and dismembered by his jealous brother Seth, is healed and brought back to life by his sisters Isis and Nephthys

Fig. 7 Statuette of god Amun, Late Period, bronze, h. 11.5 cm, Staatliche Kunstsammlungen Dresden, Skulpturensammlung, Inv. no. Aeg 472

(cat. nos. 19, 21, 24 aa, 27 b, 29), and thereafter rules in the world of the dead. His son Horus then becomes the legitimate successor and rules on earth. For this reason, every living Pharaoh embodies the god Horus on the throne of his father Osiris, and attains the status of an Osiris upon his death (see also cat. nos. 7, 10, 11 d).

Although the preceding sections could only provide minimal insights into the closely interwoven structure of the Ancient Egyptian pantheon, they have hopefully shown that no site and no city in Egypt could have been conceived without a deity, and also that the entire foundation of Egyptian kingship, as well as that of mortuary belief, would not have endured for thousands of years without this complex and meaningful network of gods.

Concepts of the afterlife and mortuary belief

Ancient Egypt is not only a country that is directly associated with temples and a huge variety of deities; even more centrally, the omnipresent mortuary cult sparks and shapes popular interest in this past culture. Hardly any other culture has produced as much evidence of how people dealt with death or attempted to "overcome" it, and these traces of material culture are also preserved for posterity in an excellent state due to the country's very favourable climatic conditions. Most of the archaeological finds and built structures from this culture are, it seems, related in some way to the mortuary cult, and the overwhelming majority of Ancient Egyptian objects in the corresponding museum departments also come from tombs and burial sites.

Jan Assmann's thesis that death is "the origin and the centre of culture" seems to be illustrated in a particularly impressive manner in Egypt, where it served as a "cultural motor" par excellence. A key factor that distinguishes the early human *Homo* variants (and subsequently the development of *Homo sapiens*) from other primates is indeed how they deal with death and with deceased members of their species. The beginning of human culture is directly linked to artificial burials, and has always been associated with the practice of placing grave goods with the dead body. This indicates the importance of the permanent integration of the deceased relatives into the community and the vital belief in the existence of a kind of "afterlife".

Human history in Egypt since the Palaeolithic age is well documented and hence traceable. From the beginning of the Neolithic Period onwards, however, a new diversity of cultures

evolved that are named Merimde, Badari and Tasa after the sites of their respective archaeological finds. These cultures span the period from c. 6000 to 4000 BCE, and are followed after 3800 BCE by the so-called Naqada culture; it marks the transition to the historical period of the Pharaonic state, and at the same time establishes on a basic level all of the characteristic elements of Ancient Egyptian culture that were to define the country for another four thousand years.

Even in the simple, pit-like graves of Naqada culture, jewellery and pottery grave goods (cat. nos. 31 a, b) were found that were presumably intended to supply the deceased with provisions in the afterlife and to protect them; to date, however, we have no knowledge about the specific concepts of the afterlife associated with these items.

With the formation of the first Dynasties and the establishment of the institution of the Pharaoh as a divine ruler from c. 2900 BCE onwards (cf. cat. no. 11), the concepts of the afterlife gradually become more clearly defined. Despite certain points of contact and overlap, a clear distinction can be made between royal/divine concepts of the afterlife on the one hand, and those of non-royals and commoners on the other. Monumental tombs were built for the god-king, first of bricks and later of stone; in the Old Kingdom, this culminated in the construction of the pyramids with their mortuary temples, which were intended to guarantee that the deceased Pharaoh ascended to the sky where he would be welcomed among the gods (cf. cat. no. 13). Both the precise orientation of the pyramids towards the north, in alignment with the North Star, and the Pyramid Texts inscribed in the royal burial chambers since the 5th Dynasty – the earliest collection of spells in royal afterlife literature – were meant to underline the unique divinity of the ruler. Members of the royal household and elite officials were buried in their own cemeteries in the immediate vicinity of the royal tombs. Their also quite monumental tombs do not take the form of a pyramid; in the Old Kingdom, they were either built as mastabas or cut into rocks. The burial furnishings and decorations in these tombs did not serve the "ascent to the sky", but rather to preserve the memory of the deceased in the social context of his relatives, and to secure his continued existence in the afterlife. The funeral equipment, along with the texts and depictions in relief or painted on the walls of the tombs, present a reliable, albeit almost always incomplete and idealised mirror image of contemporary socioeconomic conditions, as well as of prevailing religious concepts (cf. cat. no. 14).

The emphasis placed on different aspects of these beliefs differed from one era to the next, and changes in the concepts of the afterlife also became apparent. Whereas in the Old Kingdom, the Pharaoh was elevated to the gods in the northern sky after his death, in the New Kingdom he takes part in the nocturnal journey of the sun and becomes Osiris, the ruler of the afterlife. This transformation in the royal concept of the afterlife is impressively documented in the corresponding guidebooks to the netherworld – the texts and images that adorn the walls of the New Kingdom royal tombs in the Valley of the Kings. An equally fundamental transformation also occurred in the non-royal realm. Although in the 18th Dynasty the officials' tombs still followed the tradition of the commemorative self-image and served the self-representation of the tomb owner (cf. cat. nos. 15, 16, 17 b). The contents connected with divine worship continually increased, and in the 19th and 20th Dynasties the tomb was transformed into a private mortuary temple. In the depictions on the walls of tombs, the deceased and his family members now actively participated in the divine cult, and overall the tomb was no longer conceived as serving an individual, social culture of remembrance, but had become a monument to "personal piety" (cf. cat. no. 17 c).

It has thus been established that for both the king and members of the elite, the tomb was not only a burial site but also a monument and an assurance that they would live on in the memory of future generations or in the world of the gods. At the same time, the primary purpose of the tombs was of course to bury the deceased and keep their bodies intact. Here we touch upon what is perhaps the most characteristic feature of the Ancient Egyptian mortuary belief: the need to preserve the dead body, which guaranteed that the person's individuality was maintained in the afterlife. Probably based on knowledge gained from the earliest burial practices – that a human body buried in hot sand underwent a process of natural desiccation or self-mummification – an elaborate artificial method of mummification was developed over the centuries that preserved the dead body in an exceptionally good state and to a high aesthetic standard; this applied – as already explained – not only to human beings but also to sacred animals (cat. no. 8). As the Osiris cult grew in importance after the end of the Old

Fig. 8 Relief of goddess Mut, Mortuary temple of
Pharaoh Ramesses III in Medinet Habu, Western Thebes

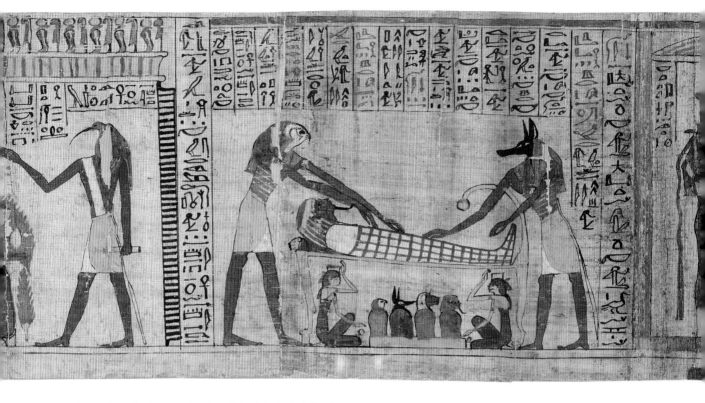

Fig. 9 Mummification scene with Horus (le.) and Anubis, including the four canopic jars protected by the mourning goddesses Isis and Nephthys, Book of the Dead belonging to Ankh-ef-en-amun (cat. no. 29)

Kingdom, the mummification of the human body was increasingly related directly to the divine myth of his death and revival. The physical death of a person concluded the phase of their earthly life and was associated, as it were, with the violent death of Osiris, whose dismembered corpse, according to the myth, was scattered throughout Egypt. Isis and Nephthys not only mourned their brother's death, they also gathered his body parts together. With the help of the god Anubis, they succeeded in "healing" Osiris through the embalming act, and he was reborn in the afterlife (cf. cat. nos. 17 a, c, 21, 29).

During the mummification process, which took up to 70 days, the individual surgical interventions, drying and embalming procedures (cf. cat. nos. 19, 20, 26) were accompanied by countless recitations by priests; this clearly demonstrates the parallelisation with the myth (fig. 9). Mummification was intended to bring "salvation" from death, as Jan

Assmann[6] so aptly describes it, and to ensure that the deceased became an "Osiris N.". The numerous depictions showing Isis and Nephthys standing at the head and foot of coffins vividly underscore this parallelisation. The coffins surrounding the mummy – depending on the type of burial furnishings, there could be several nested coffins – were specifically intended to protect the body that had been restored for the afterlife (fig. 3, cat. nos. 21, 23).

In New Kingdom concepts of the afterlife, it was very important that the spirit-like Ba of a person, which moved freely and was separate from the (physical) body, could at any time be reunited with the body of the Osiris N. and reside within it. While the Ba – as described in the Book of the Dead – "went forth by day"[7] and appeared on earth in various guises, the corpse remained in the tomb and served the Ba as a place of reunification (cf. also cat. no. 30 a).

Another important aspect of New Kingdom concepts of the afterlife was particularly fascinating for western cultures that followed the traditions of Christianity: the institution of the Judgement of the Dead, as illustrated and described in Chapter 125 of the Book of the Dead. Every deceased person is thereby required to justify themselves before a panel of judges and Osiris, the god of death (cat. nos. 21, 23 c, d, 29). Only after a successful recitation of the so-called "negative confession" by the deceased in front of Osiris, was the justified person allowed to enter the "Elysian Fields". The judgment scene is very often illustrated by the metaphoric depiction of weighing the heart of the deceased (i.e. the doings) against a light ostrich-feather representing the principles of Maat, the goddess of justice (cat. nos. 25 u, at). If the pair of scales are in balance, the justification of the deceased is likewise attested. In the chapters and spells of the Book of the Dead, further important measures are described that grant the deceased safe passage into the afterlife and protect them from danger. These include spells that appeal to the heart to not testify against its owner during the Judgement of the Dead (cf. cat. no. 25 g)[8], as well as the famous Chapter 6, which obliges the deceased to do work in the afterlife; these duties are, however, cleverly delegated to funerary figurines called shabtis, which are inscribed with the text of this spell to act as representatives of the deceased (cat. no. 28).

Independent of these actions that were assigned to the deceased in the netherworld, it was the responsibility of the relatives to uphold the mortuary cult and the provisioning of the deceased, as well as to preserve their memory. Following the elaborate burial-ceremonies with all the necessary funerary objects (see also cat. nos. 27, 31–33), this service was done by making regular visits to the burial site including food offerings in front of the statues (cat. no. 18) or in front of the funerary stelae (cat. no. 17). In recognition that any active mortuary cult is limited the depictions of sacrificial acts, scenes of provisioning and celebratory feasts on the tomb walls were intended to guarantee the existence of the named persons in eternity (cat. nos. 14, 15).

The amount of effort Ancient Egyptians invested in "overcoming" death seems almost immeasurable – and sometimes incomprehensible or even contradictory – but it resulted in a successful reconciliation with the most incisive event in the life of every human being. Today, we look upon this achievement with a mixture of fascination and envy.

1 For a general introduction to Ancient Egyptian culture, I would suggest the following: Assmann 2002; Assmann 2003 a; Baines/Málek 1980; Donadoni 2004; Hornung 1993 a; Kemp 1989; Lloyd 2010; Schneider 2010; Schulz/Seidel 1997; Shaw 2007; on historical aspects: Assmann 1996; Schneider 1996; Shaw 2003; on art and archaeology: Arnold 1997; Arnold 2012; Dodson/Ikram 2008; Hartwig 2015; Manley 2018; Riggs 2014; Robins 2000; and on religion: Assmann 1991 and 2003 b; Hornung 2005; Ikram/Dodson 1998; Morenz 1984; Quirke 1996; Taylor 2001; Wilkinson 2017.

2 Jan Assmann, *Death and Salvation in Ancient Egypt*, trans. David Lorton, Ithaca, NY 2005 [2001]: 1.

3 Jan Assmann, *The Search for God in Ancient Egypt*, trans. David Lorton, Ithaca, NY, 2001 [1984]: 19.

4 Cf. ibid.: 119–147. Some of Assmann's extremely apt definitions and terms have been borrowed here.

5 Cited ibid.: 119.

6 Cf. Assmann 2003 b: 29–53.

7 The Ancient Egyptian title of the compendium of spells or chapters translates literally as "The Book of Going Forth by Day" or "Spells for Going Forth by Day". The term "Book of the Dead" was coined by Carl Richard Lepsius, who first edited this collection.

8 Book of the Dead, Chapter 30.

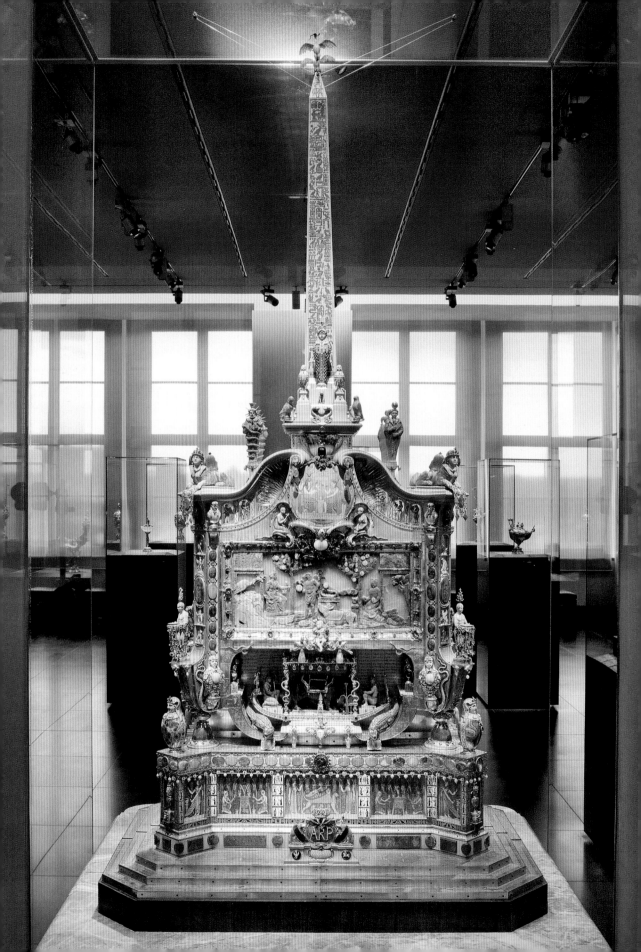

Saxon Baroque and the 18th-century fascination with Ancient Egypt[1]

Dirk Syndram

For Europeans in the early 18th century, Ancient Egypt was not only geographically, but also temporally a very distant, myth-laden and – for that very reason – strangely fascinating country. The Grünes Gewölbe (Green Vault) in Dresden holds perhaps the most impressive attestation of the reception of Ancient Egyptian art in Europe during the Baroque Period: Johann Melchior Dinglinger's *Apis-Altar* (fig. 1)[2]. At the time when this large-scale, jewel-encrusted artwork was being created, an unusually strong interest in the art of Pharaonic Egypt can be discerned, emanating from the Saxon-Polish court.

Johann Melchior Dinglinger and Ancient Egypt

Although the design and structure of the 195 cm-high artwork follows the tradition of wall-mounted Christian altars, its opulent artistic representation of existing knowledge about Ancient Egyptian deities is unprecedented. The showpiece that entered the Juwelenzimmer (Jewel Room) of the Grünes Gewölbe – Augustus the Strong's treasury, which was already filled with countless magnificent and precious works of art – in 1738 was the final work of the court jeweller Dinglinger, who died on 6 March 1731. The *Apis-Altar* became, as it were, the personal legacy of this outstanding jeweller because, like the majority of his cabinet pieces, it was undertaken without a commission. Dinglinger's engagement with the ancient myths and pictorial worlds of Egypt was thus the work of a 66-year-old artist nearing his death, who sought to capture in this work the timeless wisdom of a culture that was pervaded by, and committed to, the cult of the dead. To this day, the *Apis-Altar* testifies to the exceptional intellectual skills, artistic talent and craftsmanship of its maker. This is also reflected in the inscription the court jeweller had attached to

Fig. 1 *Apis-Altar* on its present display in the New Green Vault, Staatliche Kunstsammlungen Dresden, Grünes Gewölbe, Inv. no. VIII 202

the base of the obelisk. On the left-hand side, it reads: "QUAE ANTIQUA AEGYPTUS STUPIT / SUPERBA MOLI-MINA / NOVA LUCE HOC OPERE SIST- / UNTUR COLLUSTRA / QOD / AD VETERUM MONUMENTO- / RUM FIDEM / NEC INDUSTRIAE PARCENS NEC / SUMPTIBUS" (which translates roughly to: Superb monuments / that were looked upon with wonder in Ancient Egypt / live on, illuminated by a new light / in this work / created to be / faithful to ancient monuments / and sparing no effort or expense). On the right-hand side, this is supplemented by the inscription "INVENIT STRUXIT ORNAVIT / POTENTISSIMI POLONIARUM / REGIS / FREDERICI AUGUSTI / PRIMUS OPERIS GEMMATI ARTI- / FEX / JOHANNES MELCHIOR DINGLING- / ER / DRESDAE / A D S MDCCXXXI" (Conceived, built and decorated by / Johann Melchior Dinglinger, / the mighty King of Poland / Friedrich Augustus's / primary jeweller, / Dresden, / in the year of salvation 1731)[3].

In addition to the uniqueness of its appearance, Dinglinger's *Apis-Altar* shares with his other great works of treasury art the fact that it was not made by royal commission; it was initially the product of the jeweller's creative ambition and, above all, was created at his own financial risk. This showpiece of Baroque erudition, which doubtless cost more to produce than a city palace in Dresden, is mentioned in connection with the Grünes Gewölbe on 1 March 1738, in an entry made by the Inspektor (curator) Johann Adam Schindler in the journal of this collection: "Den 1. Marty Ao: 1738 Haben S. Königl.: Mayt. Ein grosses Cabinet Stückh, von H: Dinglinger, die Ægyptischen opfer und abgötterey vor stellend in die geheime Verwahrung des grünen gewölbes gegeben, und befindet sich solches in den Jubellen Zimmer, auf den Tisch, wo sonst der Coffeé aufsatz gestanden."[4] (1 March Anno: 1738 His Royal Majesty placed a large cabinet piece by Mr Dinglinger, depicting Egyptian offerings and idol worship, in the Geheime Verwahrung (Secret Repository) of the Grünes Gewölbe, and

this object is located in the Juwelenzimmer, on the table where the coffee service otherwise stood.)

On a narrative level, the iconography from which the treasury artwork draws is quite specific (fig. 2). The central theme in this flood of images is the myth of Osiris. The depiction in the middle of the base shows Osiris, the Egyptian god of fertility and ruler of the underworld, lying on a bier. The engraved image is flanked by depictions of two priests making offerings to Osiris. The deep niche above the base, which is framed by a hieroglyphic inscription engraved on gilt panels, is devoted to the Apis bull – the earthly incarnation of the god Osiris – crossing the Nile on a barque. The sculptural figures are remarkable, especially the two crocodiles that are studded with countless diamonds and symbolise the banks of the Nile. The large-format agate cameo, probably carved by Christoph Hübner, represents Osiris, the father of the gods – here portrayed with the head of a dog – being worshipped after his death by his wife Isis and other gods of the Egyptian pantheon. Finally, the rounded enamel painting above this depicts the transfigured realm of the divine couple Isis and Osiris, along with their son, Horus. Further small sculptures of deities are found on the entablature at the foot of the 75 cm-high obelisk, which is an exact, small-scale reproduction of the Ancient Egyptian monument that was erected in front of the Lateran in Rome in 1588. A gold-enamelled ibis – the symbol of Thoth, the god of wisdom and profound knowledge – rises up from the tip of the obelisk.

The material and graphic sources of the *Apis-Altar*

In a truly unique way, Johann Melchior Dinglinger's treasury piece incorporates the knowledge that existed in Europe in the early 18th century about the religion and art of Ancient Egypt. But how was this world of ideas and forms, which had been buried for thousands of years and was geographically almost inaccessible, transported from the Nile to the Elbe? On the one hand, it came via Dinglinger's personal encounter with Ancient Egyptian objects – to which the jeweller had special access at the time when he was working on the *Apis-Altar* in Dresden. Some Aegyptiaca were already held in the Saxon Electors' Kunstkammer (art and curiosity cabinet) and also in the Hofapotheke (court pharmacy), but when ancient sculptures from the royal Prussian Kunstkammer in Berlin came into the possession of Augustus the Strong between 1723 and 1726, artefacts from the Pharaonic Period also entered the Dresden Antikensammlung (Antiquities Collection). Above

all, however, it was the spectacular acquisition of the estate of Prince Agostino Chigi, comprising 160 sculptures, along with 34 antiquities from the collection of Cardinal Alessandro Albani, that made Augustus the Strong's electoral-royal antiquities collection one of the earliest, and at the same time largest, collections of antiquities – and Ancient Egyptian collections – north of the Alps from 1728 onwards, because with the Roman antiquities, numerous examples of the material culture of Pharaonic Egypt came to Dresden (cf. the contribution by Marc Loth in this volume). Baron Raymond Leplat, an architect who worked for many years as Augustus the Strong's Kunstintendant (artistic advisor), and also served as an intermediary in the acquisition of the Roman antiquities for Dresden, published these newly acquired pieces in 1733 in folio format as *Receuil des marbres antiques (…)* [Collection of antique marble sculptures (…)]. Nine of the large plates in this publication are devoted to objects Leplat associated with Egypt. It also contains motifs that were employed by Johann Melchior Dinglinger in his *Apis-Altar*: the Apis bull, shabtis (funerary figurines that appeared very strange to European eyes), various depictions of sphinxes, as well as several pieces that are listed as "Idol Egyptien", such as the god Thoth manifested as a baboon, Isis with the infant Horus, and a statuette of Osiris.[5]

It should be noted that the newly acquired Aegyptiaca were not published until 1733, which was two years after the jeweller's death. In addition, the engravings are accompanied only by very brief and imprecise commentaries; it is therefore unlikely that these actual objects were the source of inspiration for the *Apis-Altar* with its abundance of Baroque knowledge.

Instead, Johann Melchior Dinglinger gained his knowledge about Egyptian culture, art and religion from an 18th-century source whose influence can hardly be overstated. He was probably the first artist to use the images and interpretations contained in *L'antiquité expliquée et representée en figures* (Antiquity Explained and Illustrated) – a book of engravings published by Bernard de Montfaucon between 1719 and 1724 in 15 large folio volumes – for his own creative purposes.

Fig. 2 Johann Melchior Dinglinger (design); Dinglinger and workshop (Goldsmith's work); Christoph Hübner (stone cutting); Gottlieb Kirchner (sculpture), lower part of *Apis-Altar*, 1731, Kelheim stone, various gemstones, silver-gilt, enamel, pearls and diamonds, h. 195 cm, Staatliche Kunstsammlungen Dresden, Grünes Gewölbe, Inv. no. VIII 202

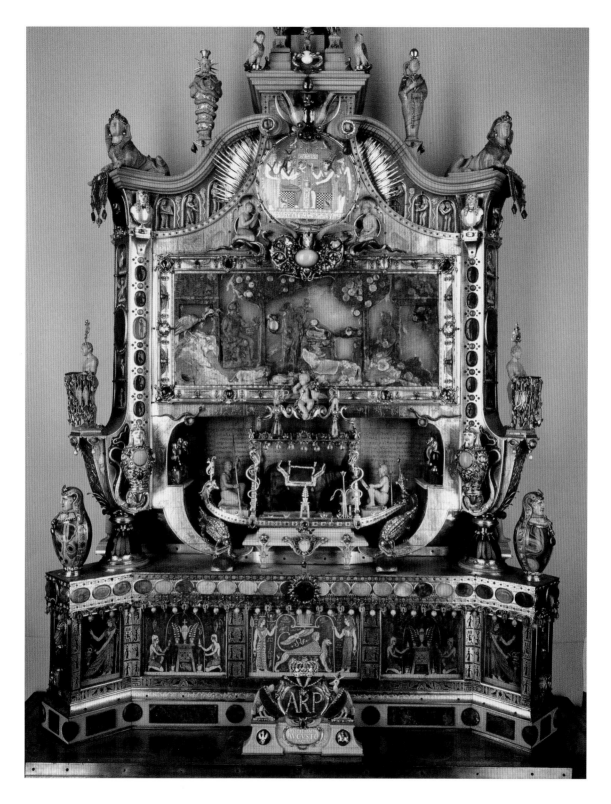

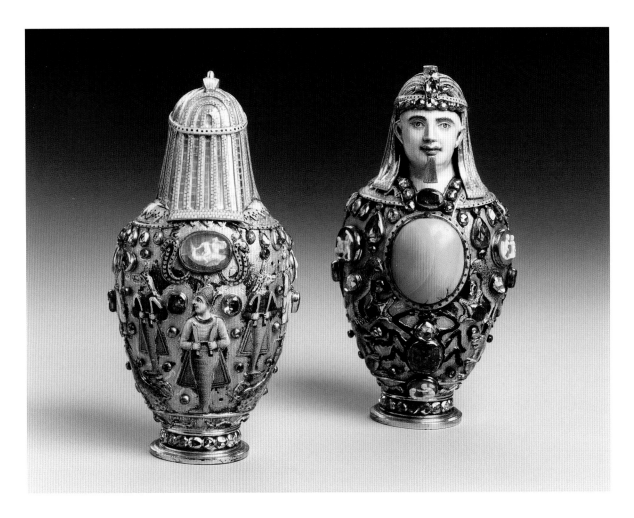

Fig. 3 Detail of the *Apis-Altar*, Canopic jar, Staatliche Kunstsammlungen
Dresden, Grünes Gewölbe, Inv. no. VIII 202

The Benedictine monk's publication, in which scholarly commentaries accompany engravings of outstanding quality, reflects existing knowledge about the ancient world at the beginning of the Enlightenment. Besides numerous artefacts from Graeco-Roman antiquity, it includes almost all of the known artworks that were considered to be Ancient Egyptian. Most of the works depicted in Montfaucon's engravings are sculptures, small sculptures or works of glyptic art from public and private collections in Europe. Some sheets, however, are devoted to imaginative views of large architectural structures in Egypt. The compendium of antiquities became one of the most frequently used pictorial reference works of the 18th century. It influenced not only the design of the *Apis-Altar*, but also numerous representations of the sphinx – which was increasingly being incorporated into 18th-century gardens as an indispensable mythical protector and symbol of nature – and at the end of the century, Montfaucon's images still determined the forms of popular Egyptianising products fabricated by Josiah Wedgwood's pottery company.

In his commentaries, Montfaucon promoted an image of Egypt that on the one hand presented Egyptian culture as the source of Western thinking, but on the other denied Pharaonic

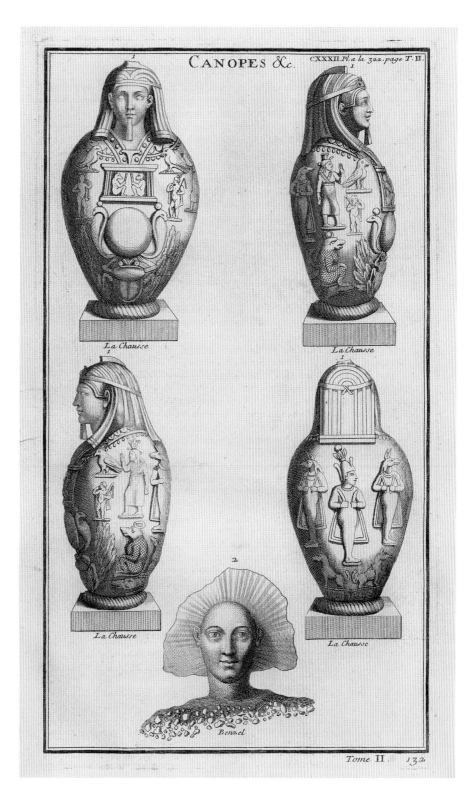

art any positive aesthetic qualities. In the early 18th century, this view was shared by the majority of people who were interested in art, and also by leading art theorists – but to a lesser extent by artists like Dinglinger, who regarded Egypt as the model of knowledge, the cult of the dead and the quest for eternal life, but also as a starting point for mystical speculations. Particularly noteworthy is Dinglinger's "translation" of Montfaucon's two-dimensional, black-and-white designs into three-dimensional, coloured sculptures and canopic jars (fig. 3). And it is remarkable to see how he succeeded in restoring an Egyptianising appearance to the already somewhat European-influenced representations in *L'antiquité expliquée* (fig. 4).

The Saxon sphinx

At the time when Dinglinger's *Apis-Altar* was created, designs and motifs associated with Ancient Egypt were popular – indeed rather *à la mode* – in Saxony and at the Saxon-Polish royal court. Sculpted sphinxes not only flanked the stairs leading down to the river Elbe at Pillnitz Palace, the royal summer residence near Dresden that was built by Pöppelmann in 1720; they also guarded the parks in Grosssedlitz and Joachimstein. Ancient Egypt also found its way into the product designs of the royal porcelain manufactory in Meissen at an early date. In 1732, for example, the sculptor Johann Gottlieb Kirchner – who had probably already produced sphinxes for the *Obeliscus Augustalis*, completed in 1721, and would also have worked

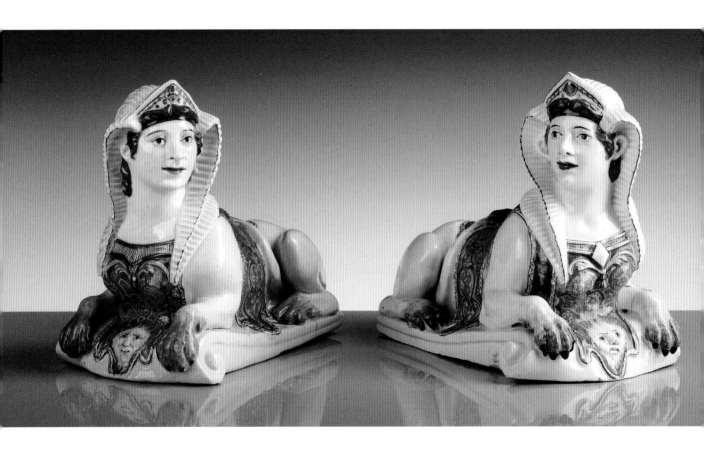

Fig. 5 Johann Gottlieb Kirchner, *Resting Sphinxes*, c. 1732, porcelain, painting: onglaze colours and gold, h. 21 cm, Staatliche Kunstsammlungen Dresden, Porzellansammlung, Inv. no. PE 1873 and PE 1875

Fig. 6 Johann Gottlieb Kirchner, *Grotesque vase in shape of a canopic jar*, c. 1735, porcelain, cold painted in red and gold, h. 80.4 cm, Staatliche Kunstsammlungen Dresden, Porzellansammlung, Inv. no. PE 5743

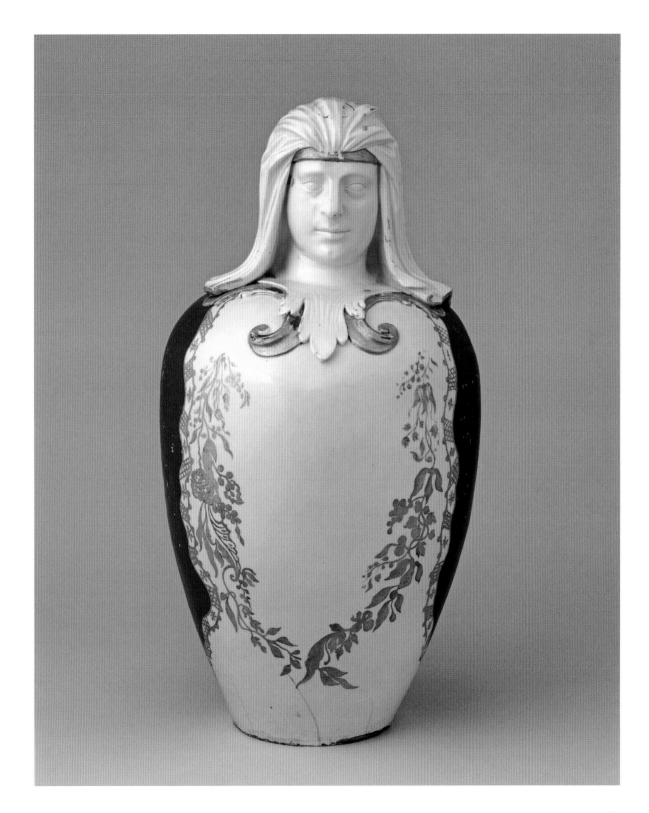

closely with Dinglinger on the *Apis-Altar* – created sphinxes made of porcelain. Augustus the Strong's Porzellansammlung (Porcelain Collection) still holds large monster figures in an Egyptianising style (fig. 5).[6] The earliest porcelain sphinxes created in Meissen are attested in various forms; in the archival records they are listed as "Sfinxe", "Spinxhe" or "Spinxe".[7] These sphinxes are usually presented in pairs, with their heads turned towards or away from each other. The 22 cm-high and 24 cm-long hybrid creatures are among the first sculptural works to be made of porcelain, and are probably based on a model produced by the court sculptor Johann Gottlieb Kirchner. They are lying in a slightly ascending position on volute-like, rolled plinths and wear a typical, close-fitting cap with two pleated lappets reaching to their chests. The erstwhile royal headdress of the Pharaoh, who was endowed with the power of the lion and depicted as a hybrid of a lion and a man, has been transformed by Kirchner into a fashionable woman's headdress; in the *Obeliscus Augustalis*, the headdress is even crowned with a jewelled diadem. Kirchner, who was the master modeller at the Meissen manufactory, created two types of Egyptianising artworks for the royal porcelain collection. One type is represented by the large, white-glazed sphinxes he recorded in his model book in 1732[8]. These 51 cm-high hybrid creatures belonged to the porcelain menagerie that was being created at that time for Augustus the Strong's pleasure palace, the Japanisches Palais (Japanese Palace); one such sphinx is still in the holdings of the Dresden Porzellansammlung. The large sphinx is related to the smaller ones in terms of artistic style, and also wears the same type of cap. However, Kirchner has

not only considerably increased the size of the piece, he has also altered the conception of the figure. The sphinx's mysterious, almost malicious expression, the more ornamental style of the pleated headdress, and the anthropomorphic representation of the chest area largely revoke the connection to Egyptian art, so that this hybrid creature seems more reminiscent of the merciless, enigmatic sphinx from the Greek myth of Oedipus.

Even more explicitly than the many sphinxes created by Kirchner and other sculptors in the Electorate of Saxony around 1730, however, two large canopic jars from the Meissen porcelain manufactory testify to the courtly interest in Ancient Egypt at that time. With a height of 80.5 and 81.5 cm and a diameter of 37.5 and 38 cm respectively, the large porcelain vessels still have their original decoration in brown oil paint and gold (fig. 6).[9] These unusual objects were also among the 156 large vases, 132 life-size animals and 120 life-size birds that Augustus the Strong ordered from his Meissen manufactory for the Japanisches Palais in 1731.

An Egyptian Room at Wilanów Palace

A further – now largely unknown – indication of Augustus the Strong's fascination with Egypt can be found in another of his royal properties: Wilanów Palace outside Warsaw. The "Polish Versailles" was built between 1677 and 1679 as the personal palace of King Jan III Sobieski, Augustus the Strong's predecessor in Poland. In 1730, the Saxon elector and later Polish king obtained a lifetime lease on the sumptuous palace from its then owner, Maria Zofia Denhoffowa.

Between 1730 and his death in early February 1733, Augustus the Strong had several rooms in the palace luxuriously refurbished, most likely under the direction of Johan Sigismund Deybel, the Polish court architect. Among these were the large dining room in the south wing and two rooms adjacent to the royal bedchamber. Each of the two small private rooms was given a decorative theme: one was styled as a Chinese Room; the other – a corner space that served as a royal dressing room – was given a clearly Egyptianising wall decoration with stucco work, elaborate wood carvings and paintings set into the wall.[10] The lime green and light grey colour of the wood panelling, which was restored in 1997, lends the small space an atmosphere that is both bright and majestic.

Above the doors of the Egyptian Room are two different representations of sphinxes. One is a rather freely interpreted, recumbent sphinx made of gilded stucco with a putto on its

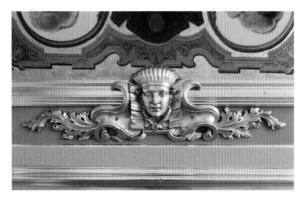

Fig. 7 Wilanów Palace, detail from the cabinet

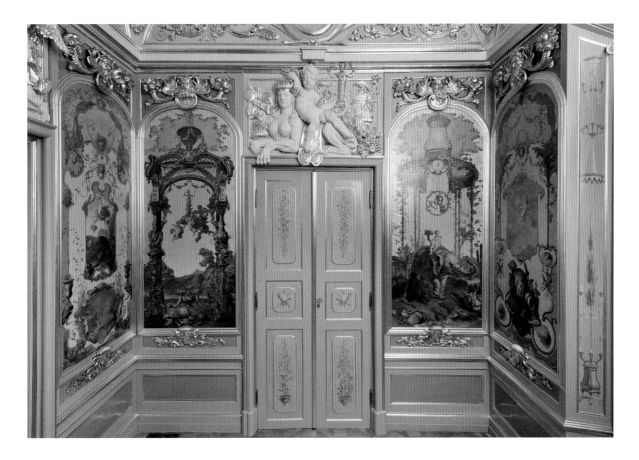

Fig. 8 Wilanów Palace, general view of the cabinet

back (fig. 8). This type of depiction has its origins in the gardens of the Palace of Versailles. In Wilanów, however, the recumbent sphinx with putto has been slightly embellished, as the sphinx is holding an incense burner in its right hand as a symbol of divine worship. The putto, meanwhile, presents the golden likeness of the many-breasted Ephesian Artemis, a symbol of universal nature that in the Baroque Period was directly associated with the Egyptian goddess Isis. The second sphinx is a very feminine hybrid, crowned with two putti holding flowering branches and depicted en face. It is also made of stucco and wears a clearly Egyptianising pleated headdress. Like the overdoor, the wall paintings executed on a gold background playfully allude to symbols of Isis or the Ephesian Artemis, and thus to the generative forces of nature. Of particular significance for this early reception of Egypt are, how-

ever, the austere Egyptian heads that are placed below the upright rectangular paintings above the socle, which were not depicted again in this form until the end of the 18th century. Their regular features are framed by severe and for their time distinctly "Egyptian" pleated headdresses (fig. 7). Their long plaits of hair are, however, tied into a typical knot of Isis below the chin (cf. cat. no. 19). This room, which was decorated by artists commissioned by the Saxon elector and Polish king himself, and belonged to his private apartments, unmistakably shows that in the final years of his life, Augustus the Strong must have had more than a passing interest in the world of myths surrounding the Egyptian gods. Perhaps Dinglinger had, in creating the *Apis-Altar*, once again correctly speculated that his royal patron would buy the tremendous cabinet piece – but then his death got in the way.

Further early sources of Egyptomania in the Baroque Period

Curiosity about Ancient Egyptian art and culture was certainly widespread in the early 18th century. This interest was mainly focussed, however, on the country's monumental architectural structures; the captivating appeal of the colossal buildings of Egyptian antiquity, which had been described by Herodotus and later travel writers, inspired others besides Montfaucon to create imaginative pictorial representations. Around the same time as the French Benedictine monk was working on his designs, the Austrian architect Johann Bernhard Fischer von Erlach was exploring this fascinating topic in his book *Entwurff einer historischen Architectur* (A Plan of Civil and Historical Architecture), which was published in Vienna in 1721. His evocative re-creations of Egyptian monumental architecture gave later generations of artists – including Giovanni Battista Piranesi and the "revolutionary" architect Étienne-Louis Boullée – ideas for their own Egyptianising designs. The textual content of Fischer von Erlach's book of engravings, which contains an accurate and unprejudiced analysis of Egyptian architecture that reflects the state of research at the time, makes his publication one of the founding texts of architectural historiography. Besides this key source, a virtual apotheosis of different representations of sphinxes can be found in the gardens of the Belvedere of Prince Eugene of Savoy in Vienna, which were designed by Dominique Girard in 1726/27.

The growing thirst for knowledge in the Age of Enlightenment led to increased interest in Egyptian culture at the beginning of the 18th century. Newly acquired insights into Pharaonic Egypt gradually replaced the traditional, mystifying image of Egypt that had been most impressively put forward in the 17th century by Athanasius Kircher, a widely published Jesuit priest who was active in Rome. The desire for objective information was also met by travelogues, which were published in increasing numbers in the first half of the 18th century. Besides those written by Paul Lucas (1714) and Benoît de Maillet (1735), the critical and detailed account by Richard Pococke (1743) and the splendidly illustrated book of engravings by Frederic Louis [Frederik Ludvig] Norden (1755) were among the key works of this type. While Fischer von Erlach's imaginative images enlivened 18th-century architectural visions, the latter two accounts of travels in Egypt contained unusually precise representations of the country's architectural forms. Both authors – the British theologian Pococke and the

Fig. 9 Richard A. Pococke, *A Description of the East, and Some other Countries*, Frontispiece, London 1743

Danish naval captain Norden – travelled around the Nile Valley in the 1730s; Pococke also went on to visit Palestine and Greece.

Pococke's travelogue, entitled *A Description of the East*, was the first of the two to be published, appearing in 1743 (fig. 9). He initially intended it to be a treatise on the little-known architecture of Egypt, and later expanded it to include useful topographic information. Over the following decades, his book was frequently reprinted and also translated

into multiple languages; it played an important part in shaping the image of Egypt in the 18th and early 19th centuries, and became an indispensable reference work for researchers as well as artists during this period. Johann Joachim Winckelmann and the Comte de Caylus also relied on Pococke's descriptions and elaborations to support their own theories about Ancient Egyptian art. In 76 engraved plates of extremely varied quality, Pococke illustrated the floor plans and elevations of Pharaonic buildings, as well as architectural details, with almost archaeological accuracy. But even for his contemporaries, the author's extensive and detailed descriptions of the buildings already seemed to be more important than the scholarly images.

Whereas in Pococke's account, the textual content outweighed the illustrations in terms of significance, in Norden's *Voyage d'Egypte et de Nubie* (Travels in Egypt and Nubia) it was the 150 outstanding full-page engravings, made after the artistically gifted Dane's own drawings, that fuelled European fascination with Egypt even beyond General Napoleon Bonaparte's Egyptian Campaign (1798–1801). The plates show not only Ancient Egyptian architecture, but also the "oriental" surroundings (that is, the contemporary reality in the Muslim country, which appeared oriental to Europeans and contrasted with Egyptian antiquity) in which these time-defying buildings stood. Norden's images were therefore received both as valuable models for architects and as evocatively atmospheric depictions in the sense of a "voyage pittoresque". The lavish, two-volume folio work was first published posthumously in 1755 by the Royal Danish Academy in Copenhagen. *Voyage d'Egypte et de Nubie* was also reprinted and translated multiple times.

These two travelogues provided Europeans with unusually detailed information about Egyptian antiquities – information that was not yet available for the classical sites of Greece at the start of early classicism in Europe. The accounts were an extremely valuable source of information and inspiration, and were used not only by scientists and scholars, but also by architects, painters and travellers to Egypt, including Dominique-Vivant Denon, who was among those who accompanied Bonaparte's campaign. Pococke's and Norden's books also set the standard for subsequent illustrated travelogues. Critics as well as supporters of the aristocratic image of Egypt that developed at the French court around the middle of the 18th century happily availed themselves of these excellent source publications.

In the second half of the 18th century, the question of whether Ancient Egypt should be regarded as an exemplary model or a cautionary tale for contemporary Europe was being hotly debated. Depending on the character, social position and fundamental political or artistic convictions of the individual theorist, philosopher or artist, the vision of Ancient Egypt could be the stuff of sweet dreams or that of nightmares. In 1786, the Académie des Inscriptions et Belles-Lettres in Paris contributed to this debate by holding an essay competition on the subject – the winner was to receive the "Prix d'émulation". That year's winner, Antoine Chrysostôme Quatremère de Quincy, did not publish his essay until 1803. Entitled *De l'architecture égyptienne* (On Egyptian Architecture), it was a critical approach to Egyptian architecture, in the sense of an image of antiquity that was shaped by Winckelmann. De Quincy's illustrations were of course based on architectural views after Pococke and Norden.

Just a few years after the French academy of classical studies held this competition to explore the significance of Egyptian art – which was particularly strong at that time due to the fashion for Egypt under Queen Marie Antoinette and the garden designs of free-thinking members of the aristocracy – numerous references to the two source publications can be found in German fashion and design magazines. Besides mysterious sphinx grottoes and proposals for garden structures in the shape of the pylons at Luxor Temple, it was the highly extravagant interiors with views of Nile landscapes that seemed especially suitable as decorative designs for Freemasons.[11]

Piranesi and the Comte de Caylus

Among these ensembles decorated in an Egyptianising style was the interior of the Caffè degli Inglesi near the Spanish Steps in Rome; it was designed by Giovanni Battista Piranesi and executed between 1765 and 1767. The earliest written reference to the spectacular coffeehouse decor is in a letter sent by the Saxon architect Christian Traugott Weinlig to Dresden in 1767.[12] He describes the room as follows: "On the left, opposite the steps ... is the English coffeehouse. It is the place where the many Englishmen who are studying here like to gather towards evening, and also the best place to find out where this person or that can be found. It is this coffeehouse that has an interior painted in the Egyptian-style, according to specifications and a drawing by the famous Piranesi. Numerous Egyptian idols, wonderfully assembled, appear here in

various colours of granite and other types of dark stone. Should you have the chance to see his chimneypieces in this style, you would be able to get some idea of it, otherwise it is probably difficult to imagine."

Piranesi presented *Diverse maniere d'adornare i cammini* (…) [Diverse Ways of Ornamenting Chimneypieces (…)] (fig. 10) – a volume of large-format etchings, comprising two interior views of the Caffè degli Inglesi and 11 designs for Egyptian chimneypieces, accompanied by a theoretical essay in Italian, French and English – to the international public in 1769. Piranesi was a technically outstanding and highly creative etcher and engraver, but he was also aware of contemporary developments in printmaking. Although his Egyptianising etchings were presented as models for interior designers, their status is rather that of autonomous works of art. Even today, many art historians are so impressed by Piranesi's fantastical fireplace designs and interior views that they believe to have found in him the creator – and in his etchings the origin – of the fashion for Egypt in early classicism. Artistic engagement with Egypt's cultural heritage is, however, a much more complex issue.

The search for the source of Piranesi's inspiration leads to one of the protagonists of 18th-century Egyptomania, a man of letters who lived not in Rome, but in Paris. The common origin of Piranesi's art-theoretical reflections and the models for his Egyptianising designs is the illustrated work *Recueil d'antiquités égyptiennes, étrusques, grecques et romaines* (Collection of Egyptian, Etruscan, Greek and Roman Antiquities) by the Comte de Caylus[13]. The key passages of Piranesi's elucidations derive from the positive, aristocratic image of antiquity promoted by Caylus, who was a highly educated antiquarian, amateur artist and committed patron of the arts. More importantly in this context, Piranesi's fireplace designs – down to the last detail – can be traced back to the illustrations in the *Recueil*; almost every element of his often rather peculiar-looking decorations can be found here. The volumes of Caylus's *Recueil d'antiquités* from which Piranesi drew his pictorial inspiration were published between 1759 and 1764 (vols. 3 to 5).

The Comte de Caylus was one of the most important and influential art and cultural theorists of his day; he actively endorsed the revival of artistic traditions associated with ancient Greece, as well as those of Egyptian antiquity. Caylus presented his reformist (in the classicist sense) views in numerous lectures before the two royal academies in Paris of which

he was a member: the Académie Royale de Peinture et de Sculpture and the Académie des Inscriptions et Belles-Lettres. Above all, however, he outlined them in his *Recueil d'antiquités*, which was published in six volumes between 1752 and 1767. Besides depictions of Greek and Roman antiquities from European collections, this publication contains hundreds of images of Ancient Egyptian and Egyptianising sculptures, along with those taken to be Egyptian, accompanied by precise and – for the time – outstanding and systematic scholarly descriptions. For creative artists in the second half of the 18th century, the *Recueil d'antiquités* was an absolutely invaluable reference work on the subject of antiquities and ancient art. Numerous direct references by furniture and vessel designers, interior designers and visual artists to this important collection of images are attested, and are by no means limited to France. Artists and scholars of ancient history found not only excellent source images, but also the first treatise on the art of Graeco-Roman antiquity and Egypt in the compendium. Caylus attached particularly high cultural testimonial value to the works he classified as Egyptian, and ascribed to these works a clearly defined aesthetic quality that to some extent anticipates Edmund Burke's notion of the sublime. This was highly innovative in the period around 1750. Even before Winckelmann's *Geschichte der Kunst des Altertums* (History of the Art of Antiquity, 1764), therefore, the – now largely forgotten – *Recueil d'antiquités* became an incunabulum of art historiography.

In the seemingly archaic and austere monumental art of Egypt, which until then had been firmly disparaged by his colleagues – including Montfaucon – Caylus discerned new aesthetic values such as "grandeur", "solidité" and "simplicité", which he recommended that the artists of his day should adopt. Moreover, in his writings, Caylus repeatedly emphasised that Egyptian culture was the common basis of all ancient cultures. In his view, all the other cultures of European antiquity, but also of the Middle East and China, were inspired by this first advanced civilisation and developed in competition with the colossal Pharaonic sculptural and architectural works that were created for eternity. The fact that the possible link between ancient Egyptian culture and Far Eastern cultures was already known around 1700 is attested by a work in the Grünes Gewölbe: *The Throne of the Grand Mogul Aurangzeb*, created by Johann Melchior Dinglinger. Because here, the two wall sections that frame the throne area are covered with engraved pseudo-hieroglyphs and depictions of Egyptian deities.[14]

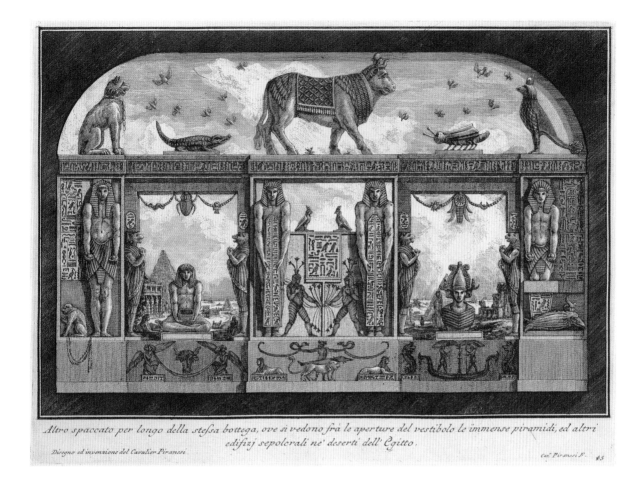

Altro spaccato per longo della stessa bottega, ove si vedono frà le aperture del vestibolo le immense piramidi, ed altri edifizj sepolcrali ne' deserti dell'Egitto.

Disegno ed invenzione del Cavalier Piranesi.

Cav.ᵉ Piranesi F. 45

Fig. 10 Giovanni Battista Piranesi, *Diverse Maniere d'adornare i cammini* [...], Pl. 45, 1769

To the Comte de Caylus, more than four decades later, the Egyptians' monumental understanding of art and creation of works for eternity seemed to be almost unattainable in his own time. He considered them to be the result of an ideal, enlightened and absolutist kingdom that had been able to develop in a period of almost constant peace, and in a country that was particularly blessed by nature. The political realities in Europe in the mid 18th century could not compete with such a utopian situation. Caylus's visions of Egypt held great appeal for the high aristocracy of the Ancien Régime, however, and contributed to the development of a fashion for Egypt under Marie Antionette – right through to the revolutionary architecture created in the years leading up to the French Revolution.[15] The idealised image of ancient Egypt that can be traced back to Caylus even shaped the thinking of Napoleon's generals and the scientists and scholars who accompanied the French military expedition.

The starting point for Caylus's scholarly investigations was his own collection, which was held in his apartment in the Orangerie at the Tuileries. The frontispiece of the first volume of the *Recueil d'antiquités* gives an insight into this collection of antiquities. The illustration shows the objects of his scholarly

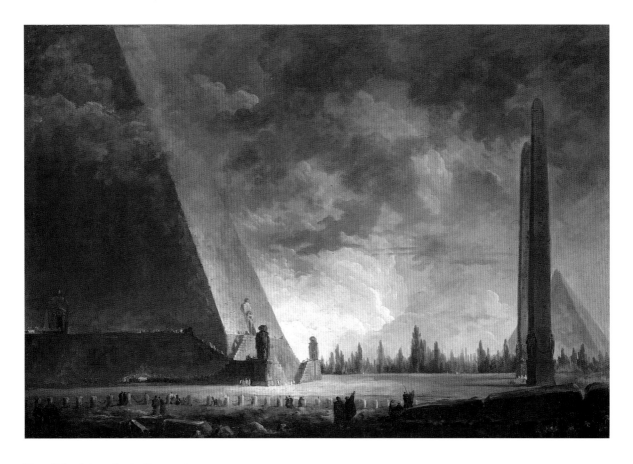

Fig. 11 Hubert Robert, *Egyptian Fantasy*, 1760,
oil on canvas, 63.5 × 95 cm, private collection

desire displayed on simple wooden shelves in a storage space. The manner of presentation is scientifically objective rather than aristocratically representative. Caylus's passion for research, which he admitted was coupled with the ownership of the objects to be described, was ultimately greater than the space available to him for their storage. He solved this problem by transferring ownership of some of his treasures to the royal cabinet of antiquities in 1752, and others in 1762. Some of the objects described in his books can still be viewed in the vitrines of the Musée du Louvre in Paris.

The roots of Baroque Egyptomania lie in France. This applies – apart from Dinglinger's *Apis-Altar* – not only to scientific and theoretical preoccupations with Ancient Egypt,

but also to a considerable extent to artistic expressions of this theme. Rome also contributed to the Egyptomania of early classicism, however. Above all, the Académie de France in Rome and some of its leading students should be mentioned here: in the appropriation of Egyptian cultural heritage shortly after the middle of the century, they played a key role as intermediaries between the reception of Egyptian artworks in Italy and the theoretical debate being conducted in France. The Comte de Caylus was probably also a major influence in this context. Hubert Robert was a trailblazer among the young artists promoted by Caylus. A painter of ruins who later worked as a garden designer, Robert came to Rome as a fellow of the Académie de France in 1754 and remained in the

city until 1765. Engaging with the sublime manifestations of Egyptian culture was an important aspect of his practice, and is evident in his extensive oeuvre from an early stage. He was introduced into the circle of the Comte de Caylus around 1760 by the antiquarian Paolo Maria Paciaudi and the painter Jean-Claude Richard, Abbé de Saint-Non. This prompted Robert to explore the painterly and monumental impact of Egyptian architecture even more intensively – as seen, for example, in two of his idealised landscapes from the period that include pyramids and obelisks, and a "capriccio égyptien" that combines elements from the Egyptian formal repertoire with unadorned arched architecture (fig. 11).[16] The fascination with Egypt that took hold of the French fellows in Rome around 1760 also led to the Egyptianising designs created by Jean-Honoré Fragonard – the later grand master of the *galant* Rococo style, who was friends with both Robert and Saint-Non.

Saint-Non compiled some of Robert's designs and copies of antiquities into a series of 18 etchings entitled *Suite de dix huit feuilles d'après l'antique* (Suite of eighteen plates after antiquity), which were executed in 1763. In addition to exact copies of Egyptian sculptures, the series includes five very interesting depictions of Egyptianising objects that testify to Robert's interest in Egypt around 1760. As Robert did not return to Paris until 1765, it is very likely that Saint-Non had been given the drawings for these etchings on his departure from Rome in 1761. Saint-Non also reproduced Fragonard's Egyptian fantasies as a suite of 10 prints entitled *Premier Recueil d'Aquatintes* (First collection of aquatints) in 1767.

Robert's Egyptianising designs include an image of a pyramid that was transformed from a drawing on a sheet of paper into a real object on not just one, but two occasions. In the first case, sometime before 1785, Robert himself created a pyramid resting on a base in the gardens of the Désert de Retz. In the second, the Prussian king and Freemason Friedrich Wilhelm II had a more sharply pointed, but otherwise very similar pyramid erected in his Neuer Garten in Potsdam between 1791 and 1792.

In European classicism before 1800, the artistic and cultural heritage of Ancient Egypt was explored and referenced in a unique and creative way that had never been seen before and has barely been surpassed since. The imagination of artists and patrons alike was fed by inspiring graphic models – perhaps more productively than by the almost Egyptologically accurate reports and representations that reached France and the rest of Europe a few years after the end of the French expedition to Egypt from 1798 to 1801. The reception of Ancient Egypt in fashionable Europe broadened in scope in the early 19th century, leading to a new definition of art and design that was to leave its mark right through to historicism.

1 This essay is based on the author's dissertation, Syndram 1990, as well as the treatise Syndram 1999.
2 This topic was first addressed by the archaeologist Ragna Enking; see Enking 1939.
3 On the translation of the Latin inscriptions on the narrow sides of the base of the obelisk in the *Apis-Altar*, see also von Watzdorf 1962: 269.
4 *Inventare des Grünen Gewölbes*; *Journal des Grünen Gewölbes* (1733–1782), fol. 48 r; see also Syndram 1999: 3.
5 Díaz Hernández 2014–2015: 64 f.
6 Syndram 1999: 46–49. Porzellansammlung der Staatliche Kunstsammlungen Dresden, Inv. no. P.E. 1872, P.E. 1874.
7 Wittwer 2004: 309.
8 Syndram 1999: 48 f. "2 Sphinxe verändert … groß" (2 sphinxes, modified … large). Porzellansammlung der Staatliche Kunstsammlungen Dresden, Inv. no. PE 5753.
9 Syndram 1999: 50. Porzellansammlung der Staatliche Kunstsammlungen Dresden, Inv. no. PE 5743.
10 Syndram 1999: 47–49, 51 fig. 48–49.
11 On this subject, see Syndram 1989 a: 38–45, above all pp. 41 ff.
12 Weinlig 1782–1787: vol. 1, 17 f.
13 The first, and probably the only, monographic essay on the Comte de Caylus was written by Samuel Rocheblave in 1889; Hausmann 1979: 191 ff.
14 Syndram/Schöner 2014: 90–93.
15 Syndram 1989 b: 48–57, above all 50 ff.
16 On this subject, see cat. Paris/Ottawa/Vienna 1994: 60–63 cat. nos. 22 and 23.

The history of the Egyptian holdings in the Dresden Skulpturensammlung

Marc Loth

The Dresden Skulpturensammlung (Sculpture Collection) holds a significant collection of Egyptian antiquities from the Predynastic, Pharaonic and Graeco-Roman Periods, comprising around 6,000 objects. Relative to their quantity and quality, these fascinating artefacts have, until now, received surprisingly little attention in terms of public awareness or recognition in specialist circles. While this may be partly due to the dazzling splendour of the other artistic treasures that Dresden has to offer, the fact that for many decades, the Aegyptiaca were either not on display or inadequately presented – above all due to a lack of exhibition space following the Second World War – will no doubt also have contributed to this situation.

Given the size of the collection, it is understandable that the Egyptian holdings were not separated into an independent institution and instead remained an integral part of the Antikensammlung (Antiquities Collection), and later of the Skulpturensammlung; this framework also secured the continued existence of the collection. The establishment of Egyptology as a university discipline in Dresden could doubtless have brought new impetus to the collection, but as this never occurred, the Skulpturensammlung has mainly been supported by Egyptologists from Berlin and Leipzig in the specialist care, interpretation and presentation of its Ancient Egyptian objects. At this point, it should be mentioned that Dresden has also produced a number of notable Egyptologists, such as Winfried Barta (1928–1992), Wolfgang Helck (1914–1993) or Eberhard Otto (1913–1974).

In the following sections of this essay, the long and eventful history of the Pharaonic objects in the Dresden Skulpturensammlung will be presented as a chronological outline of key acquisitions, museum presentations and publications.

It is no longer possible to determine exactly when Ancient Egyptian finds first entered the collections of the Saxon Electors.

As early as the late 17th century, the electoral Hofapotheke (court pharmacy) is said to have owned not only Ancient Egyptian mummies, which since the Middle Ages had been considered a (very expensive) universal medicine, but also other, smaller-format finds. These kinds of archaeological objects were collected by monarchs as historical curiosities. The Aegyptiaca are attested in an illustrated catalogue of the Dresden Antikensammlung (fig. 2) that was compiled and published by Raymond Leplat (1664–1742) in 1733. In his capacity as Generalinspekteur (general director) of the Königliche Sächsische Sammlungen (Royal Saxon Collections), Leplat had purchased many of these objects in Rome on the order of Augustus the Strong (1670–1733). The most significant additions were the antiquities from the collections of Alessandro Albani and Flavio Chigi that he acquired in 1728.

Shortly before this (probably around 1723/26), numerous antiquities had also found their way to Dresden from the Antikenkabinett (Cabinet of Antiquities) of the Brandenburgisch-Preussische Kunstkammer (Brandenburg-Prussian Art Chamber) in Berlin, most likely as a gift from King Friedrich Wilhelm I. Among these antiquities were a number of Ancient Egyptian objects, which were surely not considered to be random additions. A serious, at times scientific, but also religious and esoteric interest in Pharaonic finds can be attested by, among other things, the fact that forgeries of such objects were not uncommon at this time. Also noteworthy are the examples of artistic engagement with the advanced civilisation of Ancient Egypt; the most prominent work of this kind in Dresden is the *Apis-Altar* created by Johann Melchior Dinglinger (1664–1731) between 1724 and 1731 (cf. the contribution by Dirk Syndram in this volume), and now held in the Grünes Gewölbe (Green Vault).

The exact number of Aegyptiaca held in the Antikensammlung around 1730 can no longer be determined. This is partly due to the fact that the acquisition date of some of the subsequently attested pieces is unknown, but also because past and present assignments of these items to Pharaonic culture

Fig. 1 David Brandt, *Albertinum*, Display Storeroom, 2010

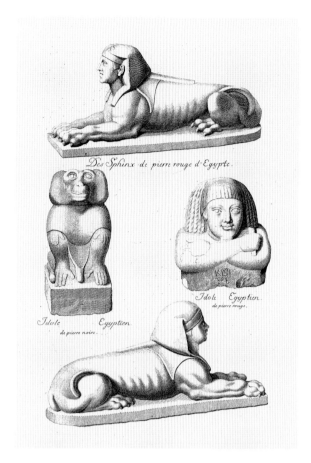

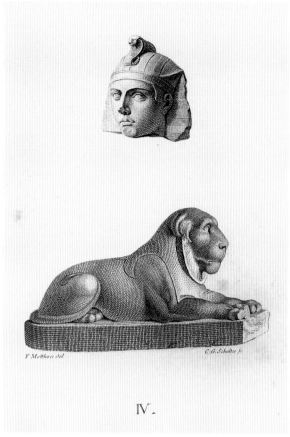

Fig. 2 Raymond Leplat, *Recueil des marbres antiques qui se trouvent dans la Galerie du Roy de Pologne à Dresden*, Pl. 189, Dresden 1733

Fig. 3 Wilhelm Gottlieb Becker, *Augusteum. Dresden's antike Denkmäler enthaltend*, Vol. I, Pl. 4, Leipzig 1804

do not always agree. Nevertheless, it can be said that in terms of its size and quality, this was one of the most important collections in the German-speaking world.

Five objects in the collection of Egyptian antiquities presumably date from the Pharaonic Period: a statue of a priest from the time of Pharaoh Amenhotep III (cat. no. 18, fig. 2); a statue of a crouching baboon (inv. no. Aeg 760, fig. 2); a statuette of the god Osiris (that can no longer be identified with certainty); and two shabtis (inv. nos. Aeg 436, 429?). Most of these came from the Saxon Electors' Kunstkammer (Art Chamber), and had therefore already been in Dresden for a long time, while the statue of a baboon is said to have previously been owned by Field Marshal and cabinet minister Christoph August von Wackerbarth (1662–1732).

The objects that date from the Graeco-Roman Period are the Ptolemaic statue of a queen or goddess (cat. no. 5); the three statues of lions (cat. no. 12 and inv. no. Hm 17, fig. 3); the head of a statue of Antinous (inv. no. Hm 23, fig. 3); the bronze statuette of an Apis bull (cf. cat. no. 6e); the two famous portrait mummies (cat. no. 20) that Pietro della Valle (1586–1652) acquired in Saqqara in 1615 (fig. 4), and two child mummies (inv. no. Aeg 779 and present whereabouts unknown).

A statuette of Ptah-Sokar-Osiris (inv. no. Aeg 761) can be classified as a modern work. The same applies to the two sphinxes from the Brandenburgisch-Preussische Kunstkammer (inv. nos. Hı 93/405, Hı 93/406, fig. 2) and to a lead statuette, possibly of the same origin, that represents Isis with her son Horus.

A coffin (inv. no. H4 134/40) with (now lost) painted decoration was transferred from the Hofapotheke in 1765, and could therefore have come to Dresden at a much earlier date. The acquisition date of a number of smaller objects that are not attested until the late 18th century is uncertain.

As mentioned above, some of these objects can be traced back to collections in Italy. It is, however, often no longer possible to ascertain whether they – like the portrait mummies acquired by Pietro della Valle – left Egypt in modern times, or whether they had come to Italy in ancient times as the spoils of war, art imports or cult objects, or indeed were produced in Italy itself.

From 1729 to 1747, the Antikensammlung was installed in the Palais im Grossen Garten (Palace in the Grand Garden) in Dresden. It was then transferred to the four pavilions surrounding the Palais, which unfortunately offered nowhere near enough space for the pieces to be viewed properly. Interrupted only by a period (1760–63) during the Seven Years' War when the objects were temporarily stored in the Residenzschloss (Royal Palace), this unsatisfactory situation continued until 1785. After visiting the Antikensammlung in Dresden in 1755, Johann Joachim Winckelmann (1717–1768), the founder of Classical Archaeology, also wrote about the Egyptian objects he had seen there.

In 1785/86 the Antikensammlung was moved to the Japanisches Palais (Japanese Palace), which was already being used by the Saxon Electors as an exhibition space. From then on, at least 17 objects that were considered to be Egyptian were displayed in Hall 10 alongside antiquities from the Classical Period as well as from Central Europe and Asia (fig. 5), while two of the statues of lions were installed at the entrance to Hall 2.

In 1798 the numismatist and librarian Johann Gottfried Lipsius (1754–1820) published a detailed outline of the collection entitled *Beschreibung der Churfürstlichen Antiken-Galerie in Dresden* (Description of the Electoral Antiquities Gallery in Dresden). Between 1804 and 1811, Wilhelm Gottlieb Becker (1753–1813), the Inspektor (director) of the Antikengalerie (Antiquities Gallery) and the Münzkabinett (Coin Cabinet), published a three-volume catalogue of the antiquities collection entitled *Augusteum*, which included numerous engraved plates (fig. 3).

This period also saw a significant increase in explorations of Egypt. Although Napoleon Bonaparte's campaign to Egypt (1798–1801) ended in military failure, the scientists and scholars who accompanied the expedition made a huge contribution to the documentation of Pharaonic monuments (published in the famous, 23-volume series *Description de l'Égypte*

(Description of Egypt), 1809–28). At the same time, through the discovery of the Rosetta Stone, the expedition supplied the key to deciphering Ancient Egyptian hieroglyphs – which were transliterated by Jean-François Champollion (1790–1832) in 1822 – and hence to the establishment of Egyptology as an academic discipline (1830). Last but not least, the French campaign facilitated the establishment of a new political leadership in Egypt under the former Ottoman military commander Muhammad Ali (c. 1770–1849), who drove out the British forces, gained de facto independence for Egypt from the Ottoman Empire and made great efforts to modernise the country. As a result, European diplomats and specialists were able to travel

Fig. 4 Pietro Della Valle, *Eines vornehmen Roemischen Patritii Reiß-Beschreibung in unterschiedliche Theile der Welt* […], 198 fig., Geneva 1674

Fig. 5 Hermann Krone, *Japanese Palace, so-called Columbarium*, Dresden 1888

around Egypt more easily, and could also acquire antiquities and conduct excavations. The exploitation of Pharaonic artefacts, which had already been practised for thousands of years, now became even more lucrative for the Egyptians, as the Europeans paid high prices for many finds of low material value or hired labourers for their excavations.

During this time, many collections of Ancient Egyptian art were founded in Europe. In 1831 Dresden was able to acquire a collection of around 300 items accumulated by Alessandro Ricci (c. 1792–1834) in Egypt. Ricci was an Italian doctor and had accompanied a number of researchers, including Champollion, on their travels through Egypt and Sudan between 1817 and 1829. Another part of Ricci's collection is now held in Florence. Among the works in Dresden, the three

papyri inscribed with various texts for the afterlife are particularly noteworthy (cat. nos. 29, 30 a, inv. no. Aeg 776). Ricci's collection otherwise consisted mainly of bronze statuettes of deities (e. g. cat. nos. 6 a, e, 7 c), shabtis (e. g. cat. no. 28 a, c), amulets (e. g. cat. nos. 24 b – d and under cat. no. 25) and jewellery (e. g. cat. no. 34 e). In the Japanisches Palais, however, the now much larger collection of Egyptian antiquities still had to share the Mumienzimmer (Mummy Room; Hall 10) with antiquities from other cultural realms (fig. 5).

A few smaller acquisitions (cat. nos. 25 ar, av, bb, 30 b) are believed to have come from the collection of the archaeologist and artist Otto Magnus Freiherr von Stackelberg (1787–1837). In 1857 a larger assortment of small-scale ancient sculptures, including 18 objects from Ancient Egypt, was purchased from

Moritz Steinla (1791–1858), at that time professor of engraving at the Dresden Academy of Art.

Although they are not from Egypt, the acquisition of the most important Ancient Near Eastern objects in the Dresden Skulpturensammlung should also be mentioned here. Beginning in 1845, the British diplomat Austen Henry Layard (1817–1894) and his successors excavated the ruins of an Assyrian capital city – above all the palace of King Ashurnasirpal II from the 9th century BCE – at Nimrud in what is now Iraq. The Ottoman Empire gave permission for the excavations to be carried out and for the transportation of the finds, which included large-format statues and reliefs, to Europe. In 1862 the Skulpturensammlung acquired four well preserved, large-format palace reliefs (inv. nos. Hm 19–22, fig. 5) in London. These were among the highlights of the collection at the time, and even now, besides Dresden, only Berlin, Hamburg and Munich own reliefs of this kind in Germany.

Since the mid 19th century, the major European powers had been increasingly extending their economic and financial influence over Egypt. In 1882, Great Britain took control of the country through military invasions, and from then on also controlled it politically. Although it was not a colony in the formal sense and only temporarily a protectorate, Egypt was virtually part of the British Empire and was not able to liberate itself completely from British control until 1956. However, the Egyptian Antiquities Service – which was, among other things, responsible for all archaeological excavations – had been under French direction since the mid 19th century. Regulations concerning Egyptian antiquities had been drawn up early on (from the 1830s onwards) and were implemented in concrete terms by representatives of various Western powers as well as of Egypt. Finds were permitted to leave the country if a firman (royal mandate or decree) had been issued, if they were diplomatic gifts or recognised legal commodities, or under the system of partage (division of excavated finds), and this practice continued after independence (until 1970/83). In principle, these procedures are recognised by the Egyptian state to this day. The complexity of the processes through which Egyptian antiquities came into the possession of museums and private collectors can, however, not be adequately discussed here. Ideally, this would involve examining the details of each specific case, but for many objects, no information is available on the circumstances of their acquisition.

For the Ancient Egyptian holdings in the Dresden collection, the period of the German Empire (from 1871) brought significantly improved display conditions and numerous important new acquisitions. From 1885 to 1889, the Zeughaus (Arsenal) at the eastern end of the Brühlsche Terrasse was converted into an archive and museum building – the Albertinum. Here, the Antikensammlung and the Abguss-Sammlung (Collection of Plaster Casts) were combined to create the Skulpturensammlung, which was expanded to include works of contemporary art. Among the exhibition galleries that were opened from 1894 onwards were two halls in the south-eastern corner of the building that were given over to the presentation of the Ancient Egyptian originals.

The first large-format relief from Ancient Egypt – from the tomb of Mereru at Saqqara (inv. no. Aeg 753) – entered the collection in 1879. It was a gift from Vice-Consul Gustav Travers (1839–1892) from Cairo, arranged by the Leipzig Egyptologist (and well-known author) Georg Ebers (1837–1898).

Ebers also served as an intermediary in the acquisition of the extensive collection of the late Colonel Carl von Gemming from Nuremberg in 1881. It contained many larger monuments in object groups that the collection had previously lacked. These items included several stelae (cat. nos. 3a, 17 b, c, inv. nos. Aeg 763, 764, 767), a statue (inv. no. Aeg 696), Late Period coffins (cat. no. 21 with mummy, and inv. no. Aeg 784, cf. the contribution by Friederike Seyfried in this volume, fig. 3), a cartonnage coffin (inv. no. Aeg 785) and cartonnage mummy trappings (cat. nos. 23 a, b), almost all of the canopic jars now held in the Skulpturensammlung (cat. no. 26 and inv. nos. Aeg 694, 695, 698–703, 705–707), a statuette of Ptah-Sokar-Osiris (inv. no. Aeg 460, cf. cat. no. 27 a), as well as many bronze statuettes (e. g. cat. no. 11 b) and implements (cat. no. 9), shabtis (e. g. cat. no. 28 b), amulets (see under cat. no. 25) and jewellery (e. g. cat. nos. 34 a–d, f).

A mummy portrait painted on wood (inv. no. Aeg 787) was acquired in 1890 from the well-known collection of the Viennese art dealer Theodor Graf (1840–1903). In 1887, Graf had managed to acquire more than 300 mummy portraits from the Fayum Oasis; as they were still little known in Europe, Graf had a virtual monopoly on these objects and sold them on to many museums. Although the piece in the Dresden collection is not very well preserved, it is painted on both sides, which indicates that is was reused.

The acquisition of 67 pieces from the Leipzig Egyptologist Georg Steindorff (1861–1951) in 1896 represented a significant addition to the collection. They included a mummy label (inv. no. Aeg 801), a bronze mirror (cat. no. 33 d) and cosmetic

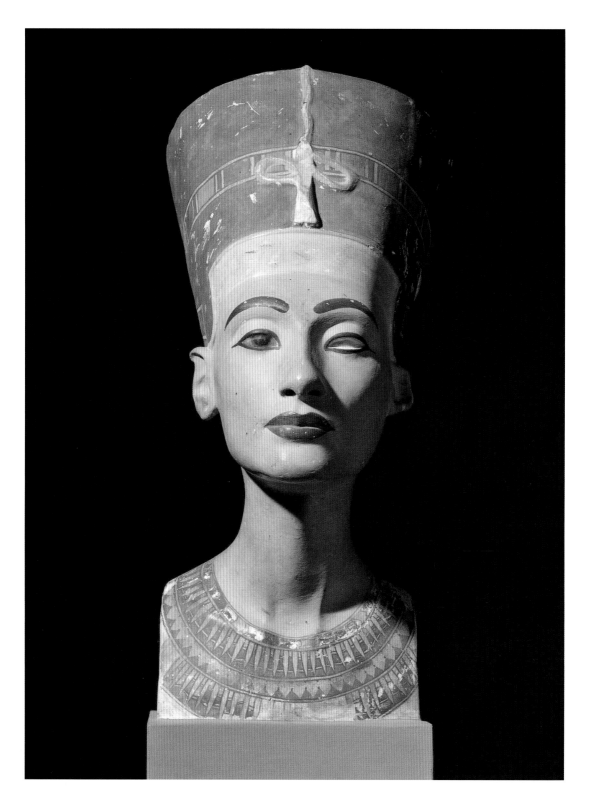

palettes (cat. nos. 33 a, b), as well as stone vessels and prehistoric ceramics from the excavations conducted by William Matthew Flinders Petrie (1853–1942) at Naqada (cf. cat. nos. 32 a, b). Petrie is regarded as the founder of scientific field archaeology in Egypt, and on the basis of his excavations in Naqada in 1895, he established a chronological system for Predynastic Egyptian cultures in the fourth millennium BCE. In 1901 a model house (inv. no. Aeg 807) also came to Dresden through Steindorff. These acquisitions resulted from Steindorff's excavating and collecting activities in Egypt, which served to expand the collection of the Egyptian Museum at Leipzig University.

Also in 1896, 10 fragments of Roman Period funerary masks (cat. nos. 22 a–i and inv. no. Aeg 796) were purchased from the Egyptologist and Prussian consul Carl August Reinhardt (1856–1903) in Cairo; Steindorff and the Dresden sculptor Robert Diez (1844–1922) were the intermediaries in this case. A full mask (cat. no. 22j) was acquired the following year from the Berlin Coptologist Carl Schmidt (1868–1938). It was also thanks to Carl Reinhardt that the painted reliefs from a 5th Dynasty tomb (cat. no. 14) were acquired in 1898, while Robert Diez donated the paintings from an 18th Dynasty tomb (cat. no. 15) to the collection in 1911.

Objects were also received as gifts from the division of finds from excavations of Old Kingdom royal tombs and temples. The fragment of a granite column from the pyramid complex of King Nyuserre at Abusir (inv. no. Aeg 741) came to Dresden in this way in 1903. Ludwig Borchardt (1863–1938) investigated this site between 1902 and 1904 for the Deutsche Orient-Gesellschaft (German Oriental Society). The association had been founded in 1898 at the initiative of the entrepreneur and patron James Simon (1851–1932), who was its main sponsor. In 1912 and 1934, the Egyptologist Friedrich Wilhelm von Bissing (1873–1956) donated seven reliefs (cat. no. 1 and inv. no. Aeg 748) from the excavations of the Sun Temple of Nyuserre at Abu Gurab (1899–1901), which were funded by him. Von Bissing was active not only as a sponsor, but also as an excavator and collector. The head of the statue of the goddess Sekhmet (cat. no. 4) and two Late Period coffins (inv. no. Aeg 783, Aeg 786) were acquired from his vast private collection in 1920 and 1934 respectively.

Fig. 7 Plate of ring of Tutankhamun, New Kingdom, Eighteenth Dynasty, c. 1334–1324 BCE, faience, 2.3 × 1.3 × 0.4 cm, Staatliche Kunstsammlungen Dresden, Skulpturensammlung, Inv. no. Aeg 205

Comprising around 4,700 pieces, the most significant addition of Egyptian objects in quantitative terms was the donation in 1910 of parts of the collection of the Stuttgart entrepreneur and patron Ernst von Sieglin (1848–1927). These pieces date mainly from the Graeco-Roman Period; most of them came from the collection of Karl Herold in Berlin, which was purchased in 1910, as well as from excavations in Alexandria (1898–1902) led by Theodor Schreiber (1848–1912) and financed by von Sieglin. They include a significant number of finds from the Predynastic and Pharaonic Period, above all stone vessels.

Although Dresden did not benefit directly from Ludwig Borchardt's best-known excavations (1911–14) for the Deutsche Orient-Gesellschaft at el-Amarna – the capital city of Akhenaten and Nefertiti – plaster casts of important sculptures such as the famous bust of Queen Nefertiti (fig. 6, original: Berlin, ÄM 21300) were acquired and produced. A few shards of decorated vessels from el-Amarna had already come to Dresden in 1896 through Georg Steindorff (cat. nos. 31 c, d).

Fig. 6 Cast of the bust of Nefertiti, original: New Kingdom, Eighteenth Dynasty, c. 1353–1336 BCE, plaster, h. with socle 61 cm, Staatliche Kunstsammlungen Dresden, Skulpturensammlung, Inv. no. ASN 4749

The period following the First World War was marked by a surge of interest in Ancient Egypt that spread all around the world. It was triggered by the finds from el-Amarna and the discovery of the tomb of the Pharaoh Tutankhamun in 1922. There are very few objects associated with this now world-famous king in Dresden – only the plate of a ring that bears his name (fig. 7), which has been in the collection since 1831.

Despite the difficult economic and political climate during this period, some important acquisitions were made. In 1925 and 1926 two stone statues (inv. nos. Aeg 752, 756) and a wooden statuette (inv. no. Aeg 803) were acquired from the Parisian art dealer S. Alfandari, as was the statue of the goddess Taweret (inv. no. Aeg 773) and several bronze statuettes of deities.

In the 1920s and 1930s, a number of smaller objects, along with a funerary stela (cat. no. 17a), a mummy head with a gilded funerary mask (inv. no. Aeg 781), and a fragment of a 21st Dynasty coffin (inv. no. K 1180) entered the Dresden Skulpturensammlung as donations from the Kühnscherf Collection. August Kühnscherf was a metalworking firm in Dresden that was renowned for its wrought ironwork; the company also manufactured showcases for the Dresden museums.

During the Second World War, the museums were closed and numerous artworks were either stored in cellars or evacuated. For this reason, the bombing of Dresden and the damage to the Albertinum do not appear to have resulted in losses of Egyptian antiquities. After the war ended in 1945, however, the entire holdings were seized by the Red Army trophy brigades and transported to the Soviet Union.

From 1951 onwards, therefore, the Albertinum also displayed plaster casts of Ancient Egyptian artworks – mainly copies of exhibits at the Egyptian museums in Berlin and Cairo. In 1958 the Soviet Union returned a large share of the artistic treasures that had been seized in 1945 to the German Democratic Republic. It has since become clear that no Ancient Egyptian objects from the Dresden Skulpturensammlung remained in the Soviet Union, but a number of items were misplaced in the course of the restitution. For example, the three statues of lions (cat. no. 12 and inv. no. Hm 17) were held at the Nationalgalerie in Berlin until 1965, and in 1970 and 1984 a total of 151 Aegyptiaca were transferred from Leipzig, including the head of the goddess Sekhmet (cat. no. 4). Gaining an overview of the losses and misrouted works from the Dresden collection was a slow and time-consuming process, as the inventories remained missing after the war.

An acute lack of space in the Dresden museums as a result of war damage meant that there were no longer any permanent exhibition spaces available for the Egyptian holdings, with the exception of the two Roman Period portrait mummies (cat. no. 20). Given the significance and popularity of the Aegyptiaca, the museum authorities attempted to make up for this by organising special exhibitions. In 1977, 337 pieces were presented at the Albertinum in the exhibition *Ägyptische Altertümer aus der Skulpturensammlung Dresden* (Egyptian Antiquities from the Dresden Skulpturensammlung), augmented by items from Berlin and Leipzig. The exhibition was supervised by the Egyptologist Steffen Wenig (1934–2022) from Berlin, who also compiled the catalogue – the first independent publication on this part of the collection.

On the occasion of the Ständige Ägyptologen-Konferenz (an annual conference for Egyptologists from German-speaking countries) in 1989, which was hosted by Leipzig University, a further special exhibition of Ancient Egyptian artworks from Dresden was presented at the Kroch-Haus in Leipzig. Leipzig-based Egyptologists under the aegis of Elke Blumenthal (1938–2022) were responsible for overseeing the exhibition and preparing the catalogue of 241 objects. This exhibition was followed by the presentation of *Ägyptische Altertümer der Skulpturensammlung* (Egyptian Antiquities in the Skulpturensammlung) at the Albertinum in 1993/94. The Leipzig Egyptologists once again acted as expert advisors and supplied texts for the accompanying brochure.

After 1990, Ancient Egyptian objects from the Skulpturensammlung were presented in numerous special exhibitions mounted by the Staatliche Kunstsammlungen Dresden (Dresden State Art Collections), but also in shows organised by other institutions. These included *Zurück in Dresden* (Back in Dresden; Dresden, 1998) – an exhibition of 190 Ancient Egyptian pieces that had previously been missing; *Grenzen des Totenbuchs* (Beyond the Book of the Dead; Bonn, 2012), *Nach Ägypten! Die Reisen von Max Slevogt and Paul Klee* (To Egypt! The Travels of Max Slevogt and Paul Klee; Dresden and Düsseldorf, 2014/15), *Tod & Ritual* (Death & Ritual; Chemnitz, 2017/18) and *Shine on me. Wir und die Sonne* (Shine on Me. The Sun and Us; Dresden, 2018/19).

Fig. 8 Serapis, 2nd cent. CE, bronze, h. 39.6 cm,
Staatliche Kunstsammlungen Dresden
Skulpturensammlung, Inv. no. ZV 30,15

Fig. 9 Investigation of the Mummy of a woman with mummy mask (cat.-no. 19)
CT examination at Städtischen Klinikum Dresden-Friedrichstadt, 2016

In addition to the catalogues that accompanied these exhibitions, inventory catalogues have also been published. Among the Egyptian holdings, a selection of the Graeco-Roman objects acquired from the collection of Ernst von Sieglin was included in these publications: Jutta Fischer recorded the terracotta objects in 1994, and Ingrid Laube catalogued the sculptures in 2012. Scientific and scholarly research has otherwise mainly been limited to individual objects and a small number of object groups, and was often carried out in support of academic theses in the fields of Egyptology or conservation sciences; for this reason, not all of the findings have been published to date. The cataloguing and digital presentation of the collection holdings has been intensified in recent years, and the *Daphne* database is a key tool in this undertaking.

The Egyptian holdings were thankfully protected from damage during the severe flooding of the river Elbe in 2002. As a result, exhibition-goers in Berlin were able to enjoy the presentation *Nach der Flut* (After the Flood, 2002/03), which also featured 24 Aegyptiaca from Dresden. Prompted by the disastrous flooding, extensive conversion works were subse-

quently carried out at the Albertinum (2004–10), and from 2012 onwards, numerous Ancient Egyptian finds could be viewed here. Thirty-nine larger Pharaonic and Egyptianising stone objects were presented among the antiquities in the display storeroom (Schaudepot) (fig. 1), while a number of other pieces were installed in the transparent storeroom (Gläsernes Depot). At weekends, visitors could view more than 170 exhibits – mainly smaller objects, but also mummies and coffins – in the study depot antiquity (Studiendepot Antike) (fig. 10).

One major event in recent years must also be mentioned here, not only with regard to gaining new scientific knowledge and understanding, but also in terms of attracting media attention. In 2016, the majority of the mummies in the Dresden Skulpturensammlung were scanned with the aid of computed tomography (CT) at the Städtisches Klinikum Dresden-Friedrichstadt (fig. 9). The data obtained from these scans was evaluated by the German Mummy Project in Mannheim in 2018/19.

The long-term plan for the new presentation of the antiquities of the Dresden Skulpturensammlung in the Sempergalerie (Semper Gallery) at the Zwinger included the aim of

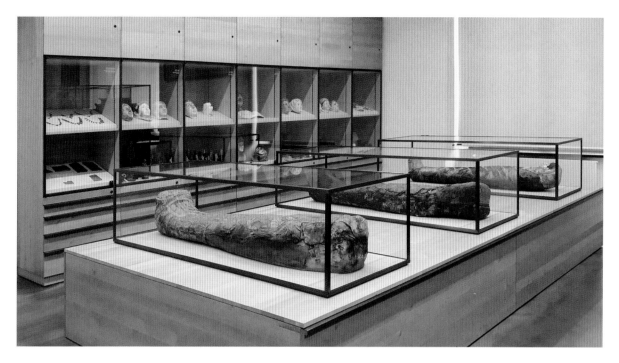

Fig. 10 Albertinum, Studiendepot Antike
(study depot antiquity), 2019

creating a permanent exhibition area devoted to Ancient Egypt. Friederike Seyfried from the Ägyptisches Museum und Papyrussammlung (Egyptian Museum and Papyrus Collection) in Berlin was initially involved in preparing these plans; in 2018, the Egyptologists Manuela Gander and the author were tasked with developing a concept for this area.

In the end, it was not possible to implement the original plan of opening this exhibition area concurrently with the reopening of the Antikenhalle (Hall of Antiquities) in the Sempergalerie. Since 28 February 2020, however, a number of important Egyptian exhibits dating from the Roman Period have found their place here among the objects from Classical Antiquity. They include two statues of lions (cat. no. 12), the head of a statue of Antinous (inv. no. Hm 23, fig. 3) and a bronze of the god Serapis (fig. 8). A small, separate area inside the Antikenhalle is now dedicated to the presentation of nine funerary masks made of stucco (cat. nos. 22 a–i) and – as highlights – the two portrait mummies discovered by della Valle and a mummy from the Fayum Oasis (cat. nos. 19, 20). After weighing up the complex scientific, legal and ethical aspects of this issue, those involved in the conception of the exhibition came to the conclusion that a dignified presentation of human remains in this location would be appropriate and desirable. A multimedia display provides detailed background information on the mummies and on the broader subject of Ancient Egypt. These outstanding exhibits can be regarded as "ambassadors" – their fascinating presence holds the promise that a comprehensive and permanent exhibition on the advanced civilisation in Pharaonic Egypt will be realised in Dresden in the future.

Literature: Becker 1804; Bierbrier 2019; Deutscher Museumsbund 2021; Fischer 1994; Gander/Loth 2019; Gertzen 2017; Girgensohn 1893; cat. Berlin 2002; cat. Bonn 2012; cat. Chemnitz 2017; cat. Dresden 1961, 1977, 1993, 1998, 2004, 2014, 2018, 2020 a, 2020 b; cat. Leipzig 1989; cat. Munich 2010; cat. Zurich 2008; Laube 2012; Leplat 1733; Lipsius 1798; Pink 2014; Reinecke 1996; Salvoldi 2018; Steinla 1893; Syndram 1999; Thiel 2020; Winckelmann 1825; Zesch et al. 2020; https://saebi. isgv.de/liste-aller-artikel (accessed: 22 May 2022)

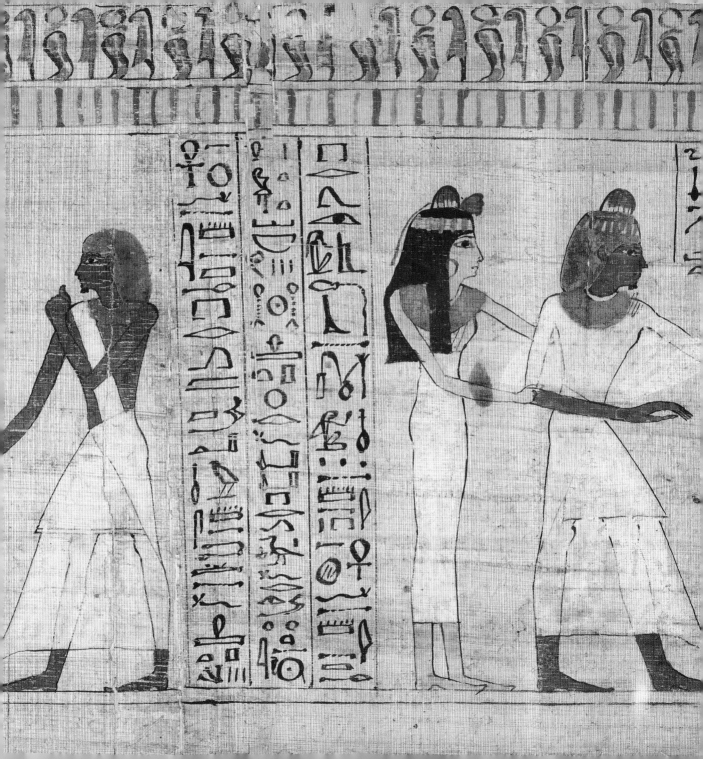

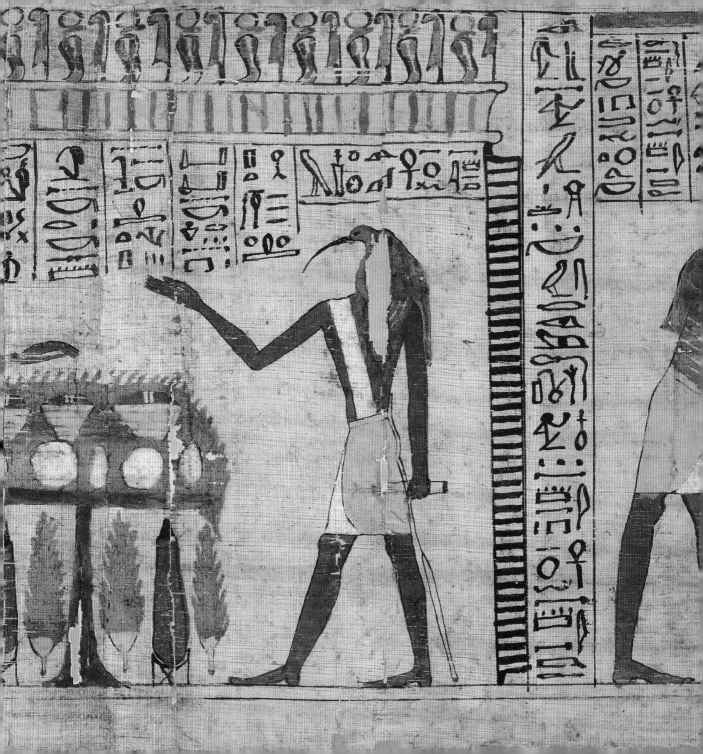

1a

Temple reliefs depicting the Sed festival

Old Kingdom, Fifth Dynasty, reign of Nyuserre,
c. 2402–2374 BCE

Limestone, painted
(a) H. 104.5, W. 50, D. 28.5 cm; (b) H. 54.5, W. 48.5, D. 14.5 cm;
(c) H. 49, W. 60, D. 14.5 cm; (d) H. 88, W. 88, D. 20 cm;
(e) H. 109, W. 79.5, D. 25 cm; (f) H. 54.5, W. 32, D. 16 cm

Findspot: Abu Gurab, Sun Temple of King Nyuserre, 1899–1901 Excavations
led by Friedrich Wilhelm von Bissing
Donated by Friedrich Wilhelm von Bissing, Munich and Agg, in 1912 (a–c)
and in 1934 (d–f)

Skulpturensammlung, Inv. nos. (a) Aeg 742, (b) Aeg 743, (c) Aeg 744, (d)
Aeg 745, (e) Aeg 746, (f) Aeg 747

These six reliefs come from the Sun Temple of King Nyuserre
at Abu Gurab. They depict scenes from the so-called large and
small Sed festival cycles. The first relief (a) shows the king
wearing the special royal regalia for the Sed festival. He wears
a short cloak, usually ending above the knee, with a shoul-
der-cut neckline, and his arms are covered. On his head he
usually wears the White or Red Crown, which were later
assigned to the regions of Upper Egypt and Lower Egypt
respectively. In his hands he holds the royal sceptres, the crook
and flail. The other reliefs (b-e) depict priests and royal officials
accompanying the king at the feast, sometimes with music (e),
or bringing the royal carrying chair (d).

The Sun Temple of Nyuserre was built at Abu Gurab,
between Abusir and Giza. Like a pyramid complex, this assem-
blage of structures included a valley temple located close to the
Nile, the main temple on the terraced desert plateau, and
a connecting causeway. The main temple is surrounded by
a rectangular enclosing wall. In its open courtyard was an
offering altar and, on a podium about 12 m high, there was a
20–25 m high obelisk, a colossal pillar with a pyramid-shaped
top. A covered gallery on the south and east side led to the
entrance in the base of the obelisk. The walls of the gallery were
decorated with the large Sed festival cycle and, in the rear
section, the famous reliefs depicting the seasons, some of
which are now in Berlin. In front of the entrance to the base
was a small chapel, which was decorated with the reliefs of the
small Sed festival cycle. This is interpreted as a vestibule pro-
viding direct access to the base of the obelisk. These two access

routes of different lengths thus each offered a version of the
Sed festival that accorded with the length of the route.

Sun Temples were built only in the Fifth Dynasty. They
were used for the cultic worship of the sun god Re, of his wife
Hathor, and of the respective monarch who commissioned
them, both during his lifetime and afterwards.

The Sed festival is documented as the most important royal
festival from the Early Dynastic down to the Ptolemaic Period.
It served to revitalise royal power and was usually celebrated
after 30 years of the monarch's reign, and thereafter at shorter
intervals. The exact sequence of events at a Sed festival is dis-
puted, as textual sources are lacking. A common suggestion is:
1. Foundation rituals, 2. Inspection of the construction work
and census of cattle, 3. Initial procession, 4. Lion furniture
procession, 5. Homage scenes, 6. Min procession and Wep-
wawet procession with ritual run performed by the king (Min
and Wepwawet are deities), 7. Census of cattle and presenta-
tion to the gods, 8. Scene depicting the washing of feet,
9. Bringing of the carrying chair and the king taking his seat
in it, and 10. Procession of the carrying chair. A key element
was probably the Sed festival run, a ritual run which the king
performed while wearing the White Crown and holding the
flail or the *mekes* staff in his hands. This was to demonstrate
his good physical condition.

Most probably, the depictions at the Sun Temple of
Nyuserre do not depict a real Sed festival, and no such cele-
bration was actually held there – that is because there is no
evidence that Nyuserre reigned for 30 years. Moreover, unlike
other Sed festival depictions, these reliefs do not name any of
the protagonists apart from the king. Hence, the images
instead reflect the king's desire for eternal rule. MG

Selected Bibliography:
(a) Bissing/Kees 1928: sheet 12 no. 225; cat. Dresden 1977: 31 f. no. 7;
cat. Leipzig 1989: no. 5; cat. Dresden 1993: 10, 16 with fig.; (b) Bissing/
Kees 1928: sheet 7 no. 177; cat. Dresden 1977: 31 no. 5; cat. Leipzig 1989:
no. 3 with fig.; cat. Dresden 1993: 10, 16 with fig.; (c) Bissing/Kees 1928:
sheet 2 no. 116; cat. Dresden 1977: 31 no. 3; cat. Leipzig 1989: no. 1;
cat. Dresden 1993: 10; (d) Bissing/Kees 1923: sheet 15 no. 38; cat. Dres-
den 1977: 31 no. 2, fig. 8; cat. Dresden 1993: 10; (e) Bissing/Kees 1928:
sheet 3 no. 118; cat. Dresden 1977: 4, fig. 11; cat. Leipzig 1989: no. 2;
cat. Dresden 1993: 10; (f) Bissing/Kees 1928: sheet 12 no. 221; cat. Dres-
den 1977: 31 no. 6; cat. Leipzig 1989: no. 4; cat. Dresden 1993: 10

Literature:
cat. Munich 2010; Kaiser 1956; Kaiser 1971; Nuzzolo 2018; Voß 2004

IC

1f

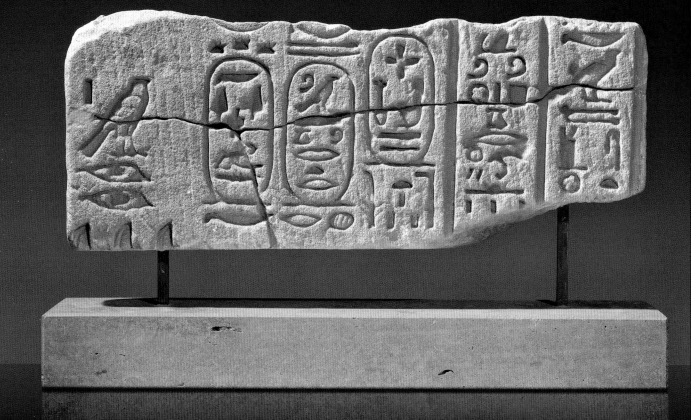

2

Temple relief depicting Emperor Augustus

Roman Period, reign of Augustus,
22/21 BCE–14 CE

Sandstone
H. 18, W. 44.5, D. 5.8 cm

Findspot: probably Karnak, Opet Temple
Donated by Countess von Rex, Dresden, in 1893

Skulpturensammlung, Inv. no. Aeg 769

This sandstone slab, broken into three pieces, bears numerous Egyptian hieroglyphs. It is known to have been separated from a massive block in modern times in order to facilitate transportation and make it easier to sell. The content and arrangement of the decoration enable the images to be reconstructed and its place of origin to be determined.

The inscription on the far left shows the god Horus as a falcon (cat. nos. 7 e, 8 b, 11 d) and two eyes. This indicates the location as Maa-Heru in the second nome (province) of Upper Egypt, the "Horus Throne" nome (main settlement Edfu). Just visible underneath are the tips of three reed plants, which topped the sign for "land" and thus formed the hieroglyph for "field, cultivated land". Because of its larger dimensions, this hieroglyph does not belong to the text, but was part of the pictorial representation. Its execution in sunk relief indicates that the block comes from an outer wall.

The text in the two following vertical lines is to be read from right to left and can be completed to make a full statement: "[Words to speak: There comes] the Lord of the Two Lands Autokrator, [son of (the sun god) Re,] Lord of Appearances, Caesar, unto you." The names Autokrator and Caesar, written in ovals (cartouches) as was customary for the Pharaoh (cat. no. 11), are among the titles of the first Roman Emperor, Augustus. As ruler over Egypt ("The Two Lands"), he was also assigned the Pharaoh's role as supreme priest in the temple reliefs.

The next line of the text cites a god whose name is also partly written in a cartouche: "[Osiris-]Wenennefer, true of voice, king of the gods". Wenennefer, "the one who continues to be perfect" is an epithet of Osiris, the god of the dead.

The two lines of hieroglyphs on the far right already belong to the next scene, as is evident from their alignment and line delimitation: "[I bring] you the "[Horus] Throne" nome […] the marshes (Pehu) of Pe (?) with the fertile land (Akhet) […]".

The mention of both a Pharaoh and a god is in itself evidence that this relief must have been made for a temple. The specific figures referred to indicate that this was the Opet Temple at Karnak (Thebes). This temple was dedicated to the female hippopotamus deity Ipet and Osiris (cat. no. 7 a), who was regarded there as Ipet's son. The site was regarded as the birthplace and burial place of Osiris-Wenennefer, who was identified with the local Theban god Amun.

To judge by the orientation of the inscriptions, the relief belongs on the southern outer wall. There, two superimposed registers of images in the lower section of the wall show a procession of the provinces of Egypt; the inscriptions name Augustus and Osiris-Wenennefer. Each province comprised four scenes, each with a deity: the personification of the province, the deity of the province, the male personification of the province's swamp (Pehu), and the female personification of the province's fertile land (Uu). The Dresden relief portrays the fertile land of the second province of Upper Egypt (Maa-Heru), which was depicted on the left as a kneeling woman with numerous offerings in her arms and the hieroglyph for "field" on her head. The two lines of inscription on the far right were intended to personify the swamp area of the same province (Shenep). In the Opet Temple at Karnak these parts of the relief are missing (scene 273). Thus, after more than 100 years, the question of the origin of the Dresden relief can be considered resolved. ML

Selected Bibliography:
cat. Dresden 1896: 253 no. 13; cat. Dresden 1920: 255 no. 23 a; cat. Dresden 1977: 37 no. 32

Literature:
Leitz 2014: 114–117; Tattko 2014; http://sith.huma-num.fr/karnak/1747 [accessed 22.5.2022]

3a

3

Stelae depicting deities

(a) Late Period, Twenty-sixth Dynasty, 664–525 BCE;
(b, c) Ptolemaic–Roman Period, 332 BCE–395 CE

Limestone
(a) H. 37, W. 26, D. 9.5 cm; (b) H. 16.1, W. 17.4, D. 6.2 cm;
(c) H. 31.5, W. 18, D. 7.5 cm

(a) Findspot: probably Memphis
Purchased from the estate of Carl Gemming, Nuremberg, in 1881;
(b–c) donated by Ernst von Sieglin, Stuttgart, in 1910

Skulpturensammlung, Inv. nos. (a) Aeg 765, (b) ZV 2600 B 192,
(c) ZV 2600 B 202

Stelae are objects resembling our gravestones. Ancient Egyptian stelae are usually free-standing slabs of stone, rounded at the top, bearing images and/or inscriptions (cat. no. 17). The objects presented here depict Ancient Egyptian deities and could therefore be used in interactions with gods in temples, chapels, and other places of worship, and also in people's homes.

Despite its damaged surface, stela (a) can be seen to bear typical decorative elements. In the top of the round-topped stela, it is possible to discern the sun with cobras and wings, the protective image of Horus of Edfu, god of the sky and the sun.

In the field below, an unidentifiable man is offering a liquid, probably wine, in two vessels. The man's hairstyle, kilt, and elongated torso are characteristic of the art of the Twenty-sixth Dynasty.

Opposite him stands a deity on a pedestal. He wears a cap and a tight-fitting robe; the so-called royal beard can be seen on his chin. In his hands he holds the *was* sceptre, whose name presumably means "power, dominion". Based on these features, the deity can be clearly identified as Ptah (cat. no. 6 a). The main cult site of Ptah, the creator god and patron of craftsmen, was Memphis, the first capital of Egypt, located south of Cairo.

Below the offering scene, the name of the god Ptah can also be read in the identifiable remains of the inscription.

The badly weathered stela (b) shows a striding sphinx, i.e. a lion with a human head. Its head is covered by the royal *nemes* headdress. Above this is a feather crown made of two ostrich feathers with rams' horns, cobras, and a sun disc. On the forehead of the sphinx, the Uraeus, symbol of the protec-

tive cobra goddess, can be discerned, while the divine beard adorns the chin. Rising up before the sphinx is the head of a cobra on which the sphinx is standing, and its tail is also shaped like a cobra. There may also have been a falcon's head at the base of the tail.

In Egypt, sphinxes were generally regarded as symbols of kings and queens from the Old Kingdom onwards (cat. no. 11 c); from the time of the New Kingdom, the Great Sphinx of Giza was considered a deity. The sphinx on stela (b), however, stands for the god Tutu, who was popular in the Graeco-Roman Period but can be traced back to as early as the Twenty-sixth Dynasty. Tutu was regarded as the son of Neith, the goddess of war, who provided protection against disease and evil demons. The numerous creatures from which his body was composed can be interpreted as symbolising the various divine powers united in Tutu.

The upright rectangular stela (c) bears a frontal representation of a human-like creature in raised relief. The broad, wrinkled, grimacing face is framed by a mane-like full beard and leonine ears. The oversized head bears a plumed crown. The naked body with short legs curved in an O-shape is reminiscent of toddlers or people with dwarfism. The raised right arm holds a sword, the left hand a snake.

Egyptian gods that are depicted with the features of children, old men, people with restricted growth, and animals are now designated as Bes, although various Egyptian names have been recorded. Their appearance and actions illustrate their main function as protectors against all evil (cat. no. 10). In particular, they were supposed to provide protection during childbirth, but were also associated with the night, music and dance, drunkenness, and love life. ML

Selected Bibliography:
(a) Hettner 1881: 135 no. 41; Herrmann 1915: 8 no. 10; Herrmann 1925: 13 no. 10; cat. Dresden 1977: no. 28; Malek 2012: 371 no. 803-070-220; (b) Watzinger 1927: 123 f. no. 111, Plate 44 top; cat. Dresden 1977: 52 no. 156; Kaper 2003: 43–45, 156, 167, 308 no. S-12 with fig.; Malek 2012: 596 no. 803-099-200; (c) cat. Dresden 1977: 52 no. 157; cat. Leipzig 1989: no. 20

Literature:
(a) Bonnet 2000: 614–619; Dijk 2001; (b) Dubiel 2011; (c) cat. Frankfurt 1993: 243–245 no. 58.

3b

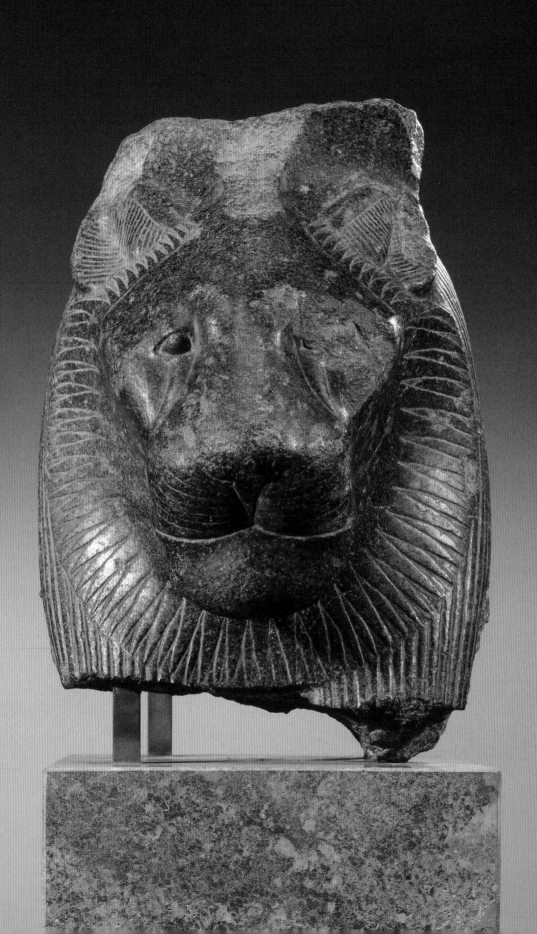

4

Statue head of the goddess Sekhmet

New Kingdom, Eighteenth Dynasty,
reign of Amenhotep III, c. 1390–1353 BCE

Granodiorite
H. 50, W. 34, D. 40.5 cm

Findspot: probably Thebes, Mortuary Temple of Amenhotep III
(Kom el-Hettan) or Mut Temple at Karnak
Purchased from the collection of Friedrich Wilhelm von Bissing,
Munich, in 1920

Skulpturensammlung, Inv. no. Aeg 758

Even in its damaged state, this life-size lion's head shows the impressive mastery of materials and aesthetic self-assurance of Ancient Egyptian artists. It is made of grey granodiorite with speckles of reddish rose granite, two hard rocks quarried near Aswan.

The facial features of the dangerous predator appear calm and tamed, an impression that is reinforced by the ornamental stylisation of the hair on the muzzle and in the ears, and of the mane, which frames the face like a wreath. Behind the mane, a streaked hairstyle is visible, part of a divine wig which rests on a human body below. The combination of animal and human features is typical of depictions of the Pharaonic gods. Above the forehead, it is still possible to see where a cobra was originally positioned (now broken off). Such a rearing cobra is an image of the serpent goddess Uraeus and was an essential part of the dress of deities and members of the royal family. The sun god is depicted as a celestial body, with the cobra curling around it. Since the sun is still partly visible as a large, convex disc above the lion's head, the cobra can be related both to the lion deity and also to the sun. A reinforcing bar visible on the rear, known as a "back pillar", is a traditional element of Egyptian statues.

We know from comparative objects that this head of a lioness with Uraeus and sun disc would have belonged on a standing or seated female body. This would have been clothed in a tight strap dress while wearing a decorative broad collar at the neck and ornamental bands around the wrists and ankles. The better-preserved seated statues hold the sign of life in their left hand; the standing figures hold it in their right hand while holding the papyrus sceptre in their left hand.

About 700 of these granodiorite statues have been discovered so far, mostly in Thebes (Luxor). Their inscriptions mostly name Amenhotep III; later kings' names were presumably added retrospectively. The most important findspots are the huge mortuary temple of this Pharaoh on the west bank of the Nile (Memnoneion/Kom el-Hettan) and the Precinct of Mut in the Karnak Temple on the east bank. There stood the temple of the goddess Mut, wife of the main Theban god Amun, where more than 200 of these statues can still be seen today.

The goddess named on the statues is Sekhmet, the goddess of war and healing at Memphis (cat. no. 6 b), who was depicted with the head of a lioness and is also associated with Mut.

The original location of the statues, and the reason for their erection, is still a matter of debate among scholars. Some researchers assume that the statues in the Mut Temple only arrived there later. They would previously have been in the royal mortuary temple, or half of them in this temple and half in the Luxor temple.

In addition to a general protective function, it has been suggested that the Sekhmet statues, along with other figures of deities, represented stars and constellations. The various epithets of Sekhmet are also reminiscent of litanies for the goddess that are found in late temple inscriptions. The total number of statues, and thus of statements, may have corresponded to twice the length of a year in days (730). The litany was probably used at various festivals, with particular consideration being given to the New Year's Festival and the Sed festival as the jubilee of the monarch's accession (cat. no. 1). ML

Selected Bibliography:
cat. Dresden 1922: 266; cat. Dresden 1977: 35 no. 20,
fig. 29; cat. Dresden 1993: 10, frontispiece fig.; cat.
Dresden 1998: 11, 14 no. 4, 15 fig.; cat. Berlin 2002:
25, fig. 79

Literature:
Bryan 1997; Bryan 2010; Yoyotte 1981

5

Ptolemaic queen and/or goddess?

Early Ptolemaic Period, 332–c. 150 BCE

Granodiorite
H. 41, W. 19.5, D. 15.5 cm

Acquired in Rome before 1733, reportedly
from the collection of Giovanni Pietro Bellori

Skulpturensammlung, Inv. no. Aeg 768

This statue fragment is made of granodiorite, which was quar-ried near Aswan on the southern border of Egypt. It represents a female body, extending from the area below the navel down to the bottom third of the lower legs. The left leg positioned in front due to the striding posture is a characteristic feature of Ancient Egyptian art. The two arms reach downwards and are held close to the body. The hands each hold an *ankh* sign, the hieroglyph for "life". This sign is usually carried by the gods, who present it to the Pharaoh (cat. no. 11) or also to other people.

Another typically Egyptian feature is the reinforcing bar on the back, known as a "back pillar". There is also a bar between the legs, but here it may also represent a robe, because the figure is not naked. In addition to the base, which is lost, the back pillar is the other place where one might expect to find an inscription naming the deity or person depicted by the statue. However, the back pillar of this object does not bear any hieroglyphs executed in relief. Some incisions scratched into the uppermost area are probably part of an ancient or modern pseudo-hieroglyphic inscription.

The elaborate smoothing of the surface of the hard stone, and the style of the statue, are the basis for dating it to the Ptolemaic Period. Comparison with similar pieces has led Sabine Albersmeier to conclude that it depicts Queen Arsinoë II. Other statues of this ruler are likewise made of granodiorite and bear the close-fitting robe and the *ankh* sign. However, it cannot be determined with certainty whether the statue was made during her lifetime or later, and its fragmentary condi-tion means that the possibility cannot be ruled out that the statue represents a goddess.

Arsinoë II was a member of the Ptolemaic Dynasty of Greek-speaking Pharaohs. The king of Macedonia, Alexander

III.

Fig. 1 Wilhelm Gottlieb Becker, *Augusteum.
Dresden's antike Denkmäler enthaltend*, Vol. I,
Pl. 3, Leipzig 1804

the Great, had conquered the Persian Empire and thereby also gained control over Egypt. After his death in 323 BC, his gen-eral, Ptolemy, took over as ruler of Egypt. His daughter Ars-inoë II married her brother, the king and Pharaoh Ptolemy II, in 279 BC, this being her third marriage. Even before her death in about 270 BC, she was probably already an object of cultic veneration, which included the erection of statues in the tem-ples of Egypt.

The statue discussed here arrived in Dresden in the early eighteenth century. Prior to that, it had been supplemented with additions so as to create a complete sculpture, and it had been inscribed with hieroglyphs on the back pillar (fig. 1). These "restorations", thought at the time to date from antiq-uity, hardly make its interpretation any easier. In view of the

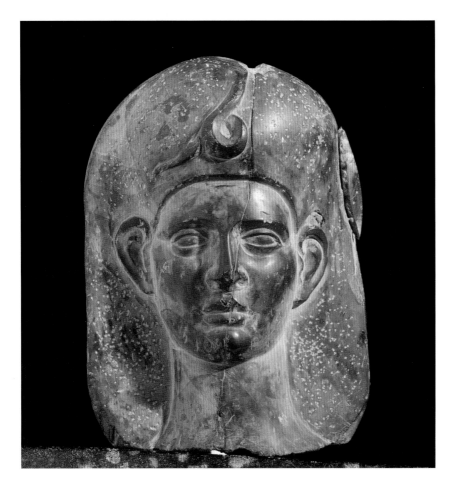

Fig. 2 Supplement of the statue inv. no. Aeg 768,
before 1733, basalt, h. 17.5 cm, Staatliche
Kunstsammlungen Dresden, Skulpturensammlung, o. Inv. 133

fact that the head of the statue wore a rather inexpertly pro-
duced Egyptian royal headdress with a cobra on the forehead,
the statue's identification as the goddess Isis (cat. no. 7 c) or as
a priestess was at least closer to reality than might have been
expected judging by the appearance of the statue. By 1836 at
the latest, these additions had been removed. It is therefore
now possible for the viewer to apprehend the style and quality
of this fragmentary, yet authentic, statue. The head that was
formerly used to supplement the statue is still present in the
Skulpturensammlung (fig. 2), but the pseudo-hieroglyphic
inscription, which is of art historical interest, has been lost,
apart from some small remnants. ML

Selected Bibliography:
Leplat 1733: Plate 150 l.; Lipsius 1798: 425–431;
Becker 1804: 30–34, Plate 3 r.; cat. Dresden 1977: 37
no. 31; Albersmeier 2002: 181, 308 no. 48, Plate 24 d

Literature:
Ashton 2001; Brophy 2015; Stanwick 2002

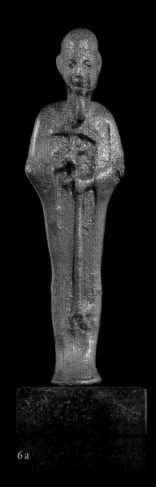

6a

6b

6c

6d

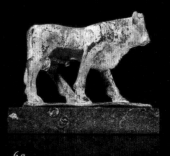

6e

6

Statuettes of the gods of Memphis

(a, c–e) Late Period, 664–332 BCE;
(b) Third Intermediate Period, c. 1077–664 BCE

(a, e) Bronze; (b–d) Faience

(a) H. 22.7, W. 3.4, D. 2.2 cm; (b) H. 5.8, W. 2.2, D. 1.6 cm;
(c) H. 12, W. 2, D. 3 cm; (d) H. 5.9, W. 2.9, D. 1.9 cm;
(e) H. 5, W. 6.6, D. 2.5 cm

(a, e) Purchased from Alessandro Ricci, Florence, in 1831

Skulpturensammlung, Inv. nos. (a) Aeg 591, (b) Aeg 466,
(c) Aeg 530, (d) Aeg 640, (e) Aeg 673

Countless small sculptures in the round – portable images of Egyptian deities – have survived, most of them dating from the Late Period. The inscriptions that have sometimes been preserved on the bronze figures request the beneficence of the deity for a specific individual, which is why they are often interpreted as votive offerings. However, since some of the bronzes and most of the faience statuettes have eyelets or holes with which they could also be attached to the body (as amulets), various uses are conceivable, and these cannot necessarily be differentiated on the basis of the material used.

The gods presented here can all be assigned to a main cult site and can thus be used to represent the topographical order of the Ancient Egyptian cults. They are the local gods of Memphis, which, as probably the oldest and longest-used capital of Egypt, helped many of its "city gods" to achieve supra-regional significance.

Probably the most important of these gods is Ptah (a), recognisable by his cap and tight cloak, the royal beard on his chin, and the *was* sceptre held in both hands (cat. no. 3a). As the patron of craftsmen and artists, he is also the creator god, who brings forth his creation with clay on the potter's wheel, in later times also by means of thought and utterance.

Ptah's wife is the lioness-headed Sekhmet, "the powerful one", mistress of both war and pestilence. The statuette (b) shows a lioness head and a human body, connected by a divine wig (cf. cat. no. 4). On the head sits an oversized rearing cobra as protection, and this merges into an eyelet at the back. According to the inscriptions that are sometimes found, this type of representation was used for both Sekhmet and Bastet. In this case, the back pillar mentions "[T]efnut-Bastet".

The god Nefertem, who can be identified by the lotus blossom and a pair of feathers on his head (c), is regarded as the son of this couple. Nefertem is considered the "lord of fragrance" and is closely associated with the sun god because the flower of the blue lotus closes at night. His warlike aspect is represented by a lion beneath his feet, or by the god himself being depicted as a lion.

Pataikoi are naked, dwarf-like beings who are interpreted as a special form of Ptah or as his children (d). The example presented here has a number of attributes which, among other things, illustrate his function as a protector against danger. In his hands, the Pataikos holds dangerous animals such as snakes, and under his feet are probably crocodiles. On his head sits the sacred dung beetle (scarab), which is a reference to the sun god and to rebirth. The falcons on his shoulders may be associated with the gods Horus, Isis and Nephthys, i.e. the family of Osiris, god of the deceased. On the back of the figure is a human-shaped goddess with wings. Her crown, made up of a sun disc between the horns of a cow, suggests that she represents Hathor or Isis.

The god Apis was worshipped in the form of a living bull. He was identified on the basis of external features, especially the markings on his coat. On the bronze statuette (e), the relevant markings are engraved onto the surface. The saddle-like zone in the middle of the back, and the vulture-shaped areas in front of and behind it, represent dark-coloured hair, while the triangular mark on the forehead indicates a white spot. ML

Selected Bibliography:
(a) Hettner 1881: 140 no. 79; cat. Dresden 1977: 46 no. 102, fig. 64; cat. Leipzig 1989: no. 43, fig.; cat. Dresden 1993: 23; (b) cat. Dresden 1977: 61 no. 271, fig. 73; cat. Leipzig 1989: no. 206, fig.; cat. Dresden 1998: 19 no. 17 with fig.; (c) cat. Dresden 1977: 51 no. 146; (d) cat. Leipzig 1989: no. 34; cat. Dresden 1998: 26 no. 143; (e) Hettner 1881: 140 no. 80a; cat. Dresden 1977: 46 no. 112, fig. 65; cat. Leipzig 1989: no. 57

Literature:
cat. Fribourg 2010; Kater-Sibbes/Vermaseren 1975/77; Weiß 2012

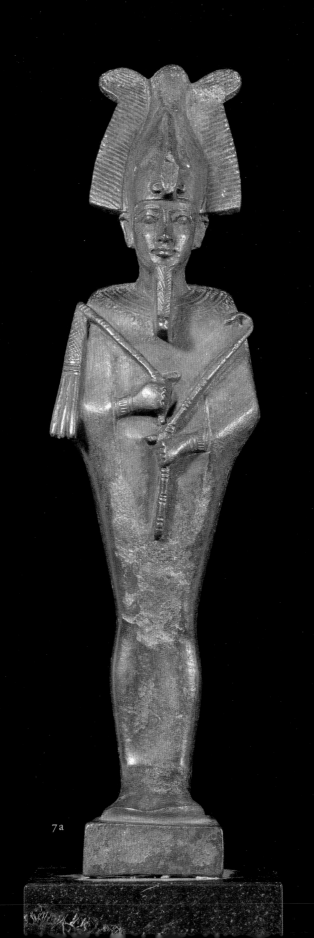

7a

7

Statuettes of deities from the family of Osiris

Late Period, 664–332 BCE

(a, c, d) Bronze; (b, e) Faience
(a) H. 21.2, W. 5.7, D. 5.4 cm; (b) H. 11.8, W. 4.1, D. 1.9 cm;
(c) H. 12.1, W. 3.8, D. 5.8 cm; (d) H. 11.6, W. 3.2, D. 5.1 cm;
(e) H. 7, W. 2.8, D. 5.9 cm

(b) Donated by Ida von Boxberg, Zschorna, in 1885;
(c) purchased from Alessandro Ricci, Florence, in 1831

Skulpturensammlung, Inv. nos. (a) Aeg 686, (b) Aeg 722,
(c) Aeg 549, (d) Aeg 473, (e) Aeg 664

In addition to regional classification (cat. no. 6), the Egyptians also organised their pantheon of deities into families. The nuclear family of father, mother, and son is frequently documented, but other and more complex structures are also known. Family relationships also meant power relationships: husbands stood above their wives, parents above their children.

The best-known Egyptian nuclear family comprised the gods Osiris, Isis, and Horus. Osiris and Isis were spouses and siblings, children of Geb (the earth deity) and Nut (the sky goddess), grandchildren of Shu (air, light) and Tefnut (fire?) and great-grandchildren of the creator and sun god, Atum. Their siblings were Seth and Nephthys, who also married each other. Horus, the son of Osiris and Isis, was the husband of Hathor.

Osiris, the god of the dead (a), is usually depicted as a mummy, wrapped in bandages. On his head he wears the *atef* crown, which consists of the royal White Crown with two ostrich feathers attached to the sides. The crook and flail in his hands refer to the office of Pharaoh (cat. no. 11), which he held before his death. Typical attributes of divinity are the cobra on his forehead and the beard on his chin. His broad collar was a popular ornament in Ancient Egypt.

The *djed* (b) is a divine object, presumably representing a pillar with plant material attached. It was associated with Osiris and ultimately came to be equated with him. As a hieroglyph, it denotes "continuity" (cat. nos. 25, 34a).

Isis, the wife of Osiris, is usually shown as a human being. Above the vulture crown on her head, a throne may appear, which in hieroglyphs is read "Isis" (cat. 27b). Alternatively, her head may be crowned by cow horns enclosing a sun disc (c),

a headdress adopted from Hathor, the goddess who was often depicted as a cow. The representation of *Isis lactans*, i.e. Isis nursing her son Horus, was popular. As a child, he is naked, but he sometimes already wears the Double Crown of the Pharaoh, a combination of the White Crown and the Red Crown (c).

The Double Crown is also recognisable on the bronze statuette depicting the naked, striding Horus (d). He also has a side braid (sidelock of youth), a typical hairstyle for children in Ancient Egypt. Since his mother is absent, Horus sucks on his finger. The Greeks, however, interpreted this hand position as closing the mouth, i.e. as a sign of discretion.

Horus also frequently appears as a falcon (e) (cat. nos. 2, 8b, 11d). The falcon is also the hieroglyph used to write Horus, which translates as "the distant, the high". Horus can also wear the Double Crown as a falcon.

The gods of the Osiris – Isis – Horus family do not have a common place of origin and each has several cult sites. The most important are Abydos and Busiris for Osiris, Philae and Iseum for Isis, Hierakonpolis and Edfu for Horus.

However, these gods are the protagonists in the most important Ancient Egyptian myth, which will only be briefly outlined here: Osiris, who ruled as Pharaoh, was murdered by his brother Seth. Isis used her magic to bring him back to life, thus enabling his continued existence as ruler in the realm of the dead. Their son Horus succeeded in avenging his father and regaining the throne from Seth (cat. no. 11). The myth thus provides a model for the ideas of life after death, succession to the throne in Egypt, and the divine power of magic.

ML

Selected Bibliography:
(a) cat. Dresden 1977: 45 no. 93, fig. 62; cat. Leipzig 1989: no. 56, fig.; cat. Dresden 1993: 25 fig. r.; (b) cat. Dresden 1977: 63 no. 303; cat. Leipzig 1989: no. 190; (c) Hase 1833: 156 f.; Hettner 1881: 139 no. 74; cat. Dresden 1977: 45 no. 98, fig. 57; cat. Leipzig 1989: no. 50, fig.; cat. Dresden 1993: 23 figs.; (d) Hase 1833: 157; cat. Dresden 1977: 45 no. 99, fig. 68; cat. Leipzig 1989: no. 54, fig.; (e) cat. Dresden 1977: 50 no. 141, fig. 46; cat. Leipzig 1989: no. 36

Literature:
Assmann 1991: 144–177; cat. Fribourg 2010; Weiß 2012

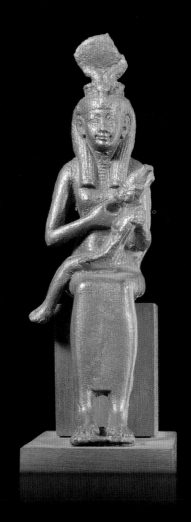

7b

7c

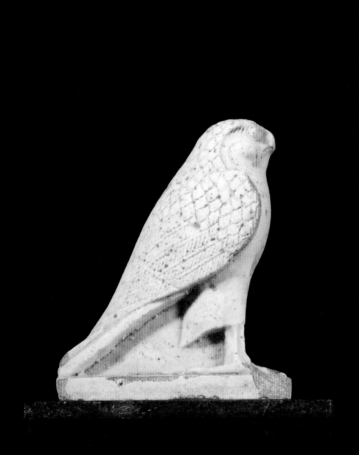

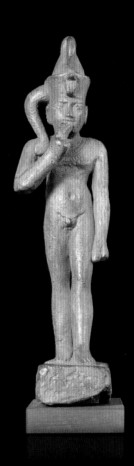

7e 7d

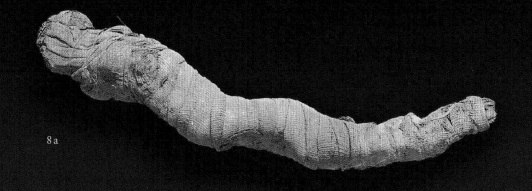

8 a

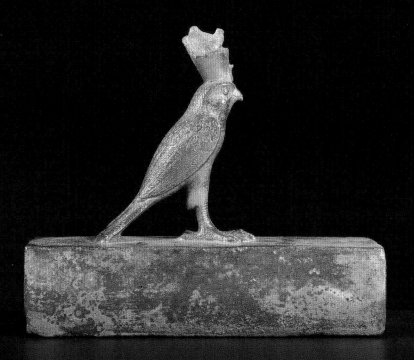

8 b

8

Animal mummies and animal sarcophagi

Late Period, 664–332 BCE

(a) Linen, Nile mud (?); (b) Bronze
(a) H. 4.5, W. 4.5, L. 27.5 cm; (b) H. 12, W. 5, L. 14.1 cm

(a) Donated by Ida von Boxberg, Zschorna, in 1885;
(b) acquired from a private collection, Dresden, in 1916

Skulpturensammlung, Inv. nos. (a) Aeg 736, (b) Aeg 818

The numerous preserved mummies and sarcophagi show that the mummification of animals was widespread in Ancient Egypt. There were various reasons for this practice. Preserved animal foodstuffs were intended as nourishment in the afterlife. Pets were also sometimes buried along with their owners. Furthermore, every temple also had a sacred animal, and this was naturally entitled to a befitting burial. Most, i.e. many millions of animal mummies, however, exist because of the Ancient Egyptian belief that specific animals of certain species were divine following their death and mummification. Thus, in many places from the Late Period to Roman times, animals were collected, cared for, and then often killed and mummified. Their burial probably took place as part of certain religious practices, such as festivals or oracles, or in connection with supplications or thanksgiving on the part of individuals.

Exhibit (a) was acquired as a crocodile mummy and is one of four crocodile mummies in the Skulpturensammlung of the Staatliche Kunstsammlungen Dresden. The object, wrapped in coarse linen, only suggests the outline of a young crocodile. Examination by computed tomography, however, did not detect any animal components. However, this does not necessarily indicate that it is a modern forgery, because many Ancient Egyptian animal mummies do not contain the animal suggested by the mummy's outward appearance. Sometimes there are several animals, animals of various or different species, animal substances (bones, feathers, faeces) or even no (detectable) animal remains at all. In cultic practice, these objects evidently also served their intended purpose. Perhaps the Dresden mummy comes from the Fayum Oasis, where important cult sites of the crocodile god Sobek, and also crocodile cemeteries, are located.

For the countless animal mummies, the use of a stone sarcophagus or wooden coffin was rare; more often they were placed in clay vessels. Coffins made of bronze would certainly have been expensive due to the material and production costs, but they have nevertheless survived in considerable numbers. They show the shape of the god and are thus similar to the bronze figures depicting the gods (cat. nos. 6 a, e, 7 a, c, d), which were themselves also deposited in animal cemeteries. In the case of the bronze coffins, the mummy (or possibly another divine substance?) was placed either in an animal sculpture, in the base, or in a pillar with a pyramid-shaped top (obelisk) behind the figure of the god (contribution by Friederike Seyfried in this volume, fig. 6).

In the case of the falcon coffin (b), the base forms a bronze box for the mummy, as shown by the lost lid on the back. On the base sits the comparatively small falcon, its royal Double Crown showing it to represent the god Horus, with whom the Pharaoh was also identified (cat. nos. 2, 7 e, 11 d). The bird's plumage and oversized talons are elaborately worked out. On its chest is a multi-stranded broad collar, with an unidentifiable amulet hanging from a necklace. Owing to the lack of an inscription, the origin of the object remains unclear, as there were falcon cemeteries in at least 14 places in Egypt. Since many of the animal mummies discovered in the nineteenth century came from Saqqara, this may perhaps also apply to the Dresden falcon coffin.

Among the holdings of the Dresden Skulpturensammlung are also Ancient Egyptian coffins for cats, shrews (?), lizards, ibises, and dung beetles (scarabs). ML

Selected Bibliography:
(a) cat. Dresden 1896: 254 no. 6; (b) cat. Dresden 1977: 46 no. 109; cat. Leipzig 1989: no. 59; cat. Stuttgart 2007: 290 no. 264

Literature:
cat. New York 2013; Fitzenreiter 2013; Ikram 2015;

9b

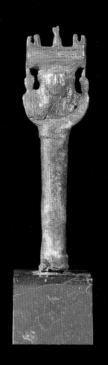

9a

9c

9

Cultic equipment:
sistrum, menat, and aegis

(a) Late Period–Ptolemaic Period, 664–30 BCE;
(b) Ptolemaic Period, 332–30 BCE;
(c) Third Intermediate Period–Late Period,
c. 1077–332 BCE

Bronze
(a) H. 12.8, W. 3.6, D. 1.7 cm; (b) H. 12.9, W. 7.2, D. 1.5 cm;
(c) H. 6.2, W. 5.2, D. 2.6 cm

Purchased from the estate of Carl Gemming, Nuremberg, in 1881

Skulpturensammlung, Inv. nos. (a) Aeg 483, (b) Aeg 326, (c) Aeg 332

Many bronze objects have survived from the Egyptian Late Period that could be used for performing rituals in the temple. These include offering vessels, incense burners, musical instruments, and containers for cult images. The large number of finds suggests that not all of these objects were used continuously in the cult. Perhaps some of them were also donated as votive offerings to a deity.

Of the musical instrument (a), only the column-like handle has survived. Its upper end is formed by the head of Hathor, the goddess of music. As usual, her locks of hair curl outwards, and on each side of her collar is a rearing cobra with a royal crown, symbolising protection.

The body of the instrument was attached to the structure at the top. A cat sits in the middle. The two ends of a bronze sheet bent into the shape of a bow would have been fixed to the side brackets. This sheet was pierced several times so that bronze rods could be passed through it horizontally. The ends of these rods were bent so that they could be moved but could not slip out. Bronze discs were mounted on the rods. When the handle was shaken, the sheet metal, rods and discs produced a rattling sound. This sound is probably the origin of one of the Egyptian names for the instrument, *sesheshet*; it is known by the Greek name sistrum.

The keyhole-shaped object (b) is called a *menat* or *menyet*. This was originally the counterweight to a broad collar, so that it lay on the wearer's back. In cultic rituals, sounds were produced by holding the collar with its numerous chains on the counterweight and shaking it. At the top, the *menat* has a depiction of a standing goddess with a papyrus sceptre and the symbol of life in her hands; according to the remnants of an inscription, this represents Isis, "Mistress of Heaven" (cat. no. 7 c). The sides of the frame are formed by two hanging cobras crowned with sun discs. The round section below shows papyrus reeds in front of which squats a woman with a sun disc and cow horns on her head – undoubtedly a representation of the goddess Isis or Hathor (cf. cat. no. 10).

Object (c), comprising the head of a deity with a broad collar, is known as an aegis. The deity featured is often a lion-headed goddess, which may be identified as Bastet, Sekhmet, Tefnut, or also Hathor. On the head, the divine wig with the protective cobra and the sun disc can be discerned (cat. no. 4). This group of objects probably originated from the heads of deities found on poles carried in religious processions, or on the prow and stern of sacred boats.

Aegises were often attached to the rear of a *menat*. In this way, it was no longer possible to make a sound. The exact use of these devices is unclear; it has been suggested that they were cult objects, part of cult images, votive gifts, or amulets.

The functions and associations of the sistrum, *menat*, and aegis are manifold and clearly go beyond their use as musical instruments. They are closely related to goddesses who personify perils (disease, war), but also love, regeneration, music, dance and drunkenness, especially Tefnut, Sekhmet, Bastet, Hathor, and Isis. It is also likely that they were associated with the myth of the dangerous solar eye (Eye of Re) in lioness form, which can be pacified through music. ML

Selected Bibliography:
(a) Hettner 1881: 143 no. 141; cat. Dresden 1977:
50 no. 137; (b) Hettner 1881: 143 no. 149; cat.
Dresden 1977: 50 no. 138; cat. Leipzig 1989: no. 189;
(c) Hettner 1881: 143 no. 143

Literature:
cat. Grenoble 2018: 362–401; Roeder 1956;
Weiß 2012

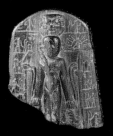

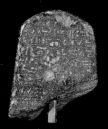

10a

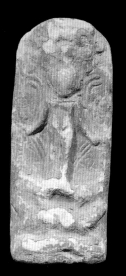

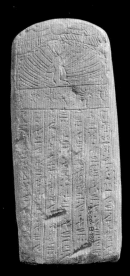

10b

10

Horus stelae

(a) Ptolemaic Period, 332–30 BCE;
(b) Early Roman Period, c. 30 BCE–100 CE (?)

(a) Probably steatite or serpentinite; (b) Limestone
(a) H. 4.5, W. 3.7, D. 1.5 cm; (b) H. 16.4, W. 7.1, D. 4.9 cm

(a) Purchased from Alessandro Ricci, Florence, in 1831;
(b) donated by Ernst von Sieglin, Stuttgart, in 1910

Skulpturensammlung, Inv. nos. (a) Aeg 262, (b) ZV 2600 B 189

The Dresden Skulpturensammlung owns three objects which, on account of their central pictorial element, are known as Horus stelae. The two higher-quality ones are presented here.

Part of the smaller stela (a) has broken off at the bottom. The upper section features a frontal view of the face of the god Bes. The broad face resembles that of an old man, and he also has lion's ears and a mane-like full beard; on top of his head is the base for a plumed crown (cat. no. 3 c).

Below, also in frontal view, is an image of the god Horus as a child (Harpocrates). In Egyptian art, children are depicted naked and with a side braid (sidelock of youth). The face has been rubbed completely smooth. The implied striding posture shows the left leg in front, as is usual in Egyptian sculpture. The god is holding dangerous animals: in each hand are two snakes, and his left hand is also holding a scorpion and a lion, while on his right further animals are missing as a result of the damage. The figure is framed on either side by a papyrus plant on the left, on which a falcon stands, and the lotus of the god Nefertem on the right (cat. no. 6 c). The latter consists of a lotus flower on a staff surmounted by two plumes. The two suspended *menats* (cat. no. 9 b) are not included here.

These depictions are surrounded by numerous engraved images of deities. Almost all of them seem to be male deities holding two snakes. Only the image to the right of Horus's head is different; it can be identified as a crouching figure of Isis, nursing her son Horus in the shelter of the papyrus thicket (cat. no. 7). The narrow sides and the back of the stela are inscribed with magical texts.

The second stela (b) is considerably larger, but the depictions on the front are much less well preserved, which is probably due, among other things, to its being made from lime-

stone. The face of Bes and the figure of Horus holding snakes are still recognisable. The other animals and the framing elements on the sides are barely discernible. On the other hand, it can clearly be seen that Horus is standing on crocodiles – in this case probably six – which is a typical feature of Horus stelae. The other sides of the stela bear well-preserved texts. On the reverse, there are also engraved pictorial scenes. At the top is the protective sign of the winged sun. Below, Isis is depicted squatting in a papyrus thicket, nursing her son Horus. This is followed by a row of six scorpions, perhaps referring to the seven scorpions allied with Isis.

Images and inscriptions indicate that the main theme of the Horus stelae is defence against dangerous animals, with the vulnerable Horus triumphing over these threats through the magical powers of his mother, Isis. An alternative, but less convincing, interpretation gives central importance to the concept of the rejuvenation of the sun god.

Archaeological evidence shows that Horus stelae were placed in temples or dwellings, rarely in graves. Small examples such as stela (a) could be worn on the body as an amulet.

It is also known that water was poured over Horus stelae and collected and drunk as a magical substance or applied externally. Erosion due to rubbing, as is found on the Dresden Horus stelae, indicates that touching these images was also believed to have a positive effect. ML

Selected Bibliography:
(a) Hettner 1881: 137 no. 29; cat. Dresden 1977: 52 no. 160, fig. 75; cat. Leipzig 1989: no. 18, fig.; cat. Dresden 1998: 18 no. 8 with fig.; Sternberg-El Hotabi 1999: Part 2, 23 f.

Literature:
cat. Paris 2004 b; Pfister 2013; Quack 2006

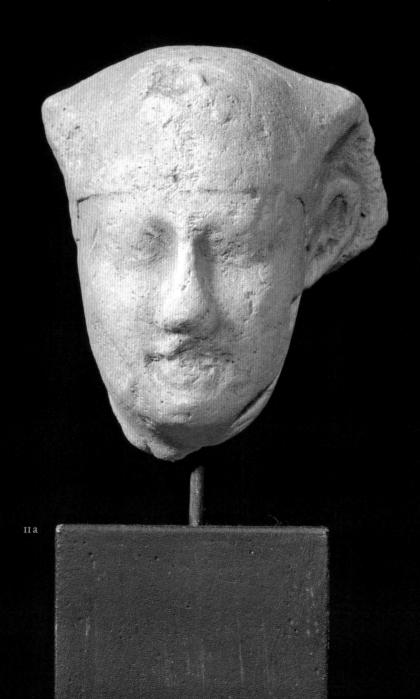

Images of Pharaoh

(a) Early Ptolemaic Period, 332–c. 200 BCE;
(b) Third Intermediate Period–Late Period, c. 1077–332 BCE;
(c) Late Ptolemaic Period, c. 100–30 BCE;
(d) Late Period, 664–332 BCE

(a) Stucco, painted; (b, d) Bronze; (c) Limestone
(a) H. 7.7, W. 6.7, D. 5.1 cm; (b) H. 4.7, W. 1.8, D. 1.8 cm;
(c) H. 26.5, W. 15.5, L. 61.5 cm; (d) H. 19.1, W. 9.2, D. 19 cm

(a) Donated by Ernst von Sieglin, Stuttgart, in 1910; (b) purchased from the estate of Carl Gemming, Nuremberg, in 1881; (c) purchased from the estate of Prof. Alfred Fiedler, Dresden, in 1921; (d) Findspot: reportedly Minya. Purchased from S. Alfandari, Paris, in 1925

Skulpturensammlung, Inv. nos. (a) ZV 2600 B 045, (b) Aeg 487, (c) Aeg 766, (d) Aeg 819

The Egyptian word Pharaoh simply means "great house". It is one of the many titles of the rulers of Ancient Egypt. Their function was unique and indispensable – the Pharaoh was the crucial interface between gods and humans. The Pharaoh inherited his rulership from the gods, and in his role as chief priest he presented the gods with the gifts of the people. As chief administrator, judge, military commander, and hunter, he preserved and protected the world order (Maat) created by the gods. The divine nature of the king is made clear in depictions of him; he is shown in forms, or with costumes and attributes, that he shares with the gods or that are reserved for him alone.

Thus, the stucco model (a) is also clearly identifiable as a Pharaoh because of the headgear. The royal headcloth, or *nemes*, one of the most common Ancient Egyptian royal crowns, is clearly visible. In this case, the headdress lacks the stripes created by artificial fabric folds (pleating), and the protective cobra on the forehead (Uraeus) seems to have been removed. Only the royal family and the gods wear a Uraeus.

The small bronze statuette (b) shows a kneeling man. In his arms, now broken off, he presumably originally held vessels containing offerings. The statuette would certainly have been part of a cult scene consisting of several figures with an image of a deity as the recipient of the offerings. Interpreting the offerer as a Pharaoh or priest is made difficult by the poor state of preservation. However, the wearing of a wig in cultic rituals is documented for kings, while non-royal priests were usually bareheaded.

The royal headdress and cobra are clearly visible on the unfinished, uninscribed limestone sphinx (c). The combination of a lion's body with a human head is known from as early as the Fourth Dynasty, and for a long time it was reserved for the Pharaoh and the queen (cat. no. 3 b). Sphinxes were often erected as guards in front of temples. Statues of recumbent lions, also representations of the king, were used in the same way (cat. no. 12). Furthermore, the lion's body of the Pharaoh was sometimes given wings, and also a bird's head, thus becoming a griffin, which particularly emphasises his aggressive, warlike nature.

From earliest times, the Pharaoh was associated with the god Horus, in his form as a falcon (d). Even inscriptions bearing the names of kings of the Dynasty 0 already feature a falcon; it surmounts a representation of a palace inside which the respective ruler's name is inscribed (cat. no. 13). The king can therefore be called Horus. Nevertheless, Horus is often not identical with the respective Pharaoh. As a falcon or winged sun, he is the ruler of the sky and a sun deity (cat. nos. 3 a, 10 b). In the form of the falcon or falcon-headed man, he often wears the royal Double Crown. Depictions of him as "Horus the Child" (Harpocrates) on his mother's lap are references to the most important Ancient Egyptian myth (cat. nos. 7, 10). He is "Horus, son of Isis" (Harsiese), who is in need of protection: his father Osiris having been murdered, he had been deprived of his inheritance, namely the kingship. After coming of age, he regains his inheritance in the form of "Horus, protector of his father" (Harendotes). Horus thus becomes the prototype of the Pharaoh. The Late Period bronze falcon (d) shown here is to be interpreted as Horus, but not as the image of a specific Pharaoh. The crown is missing, one leg is broken off, as is the base. Perhaps this was hollow and once held a deified falcon mummy (cat. no. 8 b). ML

Selected Bibliography:
(a) Pagenstecher 1923: III with fig. III; cat. Dresden 1977: 50 no. 143; cat. Leipzig 1989: no. 39; (b) Hettner 1881: 145 no. 205; cat. Dresden 1977: 47 no. 118; (c) Herrmann 1925: 14 no. 15 a; cat. Dresden 1977: 37 no. 30 fig. 83; Malek 1999 a: 169 f. no. 800-880-250; cat. Dresden 2002: 176 fig. 145, 233 no. 10; (d) cat. Dresden 1977: 46 no. 110, fig. 60; cat. Leipzig 1989: no. 52, fig.; cat. Dresden 1993: 25 fig. l.; cat. Berlin 2002: fig. 71

Literature:
(a) Tomoum 2005; (b) Hill 2000; Mendoza 2008;
(c) Dubiel 2011; (d) Weiß 2012

11b

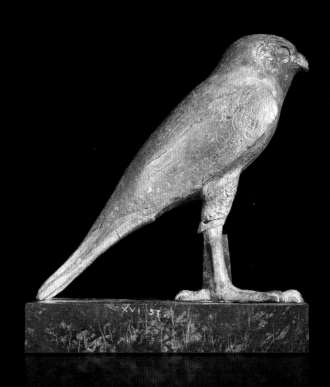

11d

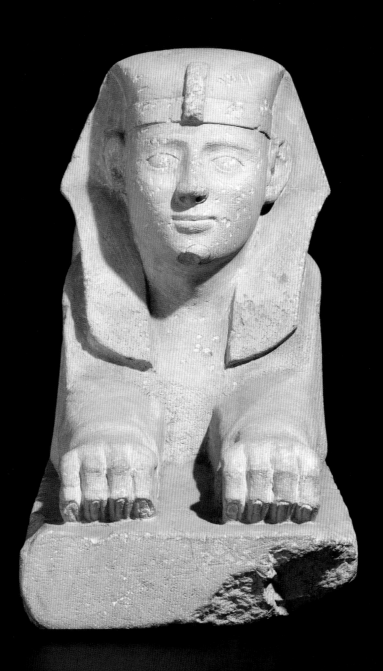

IIC

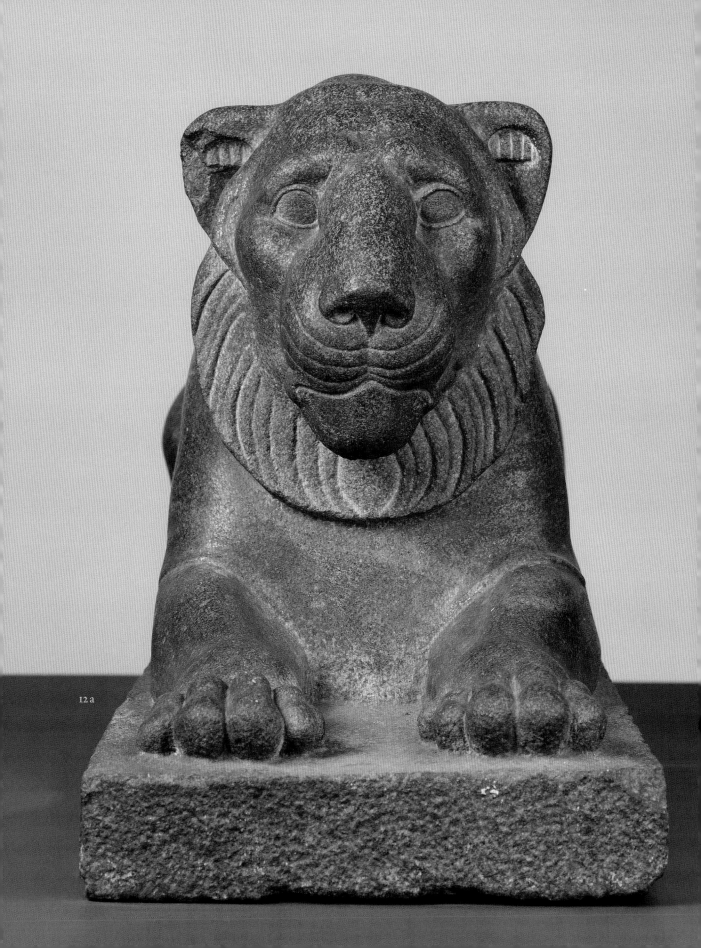

Statues of recumbent lions

1st century CE

Granodiorite or/and granite
(a) H. 69, W. 48.5, L. 134 cm; (b) H. 68.5, W. 45, L. 132 cm

(a) Findspot: 1644/55 Rome, Vigna Cornovaglia
Purchased from the collection of Flavio Chigi, Rome, in 1728;
(b) c. 1530 collection of Paolo Emilio Cesi, Rome
Donated by Alessandro Albani, Rome, in 1728

Skulpturensammlung, Inv. nos. (a) Hm 16, (b) Hm 18

These two statues belong to a group of three related lion figures from Rome (inv. nos. Hm 16–18). Their Egyptian character was recognised early on.

The material appears to be granodiorite with veins and speckles of rose granite, as found in Aswan. The posture and symmetrical structure are similar to Ancient Egyptian lion statues. The design of the head and the schematised rendering of the hair on the ears and mane are even more definitive. The facial mane frames the head with radiating tufts of hair, while the neck mane lies like a blanket on the chest and neck, forming a crescent shape around the shoulders, as is common in sphinxes (cat. nos. 3 b, 11 c). The way the tail rests on the right thigh is also typical.

The style of the lions echoes some characteristics of the New Kingdom, but the design is significantly simplified, for example by not indicating the ribs. They can thus be dated to the first century CE. It is not clear whether the lions were made in Egypt or in Rome. In the latter case, the two Ptolemaic lion statues that today stand on the steps to the Capitol might have served as models.

There are no reliable clues as to the original location of the statues. In Egypt, it was customary to position them in the entrance area of temples. The lion was regarded as the image of the Pharaoh, as a (divine) guardian, and as an animal representing the sun and the horizon. A similar use has been suggested for Rome, as there were also temples dedicated to Egyptian deities in this city. The most important was the temple of Isis on the Campus Martius (Iseum Campense), which was the source of many of the Ancient Egyptian statues discovered in Rome. The lion (a) was found around 1644/55 on the western slope of Monte Celio, where the temple of the deified Emperor Claudius (Claudianum) once stood. The other one (b), and also another statue, are first documented around 1530, when they were located in the garden of Paolo Emilio Cesi's villa, which was not far from the Circus of Claudius. However, the idea that they may have originated from the aforementioned ancient complexes remains pure conjecture.

The lion (a) entered the Chigi Collection soon after its discovery and was purchased for Dresden from that collection in 1728. The two lions from the Villa Cesi eventually entered the Albani Collection via the Ludovisi Collection and were added as gifts to the antiquities purchased there in 1728. The ancient function of the lions as symbolic guardians was often continued at their various locations in Dresden and will remain recognisable in the future.

In modern times, sculptors frequently used Pharaonic lions as models for their own depictions of lions. This is known to be the case for lion sculptures in Dresden. One pair of lions made of stone guarded the steps to the Brühl Terrace (now in the Great Garden/Grosser Garten), and another made of clay the entrance to the Great Garden (Gottlob Christian Kühn 1814). Eugen Kircheisen created two cast-iron lions, which were originally winged, for the Academy of Arts and the Exhibition Building (1887–94) on the Brühl Terrace. As early as 1801, casts of the Dresden lions were made and subsequently used as models for decorating the heating stoves in the banqueting hall at the Stadtschloss in Weimar. The Leipzig Lion Fountain (Johann Gottfried Schadow, c. 1820) is also adorned with two bronze lions based on the Dresden precedents.

ML

Selected Bibliography:
(a) Leplat 1733: Plate 188 top; cat. Dresden 1977: 37 no. 34, fig. 84, 85; Borbein et al. 2006: 63 f. no. 85 with fig.; cat. Dresden 2011: Vol.1, 116 Plate 16, Vol.2, 1048–1050 Nos. 253, 1052–1054, 1056; cat. Dresden 2020 b: 90, 91 fig.; (b) Leplat 1733: Plate 188 bottom (?); cat. Dresden 1977: 37 no. 36; Borbein et al. 2006: 63 f. no. 85 with fig.; cat. Dresden 2011: Vol.2, 1052–1056 no. 255; cat. Dresden 2020 b: 90 with fig.

Literature:
Bothe 2000; Müller 1965; Rother 1994; Zschoche 1988

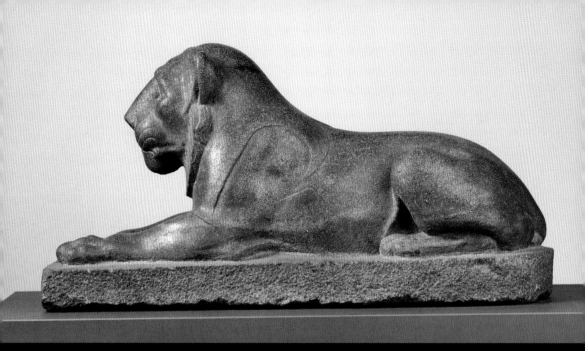

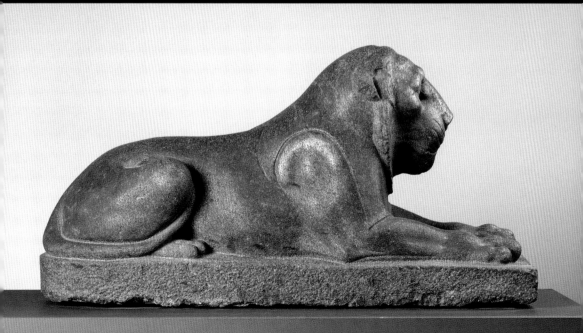

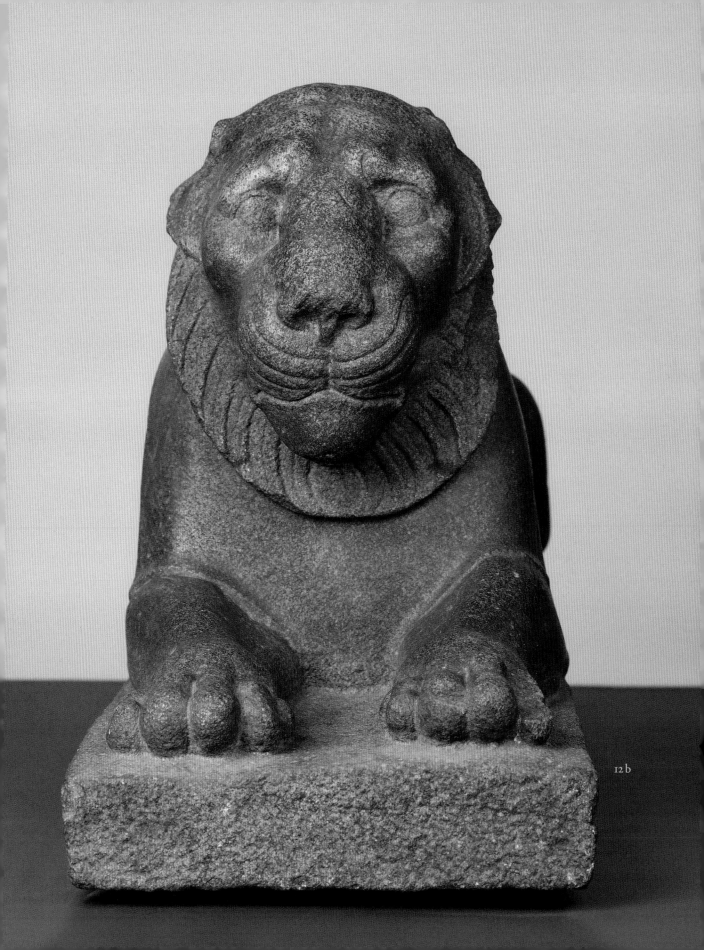

12 b

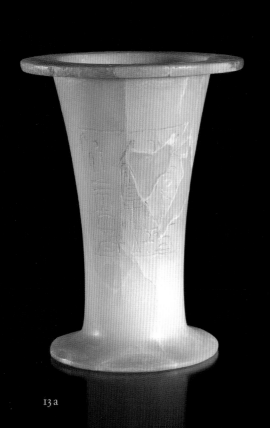

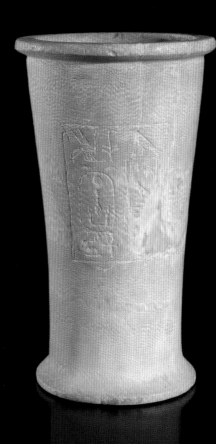

13 a

13 b

13

Cylindrical vessels bearing the names of Pepi I and Pepi II

Old Kingdom, Sixth Dynasty,
(a) reign of Pepi I, c. 2276–2228 BCE;
(b) reign of Pepi II, c. 2216–2153 BCE

Travertine
(a) H. 14.8, Diam. 11.7 cm; (b) H. 19.5, Diam. 11.2 cm

Donated by Ernst von Sieglin, Stuttgart, in 1910

Skulpturensammlung, Inv. nos. (a) ZV 2600 E 002, (b) ZV 2600 E 001

The two high, cylindrical vessels made of travertine are inscribed with the names of the Pharaohs Pepi I (a) and Pepi II (b).

The first vessel (a) is elegantly curved, worked with a wide projecting rim and provided with three vertical and one horizontal inscription lines. They contain two of the five royal names. First, the title "King of Upper and Lower Egypt" appears on the right side, followed by the so-called throne name "Beloved of Re" in an oval (cartouche). In the middle, the Horus name was added: "Beloved of the Two Lands". The Horus name shows the sky god Horus as a falcon on top of a palace containing the hieroglyphs of the name, thus associating the king with this god (cat. no. 11 d). On the left is an inscription reading "First Sed festival". Below this are two horizontal inscriptions reading "May he be given life forever", arranged as mirror images. The hieroglyph for "to give" is written only once and located in the centre and belong to both inscriptions.

The inscription is framed on either side by two *was* sceptres, which presumably stand for dominion, supporting the hieroglyph for sky; at the bottom is a horizontal line, known as the base line. The inscription carved into the stone still reveals remnants of the original blue colour intended to make the text stand out.

The second vessel (b) bears two vertical inscriptions: on the left, after the title "King of Upper and Lower Egypt", the cartouche contains the throne name Nefer-ka-Re "With perfect Ka(-spirit), a (sun god) Re" as well as "may he live forever".

Engraved on the opposite side is the Horus name: "With divine appearances". The lower part of this inscription is lost.

Again, the inscription is framed by two *was* sceptres, the sky hieroglyph and the base line.

Both vessels have been broken several times and have been restored. They probably contained precious oils used during the Sed festival. Unfortunately, the origin of the vessels is unclear. However, it can be assumed that they came from the respective mortuary temples of these kings in Saqqara. During excavations in the mortuary temple of Pepi II, vessels of Pepi I with mention of the Sed festival were discovered alongside vessels of this king.

Cylindrical vessels made of clay and different types of stone are known to have been produced in Egypt from as early as the Predynastic and Early Dynastic Periods. The form that appears here, however, was only used from the Fifth Dynasty onwards. Travertine was an extremely popular stone for making vessels in Ancient Egypt. It can be easily worked and shaped into very thin walls, whereby the veining of the stone stands out aesthetically as a decorative element (cat. no. 32 c, 33c).

The Sed festival was a royal festival celebrated for the first time when the Pharaoh had reigned for thirty years. In subsequent years, the intervals between the celebrations were shorter. Also, the requirement of thirty years was not always observed, i.e. the festival was sometimes celebrated earlier. It served to reinvigorate royal power and regenerate the physical strength of the Pharaoh (cat. no. 1). MG

Selected Bibliography:
(a) Pagenstecher 1913: 174, Plate 2 no. 5; cat. Dresden 1977: 55 no. 187, fig. 23; cat. Leipzig 1989: no. 116 with fig.; (b) Pagenstecher 1913: 175, Plate 2 no. 14; cat. Dresden 1977: 55 no. 188, fig. 22; cat. Leipzig 1989: no. 117 with fig.

Literature:
Arnold/Pischikova 1999; Von Beckerath 1999

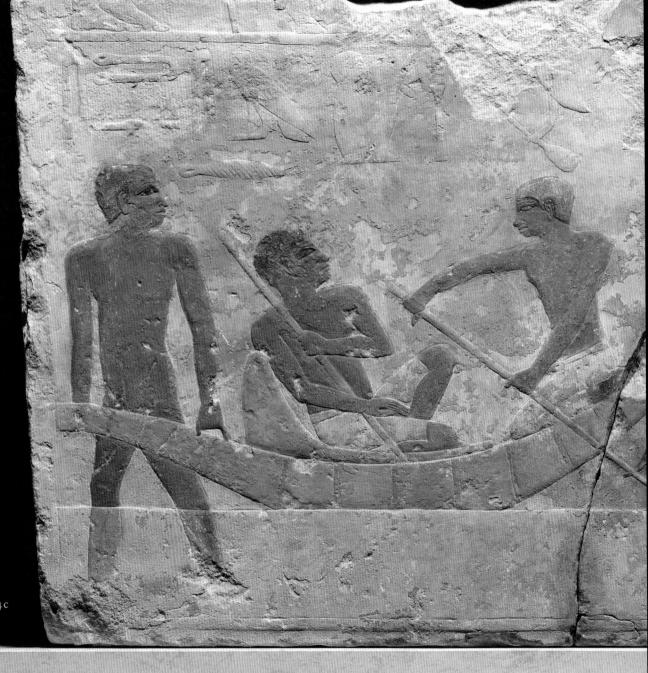

14C

Reliefs from the tomb of an official

Old Kingdom, Fifth Dynasty, probably reigns
of Userkaf–Sahure, c. 2435–2416 BCE

Limestone, painted
(a) H. 64.5, W. 55 cm; (b) H. 75.5, W. 84 cm; (c) H. 35.5, W. 75 cm

Findspot: Saqqara, tomb of Khnumhotep, D 49
Purchased in Giza from Carl Reinhard, Cairo, in 1898

Skulpturensammlung, Inv. nos. (a–c) Aeg 749–751

The three reliefs with well-preserved painting can be assigned to the tomb of Khnumhotep in Saqqara. Reliefs from this tomb are now in museums in Baltimore, Basel, Berlin, Bonn, Cairo and London. Some of them directly precede or follow on from the scenes on the Dresden reliefs.

On relief (a) Khnumhotep is sitting on a chair with a high back and sides. The chair legs are carved in the shape of lion legs. Tethered under the chair is probably a guenon (a type of monkey), a popular pet that was often depicted beneath the chairs of ladies. The tomb owner wears a long wig, a collar and a white kilt. With his left arm resting on the back of the chair, he hands a lotus plant to a kneeling woman with his right hand. Only a part of her head, an elbow, and her right thigh with a hand resting on it are still visible. The incompletely preserved inscription reads: "His wife, who loves him, Khentet[ka]". Faded green trelliswork can be seen in the background, the wall of a bower in which the couple are located. They are probably attending a banquet with their family, musicians, and dancers.

The second relief (b) has two horizontal registers preserved at full height, as well as remnants of two others. The feet visible on the upper edge probably belong to bearers of offerings. In the scene below them, a man is carrying an offering table on the left. The man in front of him holds a slaughtering knife and carries a large clay jug. On his left forearm hangs a rope, from which an object is suspended, possibly a whetstone. In front of him, two men are slaughtering a bull that is lying on the ground with its legs tied. Food production is a prominent theme in the iconographic programme of tombs from the Old Kingdom, as it was believed essential to ensuring the nourishment of the deceased in the afterlife. In the scene below, farm-

ers are harvesting grain with sickles, and tying sheaves. The man in the centre with a staff, sash, and protruding belly is an overseer. The inscription reads: "[Harvesting the grain in his villages] of his funerary foundation". The bottom sequence of images evidently depicts the threshing of grain, but all that is visible are heads and raised sticks. The relief showing donkeys being driven by the men and threshing the corn has been published but is now lost.

The third relief (c) shows shepherds with cattle crossing a ford (fig. on pages 4/5). On the papyrus boat, the oarsman and helmsman is kneeling at the stern, while an overseer with a staff in his hand is sitting on a cushion. A naked man has jumped into the water to pull the boat ashore. Six long-horned cattle follow behind. The water is signified by a strip of blue. While the images outside the water are worked in raised relief and painted in vibrant colours, the legs in the water are only lightly incised and the colours are paler. The few remaining fragments of the series of images immediately above feature a milking scene; over this was a depiction of a papyrus boat being constructed.

The other tomb reliefs include numerous titles and offices held by Khnumhotep, among others that of priest at the Sun Temple (cat. no. 1) and at the pyramid of the Pharaoh Userkaf. His wife was a priestess of the goddess Hathor. Khnumhotep and Khentetka had at least two sons and two daughters.

MG

Selected Bibliography:
(a) Herrmann 1915: 7 no. 1; cat. Dresden 1977: 32 no. 9, fig. 14; Sharawi/Harpur 1988: 64–67; cat. Dresden 1993: 13 fig.; cat. Dresden 1998: 12 f. no. 1; (b) Herrmann 1915: 7 no. 2, cat. Dresden 1977: 32 f. no. 11, fig. 1; Sharawi/ Harpur 1988: 64–67; cat. Dresden 1993: 15; (c) Herrmann 1915: 7 f. no. 3; cat. Dresden 1977: 32 no. 10, fig. 12; Harpur 1985: 36–39; Sharawi/Harpur 1988: 64–67; cat. Dresden 1993: 14; cat. Rome 1996: 26–28

Literature:
cat. Bonn 2004: 16 f. no. 3; Harpur 1987; Nuzzolo 2018: 316–318; Petrie/Murray 1952: 14–16, 24–26, Plate 15–17, 25–26; Porter/Moss 1981: 578 f.

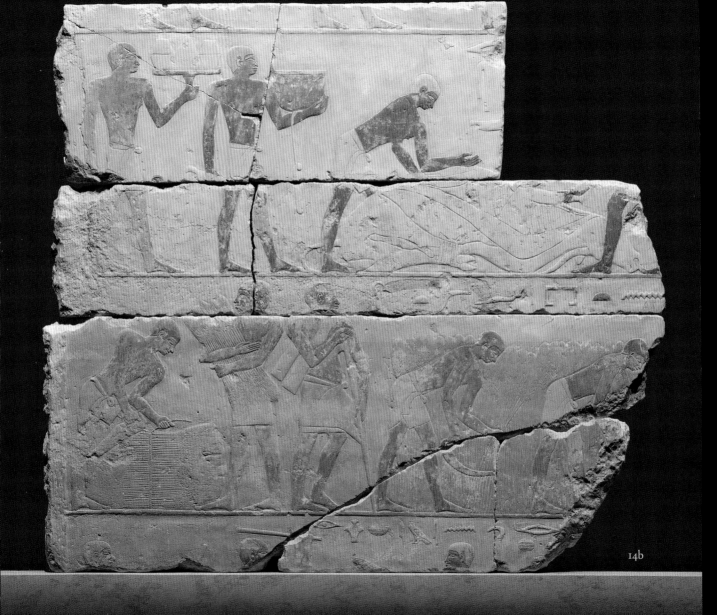

14b

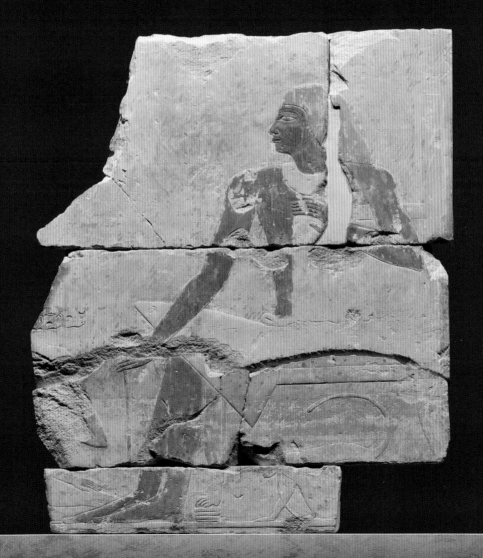

14a

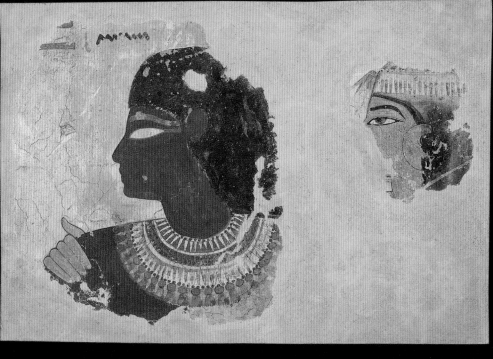
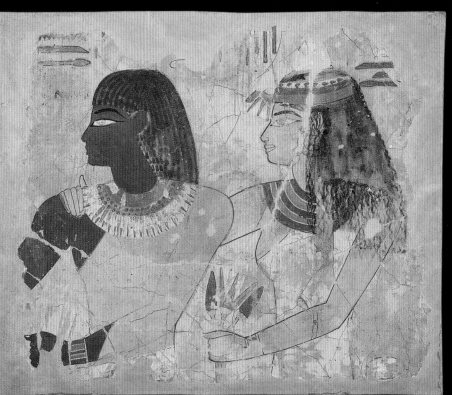

15

Fragments of tomb paintings

New Kingdom, Eighteenth Dynasty,
reign of Amenhotep III, c. 1390–1353 BCE

Limestone, plaster, painted
(a) H. 43, W. 68, D. 11.5 cm; (b) H. 35, W. 53, D. 11.5 cm;
(c) H. 39.5, W. 48, D. 11.5 cm

Findspot: Western-Thebes, reportedly tomb of Menna,
TT 69. Purchased by Robert Diez in Luxor in 1895; donated
by the same, Dresden, in 1911

Skulpturensammlung, Inv. nos. (a–c) Aeg 757 a–757 c

The first tomb painting (a) shows the owner of the tomb sitting on a chair on the left. He wears a white, pleated kilt, while his upper body is unclothed. In his left hand he is holding a lotus flower to his nose; his right hand, with a white cloth, is resting on his thigh. Around his neck he wears a broad, colourful collar. His wife was probably sitting behind him – a hand and a foot can still be discerned. Opposite them are three people. Of the two men, only one with a shaved head, i.e. a priest, is clearly visible. They are bringing gifts in the form of papyrus plants and a duck. Of the lady standing behind them, possibly the daughter of the tomb owner, only the upper section has been preserved. She wears a black wig with a perfume cone made of wax, oils and fragrant essences; at high temperatures, this was supposed to slowly release its precious ingredients into the hair. The fragments with a zigzag pattern and remnants of an inscription incorporated into the lower area do not belong to the scene. They undoubtedly come from the ceiling decoration of a tomb.

The other two fragments (b, c, see also fig. on pages 173/174) show the tomb owner and his wife. Her right hand rests on his shoulder; in (c), she holds a bouquet of one opened and two closed lotus flowers in her left hand. On her head is a wreath of lotus blossoms, with one flower hanging over her forehead. She also wears a perfume cone on her black wig. Around her neck is a broad collar consisting of several rows. Her strap dress is white and close-fitting. The tomb owner is probably dressed in a white kilt, with his upper body unclothed. Like his wife, he wears a broad collar around his neck; it is made of floral elements. His left wrist is adorned with a bracelet. The conventional colouring of the skin is clearly visible: men were

represented with reddish-brown tones and women with a light-yellow skin colour.

These wall paintings are generally attributed to tomb TT 69, belonging to an official named Menna, in the Theban Necropolis at Sheikh Abd el-Qurna on the west bank of the Nile. The decisive factor in making this attribution is the particular graphic style used by the painters. The arrangement of the scenes and the colouring of the preserved hieroglyphs certainly show similarities to the tomb of Menna.

The tomb of the official Menna has been extensively restored and scientifically investigated by the American Research Center in Egypt. It is notable, however, that in every scene of the tomb decoration, the face of the tomb owner, Menna, and sometimes also that of his wife Henuttawy, have been deliberately damaged. Menna apparently had an enemy who wished to erase his memory (*damnatio memoriae*) for some reason. However, the faces of the Dresden fragments are very well preserved. The zigzag pattern (a) most probably does not come from TT 69, as there is no evidence of this ceiling decoration there. It is therefore impossible to clarify with certainty whether these images really come from the tomb of Menna or should rather be assigned to one or more other tombs of the same period. Their current joint presentation is thus a modern collage of fragments that are contemporaneous but did not necessarily originally belong together. MG

Selected Bibliography:
cat. Dresden 1977: 34 f. no. 19; cat. Leipzig 1989:
no. 13; cat. Dresden 1993: 9, 18 fig. (c only); Heinrich
2017; Heinrich 2020

Literature:
Hartwig 2013

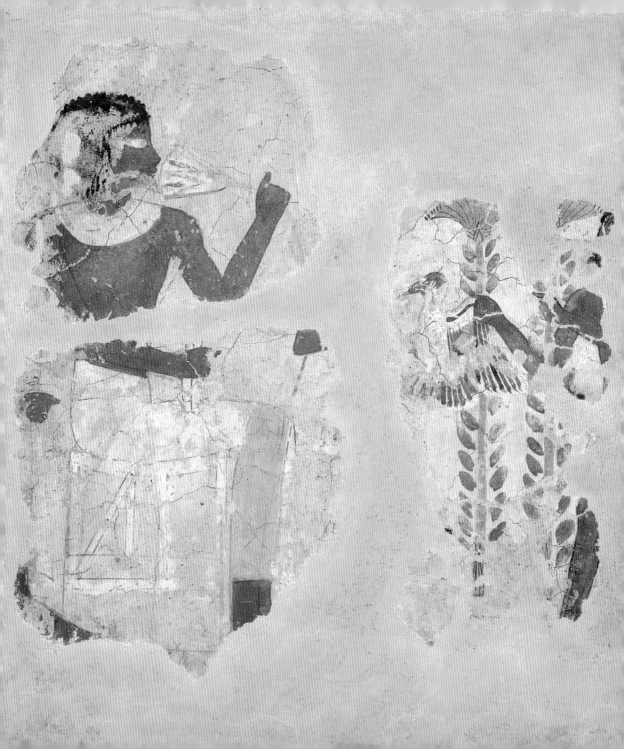

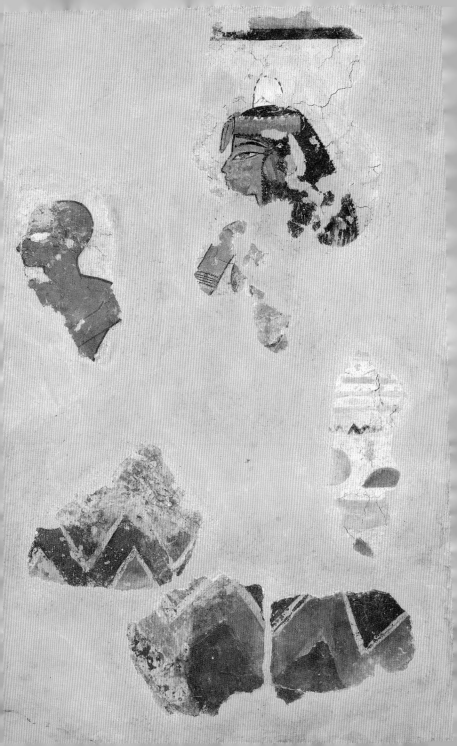

16 a 16 b

16

Funerary cones

(a) New Kingdom, Eighteenth Dynasty,
reign of Thutmose III, c. 1479–1425 BCE;
(b) New Kingdom, Eighteenth Dynasty,
reigns of Tutankhamun–Haremhab, c. 1334–1292 BCE

Clay, fired
(a) Diam. max. 7.2–7.4, L. 22.5 cm; (b) Diam. 4.6–7, L. 12.5 cm

(a) Findspot: probably Thebes. Purchased from Karl von Schlözer,
Dresden, in 1919;
(b) Findspot: reportedly Thebes. Donated by Steffen Wenig,
Berlin, in 1977

Skulpturensammlung, Inv. nos. (a) ZV 2807, (b) ZV 3963

The two cone-shaped objects are called funerary cones. They
were formed by hand from coarse clay and then fired. They
taper to a point at the back and have a round, or sometimes
square, often red-coloured face at the base. The decoration on
the viewing side was created using a matrix (stamp). Today,
only one matrix made of limestone survives; it comes from
Medinet Habu (Western Thebes). Matrices were probably also
made of other materials, such as wood or clay.

The first funerary cone (a) contains a four-line vertical
inscription. It reads: "Osiris, Iripat Hatia (a title of court rank),
Royal Seal-bearer, High Priest of Amun Men-kheper-re-seneb,
true of voice". Many funerary cones and other objects have
survived from Men-kheper-re-seneb. In the cemetery of Sheikh
Abd el-Qurna in Thebes, there are even two documented
tombs for him: TT 86 and TT 112. His funerary cones come
from tomb TT 86.

The second funerary cone (b) has a three-line horizontal
inscription. It reads "The honoured by Osiris, chief of the puri-
fication priests, Sobekmose, true of voice". The tomb of Sobek-
mose (TT 275) is located in Qurnet Murai (Western Thebes).

Ancient Egyptian funerary cones once decorated the outer
facades of tombs, especially in Western Thebes. There, large
numbers of them were inserted into the upper wall area, up to
four layers being placed on top of each other and with only
the round or square bases remaining visible on the outside.
Unfortunately, hardly any funerary cones have been found in
their original context; they were often discovered among
rubble in front of the tomb or scattered around the Theban

cemeteries. However, pictorial representations in Theban
tombs, such as in the tomb of Raya in Dra Abu el-Naga (TT
159) or in the tomb of Nebamun in el-Khokha (TT 181), show
entrances to tombs where several rows of funerary cones are
visible above the doors as round, red discs. Graves with funer-
ary cones can also be seen in the Books of the Dead written on
papyrus (cat. no. 29), e.g. on papyrus London British Museum
EA 10471, 7.

About 400 different types of funerary cones are known, but
only 80 of them can be assigned to tombs that still exist today.

In Egypt, the earliest known funerary cones, albeit without
inscriptions, date from the Eleventh Dynasty. The main period
of their use was during the New Kingdom. In that era, the title
and name of the tomb owner, and sometimes those of his wife
and other relatives, were inscribed on them. The inscriptions
could be arranged vertically or horizontally. In addition, the
funerary cones were also inscribed with short prayers to the
sun god Re or decorated with worship scenes in front of the
sun barque. Communion with the sun god is an important
theme in the outer areas of the tombs of this period.

After the New Kingdom, funerary cones no longer occur,
as hardly any decorated funerary superstructures were erected.
However, they experienced a "renaissance" in the Twenty-fifth
and Twenty-sixth Dynasties.

Owing to their unspectacular appearance, funerary cones
do not attract much attention on the part of today's museum
visitors. For Egyptologists, however, they are of enormous
value, as the names, titles, and relationship details in their
inscriptions expand our knowledge of the people, families,
administration, and funerary architecture of Thebes in the
New Kingdom and the Late Period. MG

Literature:
(a) Davies 1933; Davies/Macadam 1957: no. 100;
Dibley/Lipkin 2009: 56 no. 100, 209; Porter/Moss
1960: 175–178, 229 f.; Zenihiro 2009: 79 no. 100;
(b) Davies/Macadam 1957: no. 501; Dibley/Lipkin
2009: 22 Plate 3, 157 no. 501, 265; Porter/Moss 1960:
352; Zenihiro 2009: 187 no. 501

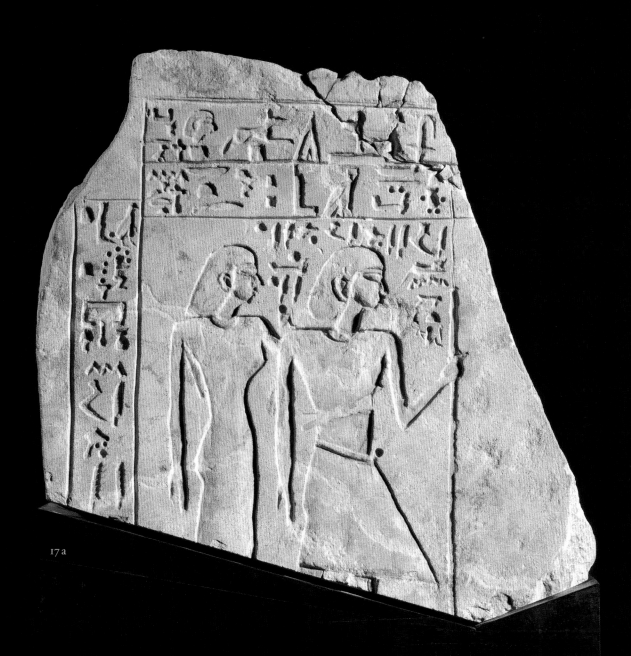

17a

17

Funerary stelae

(a) First Intermediate Period, c. 2118–1980 BCE;
(b) New Kingdom, Eighteenth Dynasty,
probably reign of Thutmose III, c. 1479–1425 BCE;
(c) New Kingdom, Nineteenth Dynasty, c. 1292–1191 BCE

Limestone
(a) H. 30, W. 31, D. 9 cm; (b) H. 48, W. 35, D. 8.5 cm;
(c) H. 53 cm, W. 24.5, D. 7.5 cm

(a) Findspot: reportedly Thebes, but probably Gebelein. Acquired
from the Kühnscherf collection, Dresden, in 1933;
(b, c) Purchased from the estate of Carl Gemming, Nuremberg, in 1881

Skulpturensammlung, Inv. nos. (a) Aeg 754, (b) Aeg 755, (c) Aeg 761

The objects known as funerary stelae are similar in form and function to our gravestones. In use from the First Dynasty onwards, they served as memorials to a deceased person at their grave, or also at another location.

Stela (a) dates from the First Intermediate Period, during which stone slabs – mostly rectangular in shape – were produced and set into the tomb wall. Depicted here are Sobeknakht and Khuyt, probably his wife, who were "provided for" in the realm of the dead. The man, dressed in a collar and kilt, holds a staff as a sign of distinction, while the woman with her arm around him wears a dress and a collar. The inscription requests offerings from Anubis, the god of the dead, who is depicted in the form of a canine (jackal or wolf) and is called the "Lord of the Cemetery", among other things. A rare practice in the writing of hieroglyphs can be observed in this text: some characters representing living creatures (in this case, horned vipers) have been mutilated to eliminate their negative influence. The form of the hieroglyphs suggests that the stela originates from Gebelein.

The second stela (b) is a work of high artistic quality that dates from the Eighteenth Dynasty and is also of historical interest. The top has the typical rounded shape and is decorated with the protective signs of the *shen* ring (a knot amulet) and *udjat* ("healing") eyes, as well as a water bowl as provision for the afterlife. In the upper register, Nebi, master builder under Pharaoh Thutmose III, and his wife It-res are seated on a bench in front of offerings made by his son Pu, "who makes his name live". Kneeling behind Pu are the women Neferet-iry

and …-hotep, who are probably relatives. In the lower register, we see the seated figures of Pu, master builder under Pharaoh Thutmose I, and "his wife, the lady of the house" Neferet-ii. The figure squatting at their feet is probably a daughter. In this scene, the son Nebnefer is depicted as the provider, followed by the daughters Meryt and Tarenenutet, as well as the latter's daughter Tjau-nyt-pet ("wind of heaven"). The inscription at the very bottom contains the so-called offering formula, which concerns provision for the chief sculptor Pu. For chronological reasons, Pu, son of the chief sculptor Nebi, and the chief sculptor Pu cannot be the same person. However, the placement on the same monument and the occurrence of the same names and titles would seem to indicate that they were related in some way.

The third stela (c) has a pyramid-shaped top, which only occurs in the New Kingdom. It shows the signs *udjat* and *shen* as well as a recumbent canine; according to the inscription, this is the god of the dead "Anubis, who is in the bandage". In the upper register, the god of the dead, Osiris, stands on the left, dressed in his typical costume: on his head he wears the high *atef* crown with two plumes, his body is completely wrapped in bandages, and in his hands he holds the royal sceptres, the crook and flail (cat. no. 7 a). In front of him are two stands, on which are an offering vessel and a lotus plant. The praying figures are the deceased, Ra-(mose?), and probably his wife. The lower register shows other people with offerings: a man, a boy, and a married woman, undoubtedly family members. The men are all bald and dressed in a long kilt; the women wear a wig topped by a perfume cone and a lotus plant, as well as a long, loose dress; the child is naked. The form of the bodies and the design of their clothing allows this object to be dated to the Late New Kingdom. ML

Selected Bibliography:
(a) cat. Dresden 1977: 33 f. no. 16, fig. 21; cat. Leipzig 1989: no. 11; Malek 2007: 49 no. 803-022-540;
(b) Ebers 1881: 66–67; Hettner 1881: 134 no. 34; cat. Dresden 1977: 34 no. 17; Malek 2012: 15 no. 803-045-060; cat. Dresden 2014: 172; (c) Hettner 1881: 135 no. 42; cat. Dresden 1977: 35 f. no. 24, fig. 42; cat. Leipzig 1989: no. 16, fig.; cat. Dresden 1993: 9; Malek 2012: 73 no. 803-048-790

Literature:
Hölzl 2001; Kammerzell 1986; Kubisch 2000

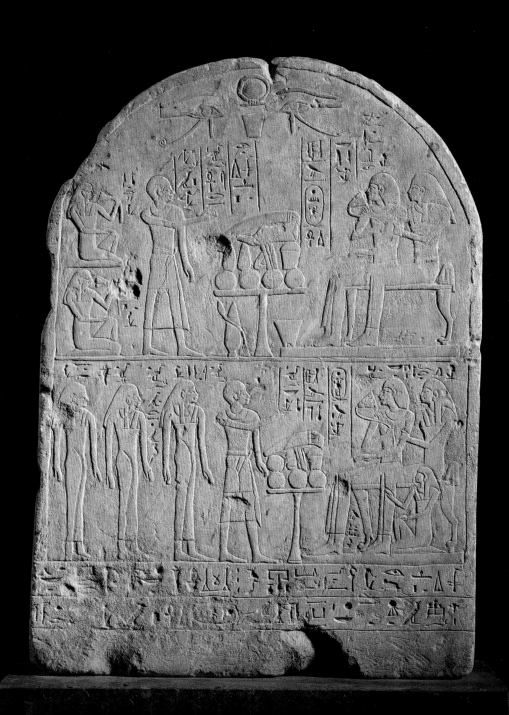

17b

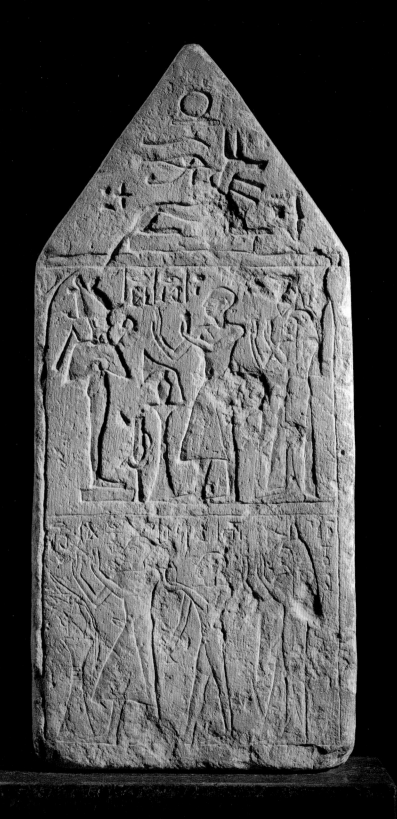

17c

Block statue

New Kingdom, Eighteenth Dynasty,
reign of Amenhotep III, c. 1390–1353 BCE

Silicified sandstone
H. 17.5, W. 18, D. 17 cm

Acquired before 1733, reportedly from the Kunstkammer

Skulpturensammlung, Inv. no. Aeg 759

Private statues, i.e. statues of non-royal persons, were understood as living bodies that were intended to represent their owner after his death. They could thus provide for his enduring existence, his cultic care, and also his participation in rituals and festivals. They were usually placed in a cult chamber or chapel of the tomb, or in a temple.

The private statue from Pharaonic Egypt that has been in the Dresden Skulpturensammlung for the longest time (cf. the contribution by the author in this volume) is probably also the most beautiful. This fragmentary object is made of a yellow-brown sandstone solidified by silicic acid, which in Egyptology is called quartzite. This material was not only associated with the sun because of its colour. The most important site where it was quarried, the hill Gebel Ahmar, was also located in the region of Heliopolis, the main centre of the cult of the sun god.

The figure consists of the head of a man with a short chin beard and a double wig. The upper, long, straight strands of hair partially cover the ears and the short locks of hair visible below the ears. The upper arms point straight forward, with the forearms folded. The right hand holds the stem of a lettuce plant, while the left is stretched out flat. The area visible at the front, below the arms, represents the legs wrapped in a robe. The person is depicted here seated, with the buttocks and soles of the feet touching the ground, the legs tucked in front of the torso and the arms embracing the knees. This type of statue is called a block statue, cube figure, or cuboid statue. In Ancient Egypt the posture shown here was typical of participants in festivals, for example. This fits in with the fact that block statues were usually erected as statues participating in rituals in the temple, where they were also supposed to benefit from the offerings to the god. It has been ascertained that such statues

only occur from the Middle Kingdom onwards and were only used for non-royal, almost always male, persons. Especially after the New Kingdom, block statues were very popular. They offered sufficient space for longer inscriptions even though the object itself was not very large.

The Dresden statue comes from the New Kingdom. The overall impression of a round, youthful face and especially the strong, high-sweeping eyebrows, the large, almond-shaped eyes with elevated make-up lines, as well as the full lips with ridged outline are typical of the reign of Pharaoh Amenhotep III. The stone used was also popular for statues of that period.

The bar on the back of the statue, the back pillar, does not bear an inscription. On the front, some hieroglyphs can be discerned in the central area, but they are difficult to read owing to their rough workmanship and subsequent damage, and because the text is incomplete. Presumably, it reads "Ka(-spirit) of the divine father, beloved of the god…". It undoubtedly appealed for the Ka-spirit of the statue's owner to be provided for. Since this priestly title was very common and no name is given, there is little prospect of learning more about the statue owner from other sources. In addition, it has been concluded from the form of the hieroglyphs that they were only added after the Eighteenth Dynasty, probably when the statue was reworked for a new owner. ML

Selected Bibliography:
Leplat 1733: Plate 189 no. 3; cat. Dresden 1977: 35 no. 21, fig. 35; Schulz 1992: 141 f. no. 62, 142 fig. 13, Plate 25; Malek 1999 b: 608 no. 801-643-272; cat. Berlin 2002: 25, fig. 80

Literature:
cat. Cleveland 1992

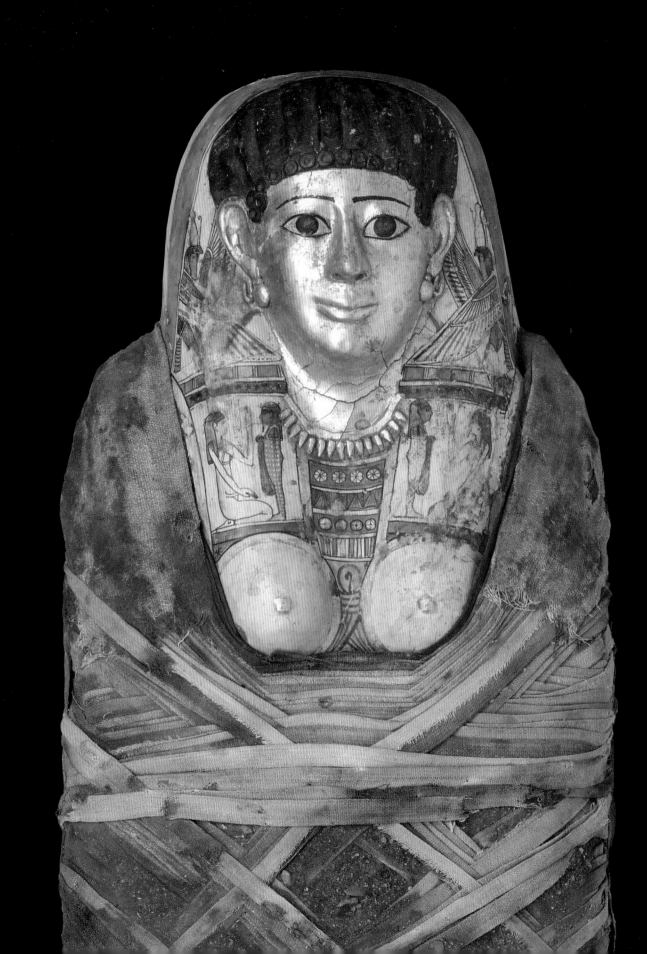

19

Mummy of a woman with funerary mask

Early Roman Period, c. 41–48 CE

Linen and plaster (cartonnage), painted and gilded, mummified corpse
H. 152, W. 38, D. 27.5 cm

Findspot: presumably Hawara, Fayum Oasis
Purchased from Ludwig von Löfftz, Munich, in 1912

Skulpturensammlung, Inv. no. Aeg 780

This female mummy comes from the Fayum Oasis, which was inhabited by many Greek-speaking settlers in Roman times. She wears an elaborately designed funerary mask made of cartonnage, which extends down to her chest. The hair is painted black and the face is gilded. Small, round, gilded earrings hang from the ears. The falcon on either side of the face is Horus, the Egyptian god of the sky and of kingship (cat. no. 11 d), who protects the deceased. The goddess Nekhbet, depicted as a vulture with outspread wings on the crown of the funerary mask, fulfils the same task.

Around her neck, the deceased wears a sculpted gilt necklace with hanging, droplet-shaped beads. Below that is a colourful collar consisting of rows of rosettes, upside-down lotus flowers, circles, and tubular beads. Standing to the right and left of the collar is the god of the dead, Osiris, with green skin and a beard. The large feather on his body symbolises Maat, the goddess of justice and truth. On each side of the mask, on the outside, is a female figure kneeling with one arm raised. These represent the mourning goddesses Isis and Nephthys, the wife of Osiris and her sister (cat. no. 7).

The mummy's breasts are three-dimensional. They are made of cartonnage, and the nipples are gilded. Between them is a painted textile knot. This probably imitates the knot of cloth that was associated with Egyptian queens and the goddess Isis from the Greek Period onwards. Its shape is similar to the Egyptian knot amulet known as *sa*, i.e. "protection".

The linen wrapping is severely damaged and encrusted with dirt. The bandages are arranged in the geometric (coffered) pattern typical of mummies from this period. The feet are covered by a mummy foot case made of cartonnage. The feet are depicted wearing sandals and with golden toenails. The badly damaged underside bears the familiar motif of two strangers bound and facing each other (fig. 3). This originally royal motif represents the power of the deceased to subdue and disarm his enemies in the realm of the dead. MG

Inside the wrappings, the anatomically intact mummy lies with arms and legs stretched out, the hands resting flat on the thighs. The chin is positioned centrally on the chest, the feet are angled at about 90° (figs. 6 a–b). The lower central incisors were lost after death (fig. 4), postmortem bone fractures have been found almost only in the ribs and pelvis. The muscles, tendons, ligaments and organs are well preserved.

A perforation in the area of the ethmoid bone and sphenoid bone indicates that the brain was removed through the nose; the nasal passages are plugged with tamponades (fig. 5). The identified dried remnants of the heart, lungs, liver, and other organs show that no organs were removed (fig. 1). The many tightly packed layers of textiles are wrapped closely around the body. The careful preparation of the corpse, its elaborate bandaging and decoration with a partly gilded funerary mask suggest that the deceased came from a financially well-off background.

The deceased's dental status and tooth wear, as well as other features on the skeleton, and the absence of wear marks on the joints and vertebrae, suggest an age of 25 to 30 years. The woman was about 156 to 161 cm tall. Specific changes in the pelvic bones possibly indicate that she had given birth (fig. 2). SZ · SP · AZ · WR

Selected Bibliography:
cat. Dresden 1914: 246 no. 25; Parlasca 1966: 109 with note 116, Plate 6, 3; Grimm 1974: 35, 49, 117, Plate 11.3; cat. Dresden 1977: 39 no. 41, fig. 82; cat. Leipzig 1989: no. 227 with fig.; cat. Berlin 2002: 23, fig. 76

Literature:
Müller 2017

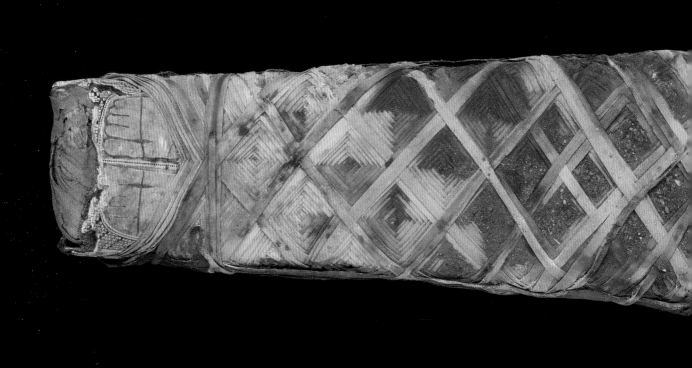

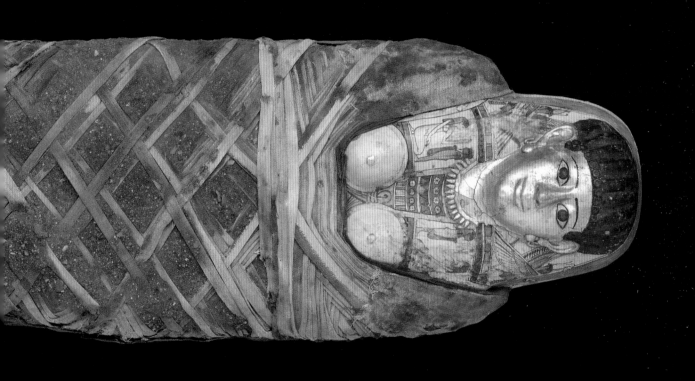

Fig. 1 Multi-planar CT-reconstruction in a coronal view of the upper body of the female mummy with funerary mask, radiopaque remnants of the liver visible in the right half of the abdomen

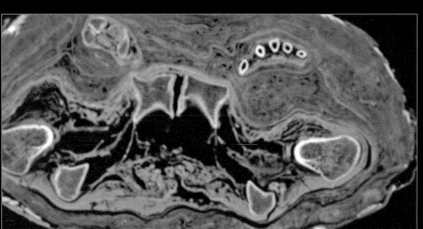

Fig. 2 Multi-planar CT-reconstruction in an axial view of the pelvis of the female mummy with funerary mask, changes in the pelvic bones possibly indicate that she had given birth

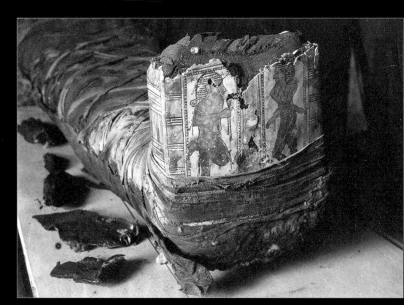

Fig. 3 Mummy foot case on female mummy with

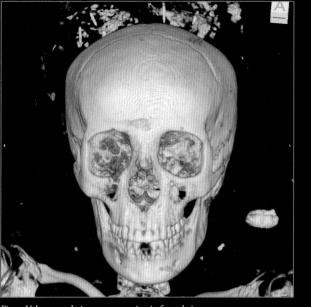

Fig. 4 Volume rendering reconstruction in frontal view
of the skull of the female mummy with funerary mask,
lower central incisors lost after death

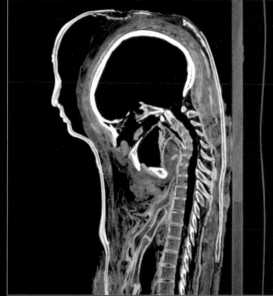

Fig. 5 Multi-planar CT-reconstruction in a sagittal view of the upper
body of the female mummy with funerary mask, the brain was removed
through the nose as a result of perforating the ethmoid and sphenoid
bone, the nasal passages are plugged with tamponades

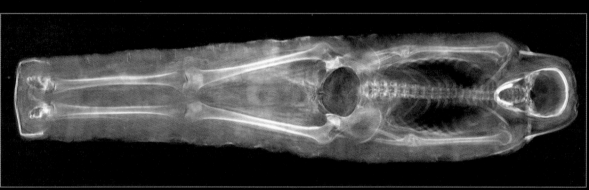

Fig. 6a Multi-planar CT-reconstruction in coronal view of the entire body of the female
mummy with funerary mask, hands resting flat on thighs

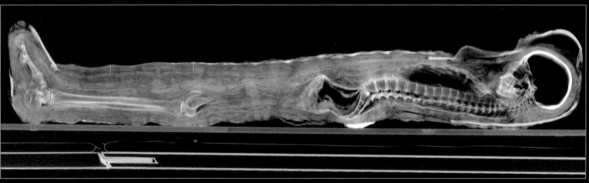

Fig. 6b Multi-planar CT-reconstruction in sagittal view of the entire body of the female
mummy with funerary mask, showing shriveled remains of viscera in the pelvis

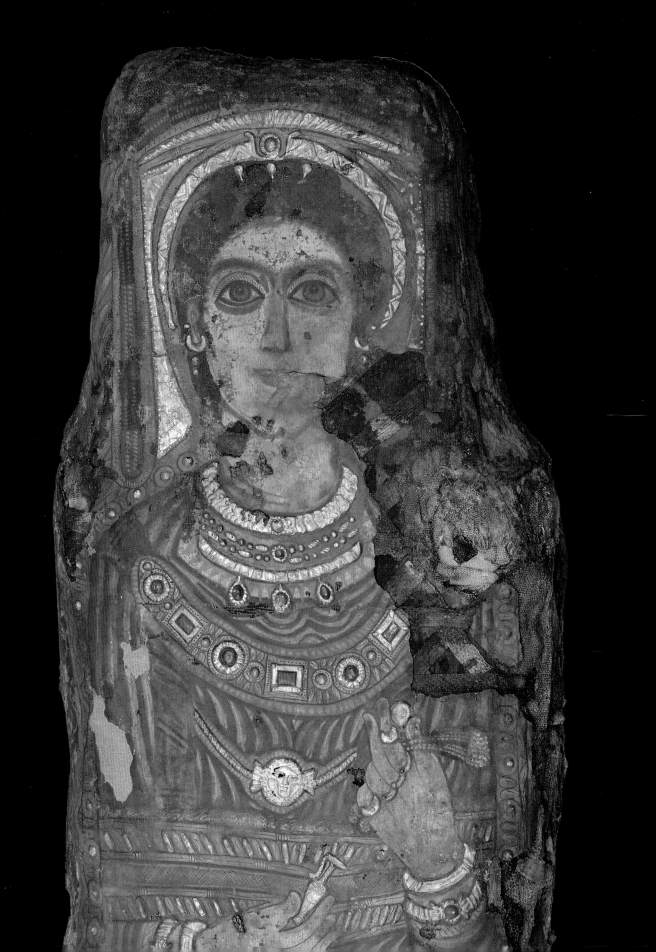

Mummies of a man and a woman, each with mummy portrait and shroud

Late Roman Period, late third to
mid-fourth cent. CE

Linen, stucco, painted and gilded, mummified corpse
(a) H. 175, W. 40, D. 29.5 cm; (b) H. 164, W. 37.5, D. 29 cm

Findspot: Saqqara, unearthed by Pietro della Valle in 1615
Purchased from the estate of Filippo Antonio Gualtieri,
Rome, in 1728

Skulpturensammlung, Inv. nos. (a) Aeg 777, (b) Aeg 778

These two famous mummies bearing the portrait of a man and
a woman date from the late Roman Period. They were brought
back from Saqqara in 1615 by the Italian explorer Pietro della
Valle and were thus probably the first traceable Ancient Egyp-
tian mummies to have been brought to Europe still existing.
While the linen bandages and the elaborately decorated and
gold-leafed shroud of the man are very well preserved, the
shroud of the female mummy is badly damaged.

The top half of each mummy is decorated with a shroud
depicting the deceased dressed like a living person. They each
wear a golden diadem on their head as well as a chiton, the
Greek tunic with textile bands called clavi. Attached to each
side of the woman's clavi is a broad decorative band with large
blue and red stones set in gold mounts. Below that is a head
of Medusa, which functions here as a magical symbol of pro-
tection. Likewise, the man's chest is protected by the Egyptian
vulture goddess Nekhbet.

In their right hands, the deceased each carry a Greek vessel
for liquid offerings: the man holds a kantharos containing
wine, and the woman a single-handled lekythos for oil. In their
left hands, they presumably hold the "wreath of vindication",
a wreath awarded to the deceased to indicate their having
passed the test in which the dead were judged, allowing them
to pass into the afterlife. While the man wears finger rings, the
woman is adorned with elaborate, colourful neck and breast
jewellery, as well as bracelets, ankle bands, and finger rings.

The Greek inscription under the man's right arm reads
ΕΥΨΥΧΙ (Eupsychi), i.e. "Farewell!"

On the lower section of each mummy, the deceased's gar-
ment is covered all over by a painted bead-net (cat. no. 24). The
pictorial elements in it have a mythological and decorative
character and can be traced back to Ancient Egyptian as well
as Graeco-Roman traditions.

An interesting feature is a small, metal seal on the left side
of the male mummy, which bears the sign of the mummifica-
tion workshop. Such seals can also be made of unfired Nile silt
clay and wax. MG

The skull and lower extremities of these two supine mummies
are well preserved, but many bones of the trunk skeleton and
the arms were anatomically displaced after death (figs. 3 a–b).
Numerous bones were broken post-mortem, probably in the
course of excavation or transportation, in the case of the male
mummy presumably also after the opening of the textile
wrapping in Egypt. Of the organs of the two mummies, only
a very few remnants have been preserved. The poor state of
preservation of the bodies means that it is impossible to make
reliable statements about the exact technique of artificial
mummification. Radiological evidence of brain removal via
the nose was not found. The materials in the skulls showing
different degrees of radiopacity are bone fragments and, pre-
sumably, sediment accumulations. In the upper part of the
man's body, a mixture of bones, sediments, and probably
plant remains was found (fig. 1). It is assumed – albeit tenta-
tively in view of the poor state of preservation – that moisture
was extracted from the bodies using natron, as was customary
in Ancient Egypt. The brain and organs were probably not
removed, which is also indicated by comparative analysis with
a third mummy of the same type from Saqqara. There is no
evidence of the use of radiopaque resinous embalming sub-
stances.

The two metal-dense foreign bodies inside the male
mummy have been radiologically identified as seals of the
embalmers from the mummification workshop. Presumably,
they were originally attached to the outer textile layer and
probably shifted into the mummy's interior when the textile
cover was opened in Egypt following its discovery. The two
metal-dense objects near the right thigh of the female mummy

are coins or medallions that were most likely laid in the hands of the deceased as grave goods and were later slightly displaced. In the woman's torso, there are also numerous circular, perforated objects of organic material, about one centimetre in size; they are presumably beads from a necklace (fig. 2). Each of the mummies was placed on a board before being wrapped in textile bandages. The mummy board of the man is now broken in several places (fig. 4 a–b).

The dental status and other features on the skeletons suggest that the man was 25 to 30 and the woman 30 to 40 years old. The man was about 163 centimetres and the woman about 150 centimetres tall. In the case of the man, two maloccluded canines had not erupted into the oral cavity (fig. 5). Several teeth had caries, and one molar even had a root abscess. The woman's left knee joint was probably affected by pronounced arthritis (fig. 6). The left half of the pelvis is higher than the right, possibly as a result of adopting a relieving posture to reduce pain in the arthritic knee joint. SZ · SP · AZ · WR

Selected Bibliography:
Della Valle 1674: 104–108; Leplat 1733: Plate 197; cat. Dresden 1977: 39 no. 39 and 40, fig. 95 and 96; Cantone 2013: 109, 117 fig. 2 (relating to inv. no. Aeg 777); cat. Dresden 2020a: 97–99 with fig.; Müller 2020; Zesch et al. 2020

Literature:
Bierbrier 1997; Borg 1998; cat. Frankfurt 1999; Corcoran 1995; Doxiadis 1995

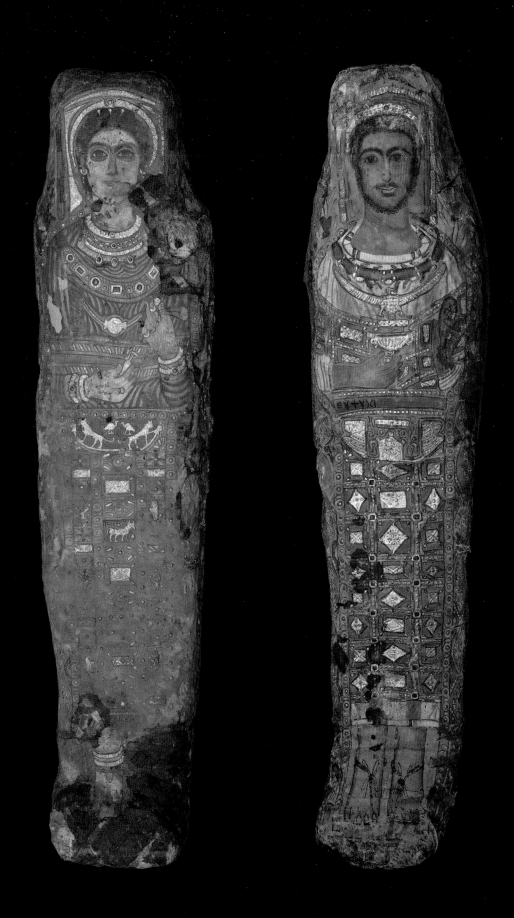

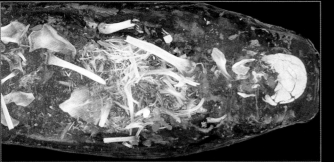

Fig. 1 Multi-planar CT-reconstruction in a coronal view of the upper body of the male mummy, the severely damaged upper body shows the second seal of the embalmers which shifted from the outside inwards

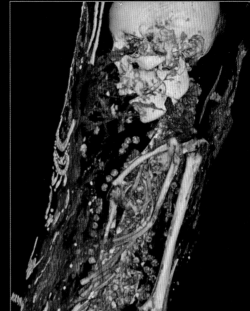

Fig. 2 Volume rendering reconstruction of a side view of the upper body of the female mummy, the numerous circular objects of organic material are probably beads of a necklace

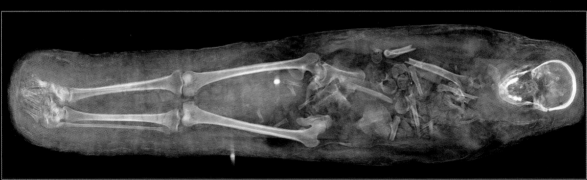

Fig. 3a Multi-planar CT-reconstruction in coronal view of the entire body of the male mummy, the two metal-dense objects are a seal of the embalmers from the mummification workshop which is attached to the outermost layer of the textile wrapping, as well as the second seal which has shifted into the inside of the mummy

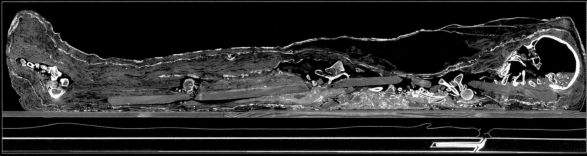

Fig. 4a Multi-planar CT-reconstruction in sagittal view of the entire body of the male mummy, parts of a broken mummy board are visible under the heavily skeletal body

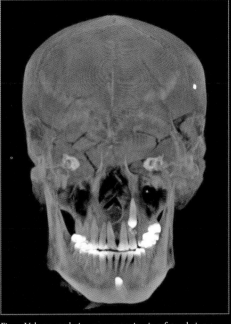

Fig. 5 Volume rendering reconstruction in a frontal view
of the skull of the male mummy, two canines did
not penetrate into the oral cavity during his lifetime

Fig. 6 Multi-planar CT-reconstruction in sagittal view of
the knees of the female mummy, paleoradiological changes
in left knee joint suggest extensive arthritis

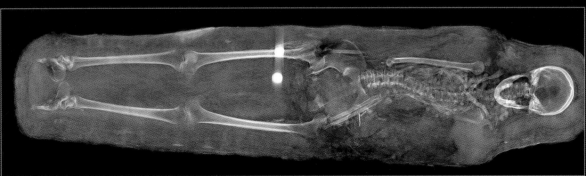

Fig. 3b Mulit-planar CT-reconstruction of the coronal view of the entire body of the female
mummy, the two metal-dense objects close to the right femur are coins or medallions

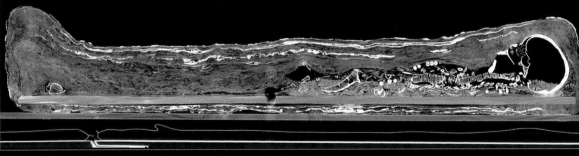

Fig. 4b Multi-planar CT-reconstruction in a sagittal view of the entire body of the female mummy,
with an intact mummy board lying underneath the severely flattened body

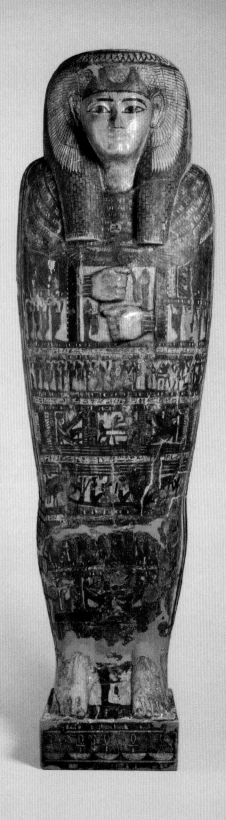 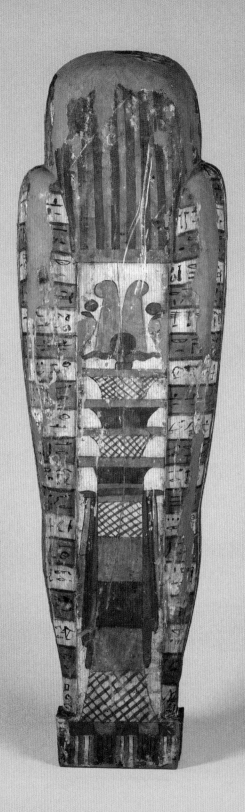

Coffin of Djed-mut-ju-ankh

Late Period, early Twenty-sixth Dynasty,
c. 660–600 BCE

Wood, clay, asphalt, plaster/chalk ground, linen, painted
H. 175, W. 54, D. 44 cm

Findspot: probably Thebes
Purchased from the estate of Carl Gemming, Nuremberg, in 1881

Skulpturensammlung, Inv. no. Aeg 782

The coffin of Djed-mut-ju-ankh depicts its owner as a deified deceased woman and bears images and texts intended to ensure her continued existence in the afterlife.

As a result of restoration work performed on this coffin, a good deal is known about how it was manufactured. It is made of numerous wooden boards joined together with glue, pegs, and dowels. The face, hands, and feet were worked separately. On top of this is a primer of pink clay. This is followed by linen and a layer of plaster and chalk. The colours consist of chalk (white), ochre (yellow, red), azurite (green), Egyptian blue, and carbon (black).

The face on the coffin lid is rendered three-dimensionally and painted yellow, as is usual for women. The divine wig on the head is partly covered by wings, probably a vulture crown. Above the floral wreath is a solar disc with cobras.

The chest and shoulders are adorned with a multi-stranded collar. Beneath this is a depiction of Nut, the sky goddess and mother of the gods, squatting with her wings protectively outstretched. Her name is written in the solar disc on her head. At the level of the hands, standing mummiform deities can be seen, probably the Four Children of the sky god Horus, the protectors of the organs (cat. no. 26).

In the next register, which is separated by lines of inscriptions and ornamental borders, the deceased is being led to an offering table by the ibis-headed god Thoth, patron of scribes, on the right; behind her, we see the scales referring to the Judgement of the Dead (cat. nos. 23 c, d, 29). The series of gods opposite is no longer clearly discernible: the mummiform sun god Re-Horakhty is followed by Osiris, the god of the dead; behind him is probably his wife Isis and her sister Nephthys. The subsequent mummiform figures may represent the 42 Judges of the Dead and the Children of Horus.

In the next register, the mummy on the bier at the centre is being tended by Anubis, the god of the dead, flanked by the sun god in the form of a falcon. In a boat underneath are the squatting figures of four deities – a sun god, Isis, and Nephthys are recognisable. On the left and right are screeching baboons.

In the next two registers, squatting and standing deities can be seen at the sides: outside are presumably the Children of Horus, while Horus and Thoth are depicted in the middle, with the winged figures of Isis and Nephthys below them. In the central axis was a sacred symbol, probably the emblem known as the Fetish of Abydos.

Between the feet is a depiction of a goddess, and the base section is decorated with a series of hieroglyphs standing for "all life (and) all dominion" (cat. no. 23 a). Under the foot is a painted depiction of the sun on the horizon. The outside of the bottom section of the coffin is decorated with a centrally positioned *djed* pillar, a symbol of the god Osiris (cat. nos. 7 b, 25, 34 a). To the side of this is what is known as an offering formula, beseeching the gods to provide for the owner of the coffin.

The inscriptions on the bottom section and the lid are executed in a cursory manner and are partly damaged. They contain offering formulas or the names of deities. They reveal the following information about the owner of the coffin: lady of the house, head (?) of the singers and sistrum players (cat. no. 9 a) of Amun Djed-mut-ju-[es-]ankh ("Mut says: [she] lives"), daughter of the head of the doorkeepers of Amun Paef-ju ("his dog") and of Shep-en-aset ("Gift of Isis").

The mummy of the coffin's owner has been preserved, but it was already unwrapped in 1881 and then wrapped up again. Whether any objects came to light at that time is not documented.

ML

Selected Bibliography:
Lösch 1837: 6; cat. Dresden 1881: 130 no. 3;
Wetzig 2017: 12–14; cat. Dresden 2018: 72;
Gander/Loth 2019: 50 f.

Literature:
Taylor 2003

22 b

Funerary masks

Roman Period, (a) c. 70–81 CE;
(b) c. 49–68 CE; (c) c. 80–100 CE;
(d) first–second century CE;
(e) c. 117–128 CE; (f) c. 70–83 CE;
(g) c. 166 CE; (h) c. 170–200 CE;
(i) c. 150–220 CE; (j) c. 160–185 CE

(a–c, h) Stucco, painted and gilded; (d, g) Stucco, painted,
glass inlays; (e, f) Stucco, painted; (i, j) Stucco, painted, glass

(a) H. 26, W. 19.5, D. 18 cm; (b) H. 23, W. 21, D. 12 cm;
(c) H. 29.5, W. 20.2, D. 12.5 cm; (d) H. 22, W. 15.5, D. 10.5 cm;
(e) H. 23, W. 19, D. 12 cm; (f) H. 27, W. 18.5, D. 15 cm;
(g) H. 26, W. 17.5, D. 18 cm; (h) H. 22.5, W. 14, D. 17.5 cm;
(i) H. 22, W. 16, D. 15.5 cm; (j) H. 35.5, W. 25.5, L. 55 cm

(a–i) Findspot: presumably Tuna el-Gebel
Purchased in Cairo in 1896;
(j) Findspot: presumably Tuna el-Gebel
Purchased from Carl Schmidt, Leipzig in 1897

Skulpturensammlung, Inv. nos. (a) Aeg 791, (b) Aeg 792,
(c) Aeg 793, (d) Aeg 794, (e) Aeg 795, (f) Aeg 797, (g) Aeg 798,
(h) Aeg 799, (i) Aeg 800, (j) Aeg 790

22 a

In addition to a Ptolemaic cartonnage mask, the Dresden Skulpturensammlung holds a total of eleven Roman Period funerary masks made of stucco. They depict men and women whose names are unfortunately unknown.

The stucco masks are well preserved, but the colouring of the faces and hairstyles is already faded and abraded. The eyes may be made of a different material, such as limestone or white opaque glass, with the inlaid pupil being made of black, or rarely blue, opaque glass. Occasionally, small slivers of thin glass are found over the pupils. A special feature was the production of copper eyelids and eyelashes. Eyes with pupils and eyelashes could also simply be painted black.

The dark hair was made separately and probably corresponds in style to the contemporary fashion of the Roman imperial family. Women's hair is often parted in the middle, crimped (g), waved (d, e) or laid into small curls (b), with the ears often left free. Long, tubular corkscrew ringlets may also hang down over the cheeks and neck (a), or the hair may be gathered at the nape and pinned into a chignon (b, g). On top of the coiffed hair is often the wreath of the dead, also known as the "wreath of vindication" (cat. no. 20). This was usually made of rose petals and is thought to symbolise the deceased having been judged worthy in the Judgment of the Dead, the precondition for admission into the afterlife. In later depictions, this wreath is also carried in the deceased's hand. Male hairstyles were of simpler design, with moulded or sculpted curls. Here, the beard provides a criterion for dating the mask. In Hadrianic times (early second century CE), for example, such masks often feature a full beard.

The section of the mask at the back of the head is, unfortunately, often broken away. This area was sometimes decorated with various Egyptian protective deities, such as the goddess Nekhbet, depicted as a vulture (a).

The heads would certainly have been accompanied by a chest section with hands moulded in relief, and together these formed a breastplate mask (j). This was then placed over the head and chest of the mummy. The head of the mask was set in a slightly raised position. This is associated with the trans-

formation of the deceased into an "Osiris" (cat. no. 7) and his or her "resurrection" and rejuvenation in the afterlife. Therefore, the funerary masks show an idealised face, described by the Ancient Egyptians as "beautiful/perfect in face".

Funerary masks made of plaster, which were fitted over the bandaged, mummified head and attached to the mummy, have been documented from the late Old Kingdom onwards. The funerary masks of the Roman Period are often made of stucco and in many cases were produced using moulds. The facial features and the individual parts of the face were subsequently refined and painted. Often the faces were also gilded (c). Gold is the flesh of the gods, and it was intended that the deceased should become a god, Osiris, after death.

Judging by their elaborate production and high quality, the Dresden masks were probably commissioned by members of a local elite. Their origin is often unclear, but the masks may have come from Tuna el-Gebel in Middle Egypt. MG

Selected Bibliography:
(a) Treu 1898: 48 no. 10 with fig.; Grimm 1974: 78, Plate 72,2; cat. Dresden 1977: 40 no. 49; cat. Dresden 1993: 9; (b) Treu 1898: 58 no. 11 with fig.; Grimm 1974: 78 with note 167, 120; cat. Dresden 1977: 40 f. no. 50, fig. 87; cat. Berlin 2002: 23, 30, fig. 54; cat. Dresden 2020 a: 80 f. with fig.; (c) Treu 1898: 55 no. 5 with fig.; Grimm 1974: 81 Plate 45,3; cat. Dresden 1977: 41 no. 55, fig. 88; cat. Berlin 2002: 23, 30, fig. 57; (d) Treu 1898: 57 no. 7 with fig.; Grimm 1974: 81 note 198; cat. Dresden 1977: 41 no. 56, fig. 89; (e) Treu 1898: 57 no. 6 with fig.; Grimm 1974: 81 note 196; cat. Dresden 1977: 41 no. 57, fig. 81; cat. Berlin 2002: 23, 30, fig. 56; (f) Treu 1898: 59 no. 12 with fig.; Grimm 1974: 83 note 216; cat. Dresden 1977: 41 no. 51; cat. Leipzig 1989: no. 232 with fig.; (g) Treu 1898: 59 no. 13 with fig.; cat. Dresden 1977: 41 no. 52; cat. Berlin 2002: 23, 30, fig. 52; (h) Treu 1898: 59 no. 15 with fig.; cat. Dresden 1977: 41 no. 53; (i) Treu 1898: 59 no. 14 with fig.; Grimm 1974: 85, Plate 89,3; cat. Dresden 1977: 41 no. 54, fig. 86; (j) Grimm 1974: 30, 86, Plate 51,4; cat. Dresden 1977: 40 no. 48, fig. 91–93; cat. Dresden 1993: 9, 42 with fig.; cat. Dresden 1998: 11, 28 no. 157 with fig.

Literature:
cat. Paris 2004 a; Müller 2021

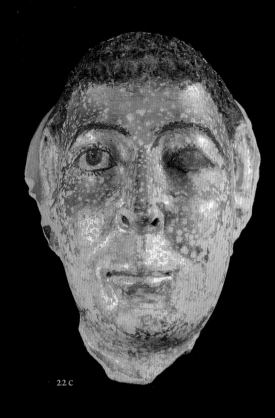

22 c

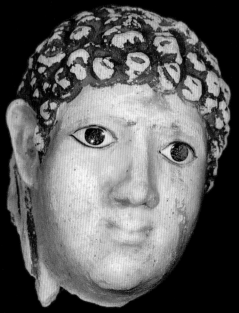

22 d

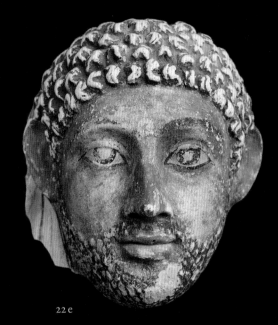

22 e

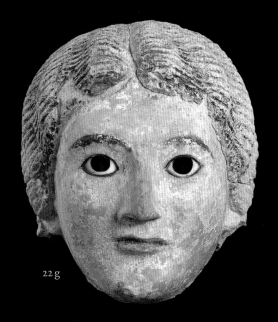

22 g

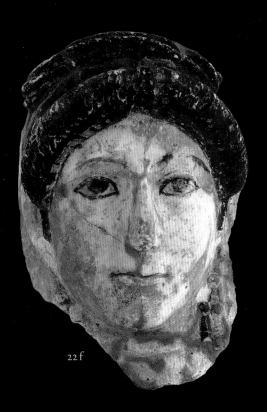

22 f

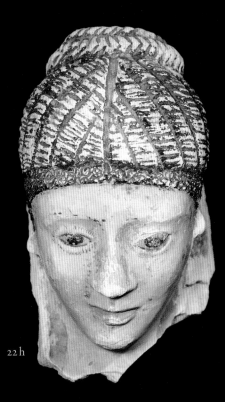

22 h

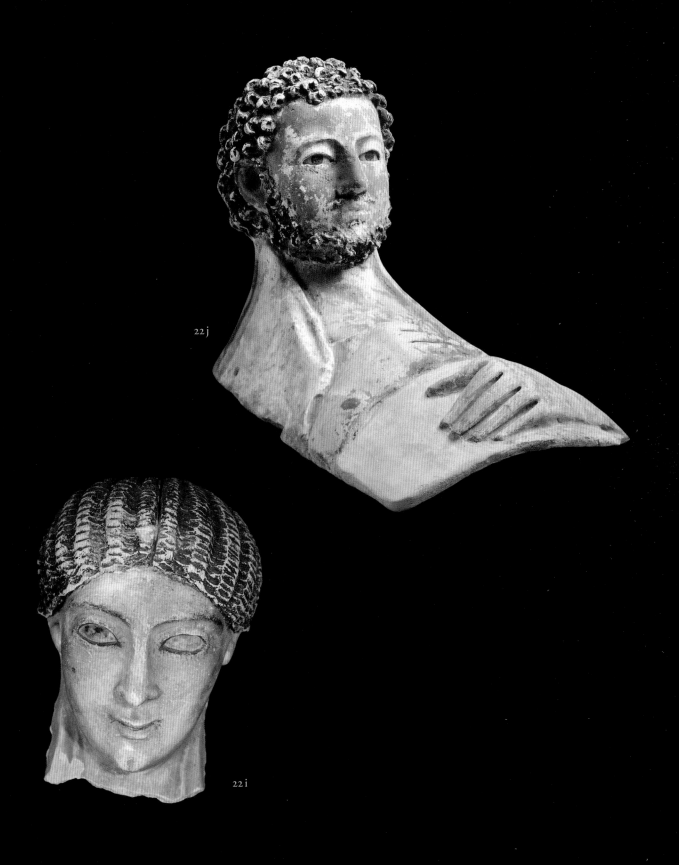

22 j

22 i

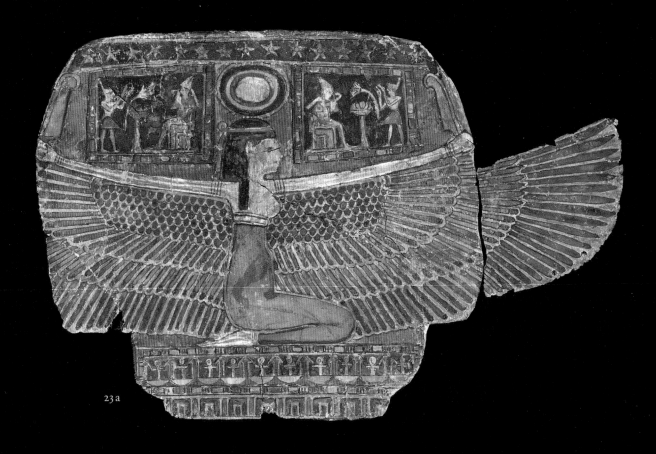

23 a

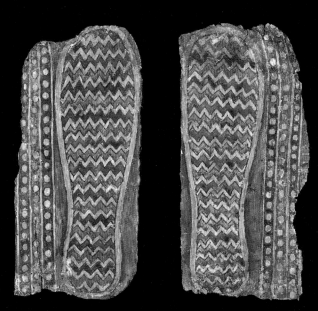

23 b

Fragments of mummy trappings made of cartonnage

Ptolemaic Period, 332–30 BCE

Linen and plaster (cartonnage), painted
(a) H. 20.7, W. 34.4, D. 0.3 cm; (b) H. 24, W. 11.5 cm and H. 23.7, W. 11.7 cm;
(c) H. 14.1, W. 19.2 cm; (d) H. 12.3, W. 15.4 cm; (e) H. 11.1, W. 13.5 cm;
(f) H. 9.3, W. 7.4 cm; (g) H. 14.1, W. 17.3 cm; (h) H. 20.9, W.14.1 cm

(a, b) Purchased from the estate of Carl Gemming, Nuremberg, in 1881;
(c–h) perhaps likewise

Skulpturensammlung, Inv. nos. (a) Aeg 788(a–b), (b) Aeg 789(1–2),
(c) H4 146/218a, (d) H4 146/218b, (e) H4 146/218e, (f) H4 146/218f,
(g) H4 146/218c, (h) H4 146/218d

Cartonnage is the name given to an Ancient Egyptian material made of plastered linen (in the Roman Period also papyrus). It was often used for funerary masks, and at certain times also for cartonnage coffins. The Dresden cartonnage fragments date from the Ptolemaic Period, when several separate pieces of cartonnage were often attached to mummies.

The largest object (a) would certainly have been positioned on the upper part of the mummy's body, for it shows the squatting sky goddess Nut protecting the deceased with her outstretched wings (cat. 21). Her skin is golden, and in her hands she holds the feathers of Maat, representing truth and justice. Above Nut, two scenes appear as mirror images. In each, a Pharaoh wearing the Red Crown is depicted venerating Osiris, the god of the dead. Between them is an altar with offerings and a lotus plant. The upper end of the scene is formed by a row of stars symbolising the sky. Below the goddess are some ornamented bands. One consists of *ankh* signs and *was* sceptres over baskets, which can be read as "all life (and) all dominion" (cat. no. 21).

The colouring and acquisition history of the two fragments of cartonnage depicting shoes (b) indicate that they probably belonged to the same mummy. They would certainly have been located in the foot section.

Objects (e) and (f) may also belong to the same mummy. The former bears an image of the scarab, or dung beetle, with falcon wings and a falcon's head with the sun disc on top. This is unmistakably the solar deity Khepri (cat. no. 24 b–d). This image would have been positioned on the head or chest of the mummy.

Fragment (f) has two scenes preserved in full. At the top, gods are shown standing in a temple: on the left, with a canine head, is Anubis, the god of the dead, or Duamutef, the protector of the mummy's stomach (cat. no. 26); the one on the right is probably Isis, the wife of Osiris. Between them is the *djed* pillar (cat. nos. 7 b, 25, 34 a) with the *atef* crown, undoubtedly representing Osiris. Below, two Nile gods are knotting together the heraldic plants of Upper and Lower Egypt with the hieroglyph "unification" (cat. no. 25 ba). This royal scene of the "Unification of the Two Lands" could here refer to Osiris, who – according to Egyptian mythology – was the ruler of the underworld and had been Pharaoh in Egypt before his death.

The paints used in the other cartonnage fragments (c, d) prove that they originate from a different mummy. They show scenes from the Judgment of the Dead (cat. nos. 21, 29). On the top of object (c) is the partially preserved row of squatting Judges of the Dead. Below this, on the left, appears the "Devourer", who punishes the dead who have not been granted vindication. Her body consists of a crocodile's head, the front part of a lion and the rear part of a hippopotamus. In front of her, Thoth, the ibis-headed god of science, is recording the minutes of the trial. On a lotus blossom stand the Four Children of the god Horus, the protectors of the organs (cat. no. 26). On the second fragment (d), the remains of a pair of scales are still visible on the left. They are used for weighing the heart of the deceased against the feather of Maat, the goddess of truth and justice. This is followed by Maat herself – with a feather on her head – leading the dead person to the judgment. The dead woman has a perfume cone and a lotus plant on her head. The second divine attendant cannot be identified with certainty; it is probably Hathor.

Fragments (g) and (h) presumably derive from a different cartonnage mummy-case. They depict mummiform deities, probably the Children of Horus. Fragment (h) also depicts a number of seated Judges of the Dead, along with the canid god Anubis on a shrine. ML

Selected Bibliography:
(a) Hettner 1881: 146 no. 216; cat. Dresden 1889: 263; cat. Dresden 1977: 40 no. 47; cat. Leipzig 1989: no. 237; cat. Dresden 2018: 60 fig., 73; (b) Hettner 1881: 146 no. 217; cat. Dresden 1889: 263; cat. Dresden 1977: 40 no. 47; cat. Leipzig 1989: no. 237; (c–h) Hettner 1881: 146 no. 218 (?); cat. Dresden 1889: 263

Literature:
Ikram/Dodson 1998: 166–192

23 e

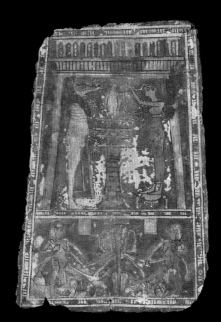

23 f

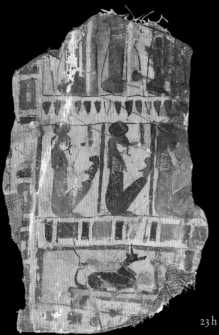

23 h

23 c

23 d

23 g

24 a

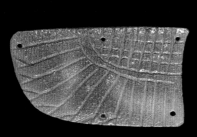

24 d

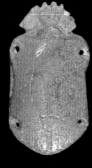

24 b

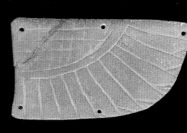

24 c

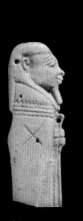

24 e

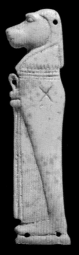

24 f

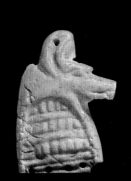

24 g

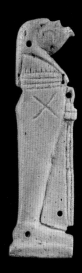

24 h

Mummy bead-net with amulets

Late Period – Ptolemaic Period (?), 664–30 BCE

(a) Faience and glass; (b–h) Faience
(a) H. 68.5, W. 12.5, D. 0.4 cm, Beads: L. 11.8, Diam. 0.3 cm;
(b) H. 5, W. 2.7, D. 0.8 cm; (c) H. 7, W. 3.8, D. 0.6 cm;
(d) H. 7, W. 3.9, D. 0.5 cm; (e) H. 5.6, W. 2.1, D. 0.7 cm;
(f) H. 8.7, W. 2.3, D. 0.7 cm; (g) H. 4.2, W. 3.3, D. 0.8 cm;
(h) H. 8.6, W. 2.5, D. 2.5 cm

(a) Purchased from Berta von Becker-Wickerhauser in 1891;
(b–d) purchased from Alessandro Ricci, Florence, in 1831

Skulpturensammlung, Inv. nos. (a) Aeg 726, (b) Aeg 39, (c) Aeg 239(a),
(d) Aeg 239(b), (e) Aeg 613, (f) Aeg 619, (g) Aeg 621, (h) Aeg 626

Huge numbers of small, three-dimensional images – often with fastenings – have been found on mummies. Because of the protective, or otherwise positive, effect attributed to them, they are known as amulets. Their wealth of shapes, colours, and materials is matched by a multitude of meanings and functions, some of which can also be deduced from textual sources.

Mummy amulets are generally not visible, but are wrapped inside the mummy's linen bandages, sometimes sewn tightly or mounted on strings. The valuable materials of the amulets led to many mummies being unwrapped and destroyed in search of these objects.

A larger number of amulets were sometimes arranged in several layers in the linen wrapping. From the Twenty-second Dynasty until the end of the Ptolemaic Period, a bead-net with certain amulets was used on mummies as the outer amulet layer. The mummy nets (a) mostly consist of tubular beads of blue faience arranged in a diamond shape, with yellow or white faience beads as connecting elements. In the Roman Period, the net was often painted on the coffin, funerary mask, or shroud (cat. no. 20).

The Ancient Egyptian symbolism of the net is complex. As a tool for catching, holding, and warding off, it can be used by both dangerous and good powers. At the same time, knotting, linking, tying, and binding are typical images used in magical practices, both in Egypt and in other cultures.

The amulets belonging to the bead-net are easily identifiable even without any information about the find context. They are mostly flat, made of faience, and provided with holes

that allowed them to be attached to the net and the mummy, or they were made of beads. Only a few forms occur.

Among the most important was the sacred dung beetle, the scarab (b). It was a symbol of the morning sun and of resurrection. Being placed on the chest, it occupied the position of the heart scarab, but it is not made of green stone (serpentinite) with a precious metal setting like the latter, nor does it have the typical inscription from Chapter 30 of the Book of the Dead (cat. no. 25). In addition, the scarab in the mummy bead-net has falcon wings (c, d), so it can move freely in the sky.

Below the scarab, the Four Children of the sky god Horus, the grandsons of the god of the dead Osiris, are often found (e–h). These mummiform figures with human and animal heads were intended to protect the body and especially the internal organs (cat. no. 26).

Other amulets are less common. In the upper part of the mummy bead-net, a collar and a face in frontal view may appear, the latter probably representing the face of the sun god. Frequently found beneath the scarab are Isis, the wife of Osiris, the god of the dead, and her sister Nephthys; they mourn the deceased, who is equated with Osiris, and protect him with their wings. Instead of them, Nut, the goddess of heaven and mother of Osiris and the sun god, can also protect the deceased in her womb and give birth again (cat. no. 21). Sometimes there was also a centrally placed inscription band bearing the names of the deceased and the protecting deity. ML

Selected Bibliography:
(a) cat. Dresden 1977: 43 no. 69; cat. Leipzig 1989: no. 236; cat. Bonn 2012: 138 no. 14 with fig., 158 no. 14; (b) Hettner 1881: 135 no. 3; cat. Dresden 1977: 60 no. 255 (along with inv. no. Aeg 191); (c) Hettner 1881: 139 no. 60; cat. Dresden 1977: 60 no. 256 (along with inv. no. Aeg 2); cat. Leipzig 1989: no. 169 (along with inv. no. Aeg 2); (d) Hettner 1881: 139 no. 60; cat. Dresden 1977: 60 no. 256 (along with inv. no. Aeg 2); cat. Leipzig 1989: no. 169 (along with inv. no. Aeg 2); (e) cat. Leipzig 1989: no. 222, fig.; cat. Dresden 1998: 24 no. 114, 25 fig.; (f) cat. Dresden 1977: 43 no. 71; cat. Leipzig 1989: no. 221, fig.; cat. Dresden 1998: 24 no. 115, 25 fig.; (g) cat. Leipzig 1989: no. 223; cat. Dresden 1998: 24 no. 116, 25 fig.; (h) cat. Dresden 1977: 43 no. 70; cat. Leipzig 1989: no. 220; cat. Dresden 1998: 24 no. 117, 25 fig.

Literature:
Arnst 1998; Strecker/Heinrich 2007

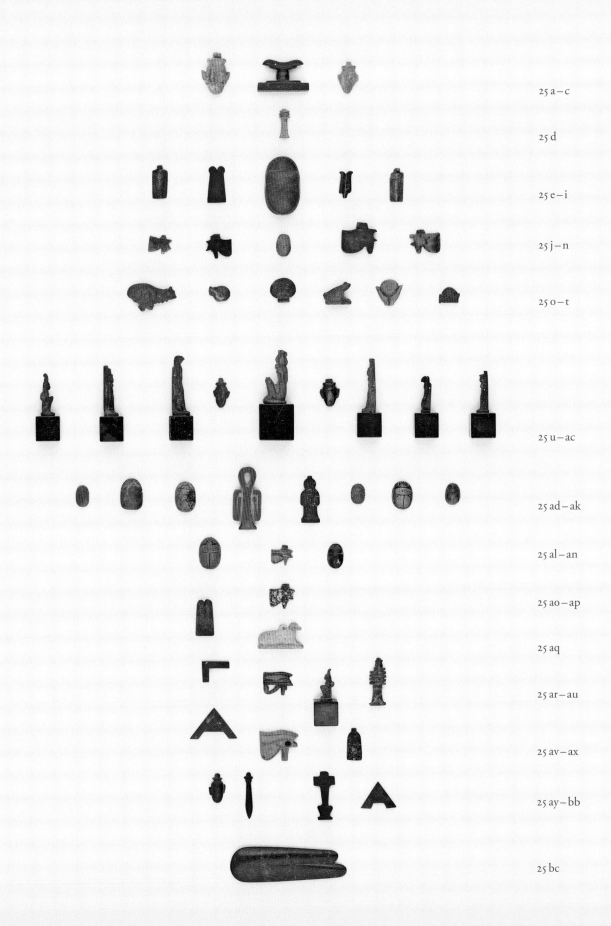

25 a–c

25 d

25 e–i

25 j–n

25 o–t

25 u–ac

25 ad–ak

25 al–an

25 ao–ap

25 aq

25 ar–au

25 av–ax

25 ay–bb

25 bc

Fig.: The arrangement of the amulets here is based on the position of the amulets inside the Thirtieth-Dynasty mummy of Djed-hor from Abydos, published by Petrie in 1914. The materials used only correspond as far as was feasible with the Dresden collection.

(a) Heart, limestone, Aeg 140(1); (b) Head support, haematite (?), Aeg 172; (c) Heart, clay, Aeg 140(4)

(d) *Djed* pillar, faience, Aeg 137(4)

(e) Papyrus, feldspar, Aeg 142(7); (f) Double plumes, obsidian (?), Aeg 138(8); (g) Scarab, serpentinite (?), Aeg 102; (h) *Pesesh-kef*, obsidian (?), Aeg 138(4); (i) Papyrus, feldspar, Aeg 142(8)

(j) *Udjat* eye, carnelian (?), Aeg 141(20); (k) *Udjat* eye, obsidian (?), Aeg 141(15); (l) Scarab, faience, o. Inv. 300; (m) *Udjat* eye, diorite, Aeg 141(16); (n) *Udjat* eye, granite (?), Aeg 141(1)

(o) Bound ox, reddish stone, Aeg 343; (p) Bound ox, brown stone, o. Inv. 177; (q) Sun, lapis lazuli, Aeg 143(7); (r) Frog, serpentinite (?), Aeg 348; (s) Cow horns with sun disc, faience, Aeg 370; (t) Sun on the horizon, jasper, Aeg 379

(u) Maat, lapis lazuli, Aeg 482; (v) Isis, lapis lazuli, Aeg 337; (w) Horus, lapis lazuli, Aeg 508; (x) Heart, lapis lazuli, Aeg 140(8); (y) Solar deity, faience, Aeg 507; (z) Heart, haematite, Aeg 140(15); (aa) Nephthys, lapis lazuli, Aeg 564; (ab) Thoth, lapis lazuli, Aeg 589; (ac) Selkis, lapis lazuli, Aeg 335

(ad) Scarab, carnelian, Aeg 36; (ae) Scarab, Aeg 30; (af) Scarab, steatite, o. Inv. 161; (ag) *Tit* knot, glass gem (?), Aeg 214(1); (ah) *Tit* knot, glass gem (?), Aeg 214(2); (ai) Scarab, steatite (?), Aeg 19; (aj) Scarab, faience, ZV 3947; (ak) Scarab, amethyst, Aeg 10

(al) Scarab, faience, Aeg 40; (am) *Udjat* eye, light green stone, Aeg 141(22); (an) Scarab, basalt (?), o. Inv. 307

(ao) Double plumes, stone, Aeg 138(15); (ap) *Udjat* eye, diorite, Aeg 141(17)

(aq) Ram, faience, Aeg 490

(ar) Set square, haematite (?), Aeg 245(1); (as) *Udjat* eye, carnelian, Aeg 181; (at) Maat, lapis lazuli, Aeg 481; (au) *Djed* pillar with *atef* crown, lapis lazuli, Aeg 232

(av) Plummet, haematite (?), Aeg 245(2); (aw) *Udjat* eye, faience, Aeg 157(3); (ax) *Menkhet* counterpoise, diorite, Aeg 127(2)

(ay) Heart, dark-coloured stone, Aeg 140(12); (az) Papyrus, dark-coloured stone, Aeg 142(3); (ba) Lungs with wind pipe, obsidian (?), Aeg 228; (bb) Plummet, haematite (?), Aeg 245(3)

(bc) Two fingers amulet, dark-coloured stone, Aeg 129(3)

25

Amulets arranged inside a mummy

Late Period, 664–332 BCE

Materials: see fig.

(b, g, t, ad, ag, ah, ak, al, am, aq, as, at, aw, ay, ba) Purchased from Alessandro Ricci, Florence, in 1831;
(d–f, h–k, m, n, q, r, v, ao, ap, ax, az, bc) purchased from the estate of Carl Gemming, Nuremberg, in 1881;
(aj) acquired from the collection of Dr. Luckow, West Berlin, in 1976;
(ar, av, bb) acquired from the collection of Otto Magnus von Stackelberg before 1838

Skulpturensammlung, Inv. nos.: see fig.

The numerous amulets found in mummies (cat. no. 24), together with various textual sources, provide many clues as to their respective use and meaning, and also reveal certain regularities in their arrangement.

The selection and arrangement of the amulets belonging to the Skulpturensammlung presented here is based on an extremely lavishly endowed and well-documented mummy of the Late Period from Abydos (see fig.). It thus reflects only one of numerous possibilities regarding the choice of amulets and their arrangement on a mummy.

The headrest (b) is found in the neck area. It is usually made of haematite, which is similar in colour to the wooden headrests commonly used in everyday life, but which was also considered a heavenly material. The headrest was intended to enable the head to be lifted in the afterlife and to ensure that it remained attached to the body.

Hence, it is stated in Chapter 166 of the Book of the Dead (cat. no. 29):

"Formula for a headrest:
[…] Thou art raised up, and dost triumph
by reason of what hath been done for thee! […]
Thou art Horus, […], to whom his head
was restored after being cut off.
[…] Thy head shall never, never by carried away from thee."

In Ancient Egypt, the heart signified the life force and was regarded as the seat of the intellect and feelings; hence, it was considered the most important organ (cat. no. 34 b). The Book

of the Dead contains information about the heart amulet (a, c, x, z, ay), among other things, in Chapter 29 B:

"Formula for a heart amulet of green stone:
I am the Benu bird, the Ba(-spirit) of Re,
who guides the gods to the underworld. [...]"

The *pesesh-kef* (h), made of obsidian, represents a fishtail-shaped knife that was used in rituals on the mummy. As the knife was made of dark flint, the amulet was also usually made of dark stone.

The popular *djed* pillar (d, au) was used on the neck and abdomen. This cult object – probably a wooden post wrapped with plants at the top – stood for duration and stability. It was then also associated with the god of the dead, Osiris, and his spine, and hence also with the spine of the deceased (cat. nos. 7 b, 34 a). The material used, green faience, may have been intended to imitate the plant material of the cult object, while also signifying regeneration. Chapter 155 of the Book of the Dead deals with the *djed* amulet:

"Formula for a *djed*-amulet of gold,
placed at the throat of the deceased:
Raise thyself up, Osiris,
Thou hast thy backbone, Weary-hearted One,
thou hast thy vertebrae, Weary-hearted One.
Mayest thou put thyself on thy side,
that I may supply thee with water.
Behold, I have brought thee the pillar amulet (of gold),
that thou mayest rejoice thereover. [...]"

The papyrus plant (e, i, az) stands for "green" and "fresh", and as an amulet in the form of a column or on a small plaque (cat. 34 c) it promises health and freedom from injury. The material and place of attachment are prescribed in Chapter 160 of the Book of the Dead:

"Giving the papyrus amulet of feldspar to N. [authors' note: the name of the deceased was inserted here]:
I am the papyrus amulet of feldspar, which is not fettered (but) is raised by the hand of Thoth;
Injury is an abomination for it.
If it is not injured, I am also not injured, [...]"

The two ostrich feathers (f) belong to the *atef* crown of Osiris, the god of the dead (cat. no. 7 a) and are usually made of dark stone.

The scarab (g, l, ad–af, ai–ak, al, an) is the most common Ancient Egyptian amulet. It symbolises regeneration and the god of the morning sun. The heart scarab (g) placed on the chest was supposed to prevent the heart of the deceased creating opposition to him in the Judgment of the Dead (cat. nos. 23 c, d, 29). Chapter 30 B of the Book of the Dead states:

"Formula for preventing the heart of the deceased creating opposition to him in the afterlife:
Oh my heart of my mother, [...]
Do not stand as a witness against me,
Do not oppose me in the tribunal,
Do not show hostility against me in front of the Keeper of the Balance! [...]
To be spoken over a beetle of green stone,
mounted in white gold,
with a ring of silver.
To be placed at the throat of the deceased. [...]"

Among the most common mummy amulets is also the *udjat* eye (*udjat*: "intact, healthy") (j, k, m, n, am, ap, as, aw). It represented the destroyed and healed eye of the god Horus, but also the eye of the sun and the moon, and could be used as a symbol for any offering. In the Book of the Dead, Chapter 167 deals with the *udjat*:

"Formula for bringing the *udjat* eye:
Thoth hath brought the *udjat* eye, [...].
If I am not injured, it is not injured,
If I am not injured, it is not injured,
and so N. is not injured."

The bound ox (o, p) represents the ideal animal for an offering and was often made of red stone (e. g. jasper, sandstone, carnelian) or red glass.

The usually dark-coloured, i.e. nocturnal sun on a base, here made of lapis lazuli (q), and the usually red sun rising between the mountains (t) are symbols of the continuation of life after death and cyclical rejuvenation.

The crown consisting of a sun disc held between cow horns (s) was mainly used by the goddesses Hathor and Isis (cat. nos. 6 d, 7 c, 9 b).

The frog and toad (r) stood for fertility and new life. These amulets were often made of a green material (e. g. green faience, feldspar, serpentinite) and were placed in the upper area of the body.

Amulets of the gods are often found in the chest area of the mummy. They usually depict deities closely associated with the god of the dead, Osiris (cat. no. 7), and the gods present at the Judgement of the Dead, such as Isis (v), Nephthys (aa), Horus (w), the mummiform solar deity Re-Horakhty (y), Maat (u, at), and Thoth (ab). The latter, as well as the scorpion goddess Selkis (ac), were substituted here for the unidentified gods on the Late Period mummy from Abydos, since they are attested on other mummies.

The knot amulet (ag, ah) known as *tit* or *tiyet* was to be made of red jasper. It was used as an amulet from the New Kingdom onwards and was associated with the goddess Isis. Chapter 156 of the Book of the Dead reads:

"Formula for the *tit* knot of red jasper,
placed at the throat of the deceased:
Thy blood is thine, Isis,
Thy power are thine, Isis,
Thy magic are thine, Isis.
Amulets are the protection of this great one,
guarding (him) against the one who would inflict injury
upon him. […]"

The two falcon feathers (ao) are interpreted as symbols of power, since they are adopted from the crowns of the gods. The best known here is certainly the crown of Amun of Thebes, the god of the air.

The recumbent, mummy-like ram (aq) may also refer to the god Amun(-Re) or the ram god of Mendes.

The set square (ar) and plummet (av, bb) were often made of haematite and represent balance, presumably in reference to the Weighing of the Heart in the Judgement of the Dead (cat. nos. 23 c, d, 29).

The counterpoise, a counterweight to a collar, could be read hieroglyphically as "clothing" (*menkhet*) or "equipment, jewellery" (*aper*). The corresponding amulet (ax) was called *mankhet* in Egyptian, but today it is also called *aper*. It is generally made of mottled stone, usually diorite.

The hieroglyph representing a widepipe and lungs (ba), called *sema* in Egyptian, means "unification" (cat. no. 23 f). The amulet was therefore perhaps intended to ensure that the corpse remained unified. It was usually made of obsidian.

The two fingers amulet (bc) was always made of dark material, often obsidian, and was placed near the incision through which the mummifiers removed the organs from the abdomi-

nal cavity. The knife used for this incision was probably also made of obsidian. It is assumed that the amulet stands for the protective fingers of the embalming priest or the closed edges of the wound.

ML

Selected Bibliography:
(a) cat. Dresden 1977: 64 no. 311; (b) cat. Dresden 1977: 65 no. 323; cat. Leipzig 1989: no. 195 b; (d) Hettner 1881: 142 no. 126; (e, i, az) Hettner 1881: 142 no. 116; (f, ao) Hettner 1881: 142 no. 119; (g) Hettner 1881: 135 no. 5; (h) Hettner 1881: 142 no. 119; (j, k, m, n, am, ap) Hettner 1881: 142 no. 117; (o) cat. Dresden 1977: 63 no. 290; (q) Hettner 1881: 142 no. 118; (r) Hettner 1881: 142 no. 128; (t) Hettner 1881: 137 no. 31; (u) cat. Dresden 1998: 20 no. 26; (v) Hettner 1881: 143 no. 152; cat. Dresden 1998: 18 no. 13; (w) cat. Dresden 1998: 21 no. 39; (y) cat. Dresden 1977: 51 no. 145; cat. Leipzig 1989: no. 225; (aa) cat. Dresden 1998: 22 no. 83; (ab) cat. Dresden 1998: 24 no. 106; (ac) cat. Dresden 1998: 18 no. 10; (ad) Hettner 1881: 136 no. 20; (ag, ah) Hettner 1881: 137 no. 34; (al) Hettner 1881: 136 no. 19; cat. Dresden 1977: 60 no. 253; cat. Leipzig 1989: no. 165; cat. Dresden 1993: 38 fig.; (aq) Hase 1833: 158; Hase 1839: 233; Hettner 1881: 141 no. 93; cat. Dresden 1977: 63 no. 292; (ar) Hase 1839: 234; Hettner 1881: 137 no. 36; cat. Dresden 1977: 65 no. 320; cat. Leipzig 1989: no. 194; (as) Hettner 1881: 136 no. 24; cat. Leipzig 1989: no. 198; (at) Hettner 1881: 140 no. 78; cat. Dresden 1977: 62 no. 276; cat. Leipzig 1989: no. 202; (av) Hase 1839: 234; Hettner 1881: 137 no. 36; cat. Dresden 1977: 65 no. 321; (aw) Hettner 1881: 136 no. 24; cat. Dresden 1977: 60 no. 257–260; (ax) Hettner 1881: 142 no. 125; (ba) Hettner 1881: 137 no. 40; (bb) Hase 1839: 234; Hettner 1881: 137 no. 36; (bc) Hettner 1881: 142 no. 123; cat. Dresden 1977: 66 no. 333

Literature:
Andrews 1994; cat. Fribourg 2010; Hornung 1993 b; Müller-Winkler 1987; Petrie 1914: Plate 51 no. 10

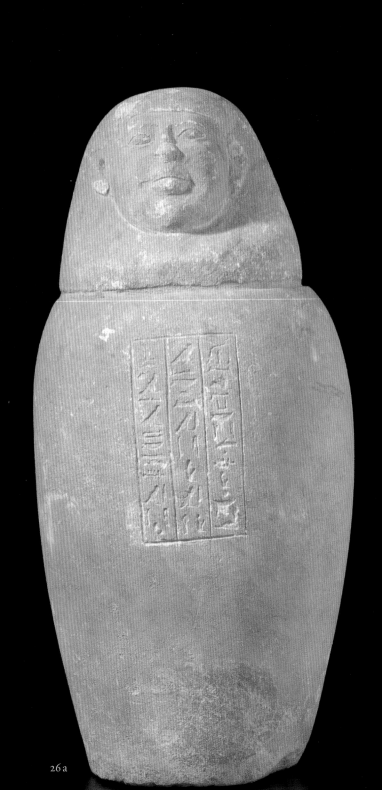

26a

26

Canopic jars

Late Period, 26. Dynasty, 664–525 BCE

Limestone
(a) H. 30, Diam. 14.7 cm; (b) H. 29, Diam. 14 cm;
(c) H. 33.5, Diam. 16.4 cm; (d) H. 29.5, Diam. 16.1 cm

Purchased from the estate of Carl Gemming, Nuremberg, in 1881

Skulpturensammlung, Inv. nos. (a–d) Aeg 690–693

No doubt on the basis of practical experience, the Egyptians removed the internal organs during mummification. While the heart remained inside the mummy and the brain was disposed of if it was removed, the liver, lungs, stomach, and intestines were often deposited separately in the tomb. The vessels used for this purpose often have lids in the shape of human and animal heads. Their designation as canopic jars derives from a misunderstanding: in fact, they have nothing to do with the local god of Canopos, who was depicted as a sacred vessel with a human head.

From the Middle Kingdom onwards, canopic jars and organs were placed under the protection of the Four Children of the god Horus (cat. nos. 23 c, g, h, 24 e–h). These ancient deities were then given different heads, which appear as canopic lids from the New Kingdom onwards. The responsibility of the four deities for each particular organ was as follows: the human-headed Imsety protected the liver, the baboon-headed Hapy the lungs, Duamutef – with the head of a canine (wolf or jackal) – cared for the stomach, while the falcon-headed Qebehsenuef was responsible for the intestines.

The Dresden Skulpturensammlung holds eight canopic jars, one canopic jar fragment, and 13 lids, only some of which fit together. A complete ensemble of four canopic jars with different lids dates to the Twenty-sixth Dynasty. However, these items belong to two different individuals. The inscriptions also indicated that two of the vessels were probably fitted with non-matching lids in modern times. The lids with the human (a) and falcon (c) heads are on the correct vessels. The vessel with the baboon-head lid (b) ought to have a canine-head lid. The vessel with the canine head (d), which belonged to a second individual, ought to have a falcon-head lid. Although in certain periods the assignment of the canine and

falcon heads was often reversed, the canopic jar (d) is known to have had a falcon-headed lid in the nineteenth century; moreover, the vessel and the lid are of slightly different materials and are in different states of preservation. It is no longer possible to return the original lids to the vessels from among the current holdings in Dresden.

The three canopic jars (a–c) belong to T(a)semtjek, whose mother Neith is mentioned on canopic jar (b). The name T(a)semtjek is interesting because it is the – rarely attested – female form of the name Psemtjek (modern Psamtek, Greek: Psammetichos) – the "P" or "T(a)" at the beginning of the name are the masculine and feminine article, respectively. Obviously, the Egyptians understood the name Psemtjek as "man/merchant of mixed wine (jars)" and also constructed a female name from it. However, Psemtjek is not an Egyptian name, but probably a Libyan one, the meaning of which is unclear. It is first attested for Pharaoh Psamtek (or Psammetichus) I, the founder of the Twenty-sixth Dynasty. The name of the owner of the three canopic jars is therefore based on inaccurate "folk etymology".

The canopic jar (d) belonged to the "overseer of the houses" Heka-tayef-nakht, son of Psemtjek, who also bore the same title. The title "overseer of the houses", whose exact meaning is unclear, already occurs in the Old Kingdom. In the Late Period it is often associated with the goddess Neith and her main place of worship Sais, the residence of the Twenty-sixth Dynasty kings. Other canopic jars belonging to Heka-tayef-nakht are held by the Egyptian museums in Berlin and Budapest. Despite their resemblance and the fact that they come from the same collection, there is no proven family connection between Heka-tayef-nakht and T(a)semtjek. ML

Selected Bibliography:
(a–c) Ebers 1881: 68; Hettner 1881: 131 nos. 7–9; cat. Bonn 2012: 136 f. nos. 10–12 with fig., 156–158 nos. 10–12; Jansen-Winkeln 2014: 1170 no. 60.812; cat. Chemnitz 2017: 122 no. 60; (d) Ebers 1881: 68; Hettner 1881: 131 no. 11; Jansen-Winkeln 2014: 1154 no. 60.747; cat. Chemnitz 2017: 122 no. 60; Gander/Loth 2019: 51

Literature:
El-Sayed 1976; Ikram/Dodson 1998: 276–292; Quaegebeur 1990

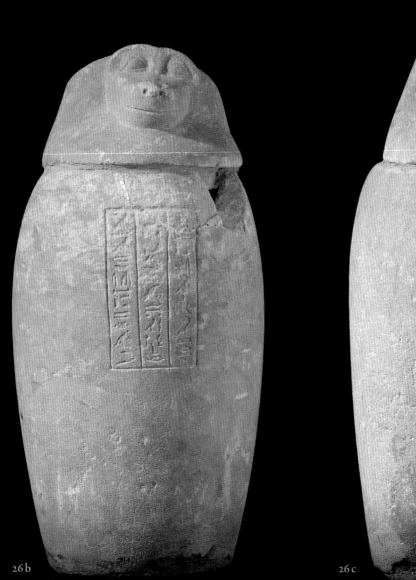

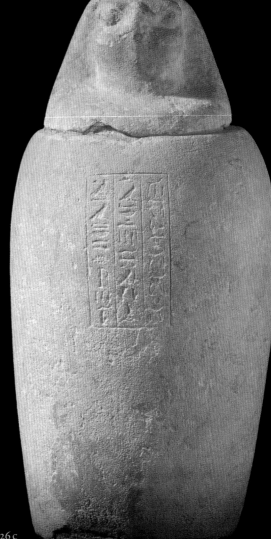

26b 26c

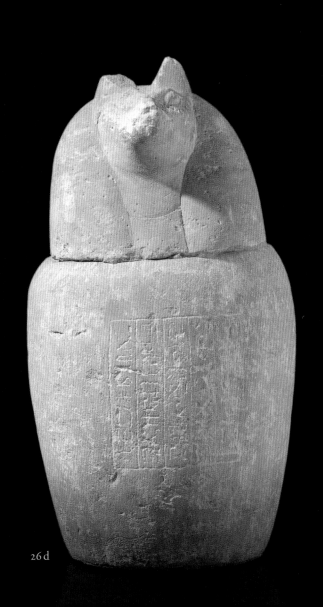

26 d

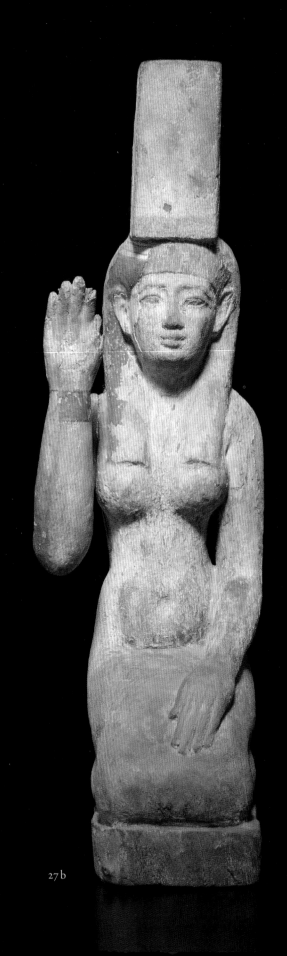

27 b

Funerary statuettes of Ptah-Sokar-Osiris and Nephthys (?)

(a) Late Period, Twenty-sixth Dynasty, 664–525 BCE;
(b) Late Period–Ptolemaic Period, 664–30 BCE

Wood, painted
(a) H. 29.3, W. 8.2, D. 7.1 cm; (b) H. 36.5, W. 7.8, D. 14.8 cm

(a) Findspot: reportedly Saqqara
Purchased in Cairo from Dr. von Becker-Wickerhauser in 1889;
(b) purchased on the Dresden art market in 1885

Skulpturensammlung, Inv. nos. (a) Aeg 462, (b) Aeg 463

Wooden statuettes of funerary deities have also been found in non-royal burials. The Dresden Skulpturensammlung also has some typical examples from the Late Period.

The male figure (a) wears the tripartite divine wig, and the divine beard is visible on the chin. The green skin colour of the face refers to Osiris, the god of the dead. A broad decorative collar covers the chest. The red robe envelops the body without indicating the arms. The feet covered by the robe are partially broken away, and the separately made base is missing completely. Another lost feature is the crown that was originally on the head; its former existence is confirmed by the hole into which it was inserted.

Running centrally down the front is a vertical inscription which continues on the back. This is the offering formula frequently found on funerary items, requesting that the deceased be provided for by the gods. It first mentions the god Osiris as the provider, followed by what is probably the name of the deceased (Pa-di-month?). The inscription on the reverse reads: "may he give all offerings for the Ka-spirit of Osiris". In this case, the name Osiris refers not to the god, but rather to the deceased, who, it is hoped, will attain a status similar to Osiris.

The figure belongs to the group of Ptah-Sokar-Osiris statuettes, on which the god of the afterlife is often named in this way, but the Egyptians also used other names, e. g. Osiris.

Statuettes with the colour scheme used here date to the late Twenty-fifth and Twenty-sixth Dynasties. Their base was partially hollow and was closed with a lid. It often contained a linen-wrapped effigy depicting the god Osiris, made of soil and grains of wheat. Such a Corn Osiris or corn mummy was a symbol of resurrection, because when water was added, plants began to sprout from it.

The second wooden figure represents a kneeling woman (b). She wears a tripartite wig with a headband. Except for green painted bracelets, little of her costume can be discerned. She probably wore a red dress with a multi-coloured belt. The right arm was evidently painted yellow, the conventional colour for female skin in Egyptian art. While her left hand rests on her thigh, her right arm is raised.

The posture and the object on the woman's head clearly indicate that she is the goddess Isis or her sister Nephthys. They kneel beside the corpse of the god Osiris, Isis' husband, mourning him. They hold their right hand, or both hands, in front of their faces, with the inside of the hand usually turned towards the face. The rarely documented deviating hand position of the Dresden statuette, as well as the better-preserved colours on the right arm, would seem to suggest that this arm was replaced or added at a later date.

The object on top of the head is the name hieroglyph of the goddess – for Isis a high throne, for Nephthys a basket above a house. Unfortunately, this wooden cuboid does not provide any clear information about which hieroglyph was intended, and thus about the identity of the goddess – presumably it is Nephthys.

Just as Osiris was brought back to life after his death through the care of his wife and sister-in-law, eventually enabling him to become ruler of the underworld (cat. no. 7), the deceased also hope to receive assistance from these goddesses.

ML

Selected Bibliography:
(a) Hettner 1881: 146 no. 212 or 213 (?); cat. Leipzig 1989: no. 33; (b) cat. Dresden 1977: no. 127, fig. 80; Böhme 2007; cat. Bonn 2012: 126 no. 4, 127 colour ill., 151 f. no. 4; Budka/Mekis 2017: 227 note 48

Literature:
Raven 1978–1979; Raven 1982

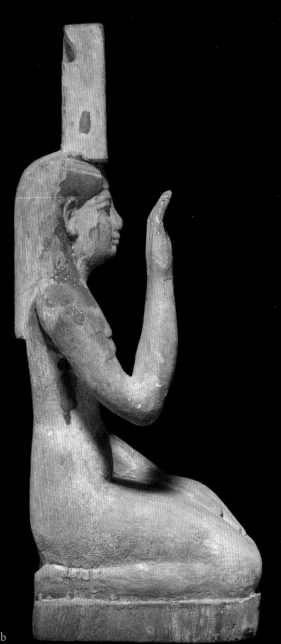

27 b

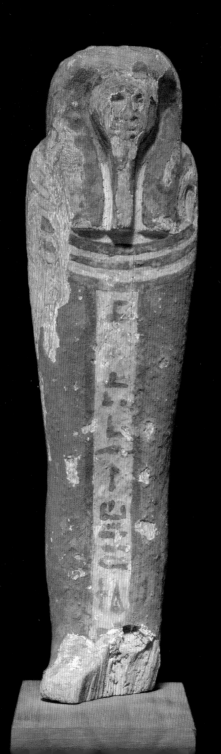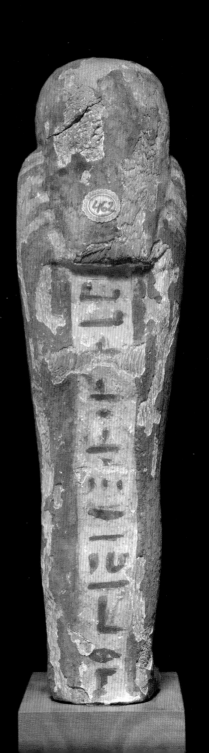

27 a

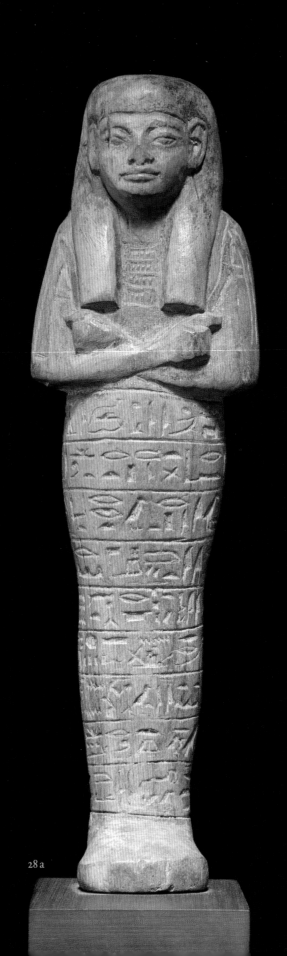
28 a

Shabtis

(a) New Kingdom, Eighteenth/nineteenth Dynasty,
c. 1539–1191 BCE; (b) Third Intermediate Period,
Twenty-first Dynasty (?), c. 1077–944 BCE;
(c) Late Period, Twenty-seventh Dynasty, 525–404 BCE

(a) Wood; (b–c) Faience
(a) H. 22.5, W. 6.5, D. 3.8 cm; (b) H. 9.9, W. 3.6, D. 2.4 cm;
(c) H. 13, W. 3.9, D. 2.8 cm

(a) Purchased from Alessandro Ricci, Florence, in 1831; (b) Purchased
from the estate of Carl Gemming, Nuremberg, in 1881; (c) Findspot:
probably Giza. Purchased from Alessandro Ricci, Florence, in 1831

Skulpturensammlung, Inv. nos. (a) Aeg 398, (b) Aeg 406, (c) Aeg 425

Funerary statuettes, called shabtis (or ushabtis), have survived
in enormous numbers. The Dresden Skulpturensammlung has
no fewer than 70 shabtis among its holdings.

Contrary to what the term shabti suggests, the history of
these objects is complex, and the Egyptians also had varying
designations and uses for them. In the Middle Kingdom,
people began to place a small, mummiform image of the
deceased into the tomb among the grave goods. These figurines
were often laid in a miniature coffin and bear the name of the
owner of the tomb. At about the same time, texts (spell 472 of
the Coffin Texts) describe the making of statuettes (shabti:
"provisions"?, "staff"?) to carry out the tasks required of the
deceased in the afterlife.

The *ushebet* of the New Kingdom combined both aspects:
as a (substitute) body and as a representative image of the tomb
owner. A beautiful example from this period is the wooden
figure of Merire (a). His head is covered by a smooth, tripartite
wig, and he wears a broad collar around his neck. The arms are
folded in front of the chest and each hand holds an agricultu-
ral implement – the so-called hand plough. The rest of the
body, down to the feet, is covered by inscriptions running
horizontally around the figure, interrupted only in the middle
of the back by a vertical line of text. These inscriptions contain
the formula addressed to the shabti found in Chapter 6 of the
Book of the Dead (cat. no. 29). Since Merire ("He who is loved
by the (sun god) Re") is identified only by his name, which
was a very common one, no further details are known about
him.

In the Third Intermediate Period, the servant function of the
statuettes became more important; they were now called *shebti*
("substitute") or *ushebti* ("answerer"). Ideally, the deceased
would be accompanied by 365 farm workers. The shabti (b),
however, carries a whip in his right hand and wears a protrud-
ing kilt that is impractical for working in the fields. He is an
overseer-shabti who is in charge of ten agricultural labourers
– in analogy to the Ancient Egyptian calendar, in which the
year consisted of 365 days, with 36 weeks of 10 days each (and
five additional days). Typical of shabtis from this period are
the blurred contours, the cobalt blue glaze, and the black
painting. A beard is usually absent, but the ribbon wound
around the wig is characteristic. The barely decipherable
inscription on the kilt probably reads "divine father of Amun,
beloved of the god" and perhaps "royal (?) scribe", while the
name itself is illegible.

The appearance of Late Period shabtis is well illustrated by
the high-quality object (c). The faience – from which almost
all shabtis were made at this time – is less lustrous and is mostly
green. The braided divine beard is in keeping with the divine
status of the deceased. In his left hand he holds the hoe typical
of the period, while in his right he holds the hand plough and
the cord of a sack or basket carried on his back. The pedestal
under the feet and the back pillar are adopted from stone sta-
tues and are also found on coffins (cat. no. 21) and Ptah-Sok-
ar-Osiris statuettes of this period (cat. no. 27 a). The T-shaped
inscription only became common during the Twenty-seventh
Dynasty. It names the Royal Seal-bearer Horudja, son of Aset-
en-mehyt. The tomb of this high-ranking individual of the
Thirtieth Dynasty is in Giza. Several dozen of his shabtis that
were found there are now distributed among more than ten
museums. ML

Selected Bibliography:
(a) Hettner 1881: 141 no. 102; cat. Dresden 1977: 43
no. 75, fig. 50; cat. Leipzig 1989: no. 151, fig.; Salvoldi
2018: 64 (as inv. no. Aeg 399); (b) Hettner 1881: 145
no. 185; (c) Hettner 1881: 141 no. 101; cat. Dresden
1977: 44 f. no. 85; cat. Leipzig 1989: no. 159;
cat. Dresden 1993: 35 fig.; Salvoldi 2018: 64

Literature:
Milde 2012; Schneider 1977; Taylor 2001: 112–135

28 b

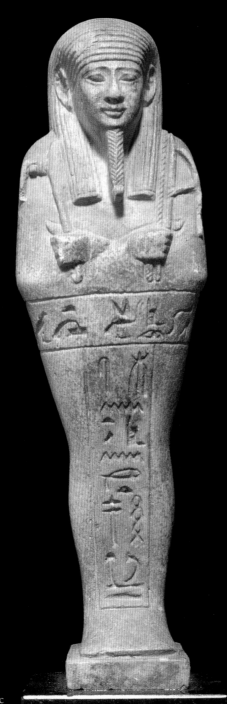

28 c

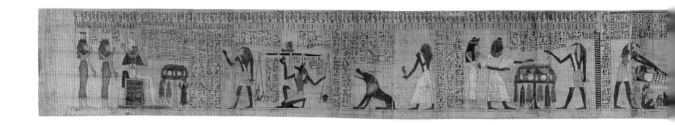

29

Book of the Dead belonging to Ankh-ef-en-amun

Third Intermediate Period, Twenty-first Dynasty, c. 1077–944 BCE

Papyrus, painted
H. 22.5, L. 280.5 cm

Findspot: presumably Thebes. Purchased from Alessandro Ricci, Florence, in 1831

Skulpturensammlung, Inv. no. Aeg 775

This colourfully painted Book of the Dead belonging to Ankh-ef-en-amun is undoubtedly one of the most beautiful Pharaonic objects in the collection. What we refer to as the Ancient Egyptian Book of the Dead is a collection of about 200 incantations or spells ("chapters') relating to the afterlife, which the Egyptians called the "Book of Going Forth by Day". From the New Kingdom onwards, it was popular to include a papyrus with a selection of chapters from this book among the grave goods of upper-class individuals.

The Dresden papyrus is still preserved in one piece, but a short section is missing at the beginning (on the right). From the alignment and gluing of the papyrus sheets, it can be concluded that two originally separate papyri were joined together with a central connecting piece to form a scroll. The decoration is divided into a central field and two outer areas, each of which has images that are architecturally framed by a hall.

The right-hand section contains invocations to various gods assigned to certain caves in the afterlife. It is a small excerpt from the Book of Caves, which used to be counted as Chapter 168 of the Book of the Dead. In accordance with the

number of night hours, the Egyptians recognised twelve caves, which were inhabited by 62 groups of gods.

In the centre of the papyrus is a depiction of the deceased addressing a long prayer to Osiris, the god of the dead. Osiris stands in an arbour, embraced by his wife Isis and her sister Nephthys (fig. on page 8). To the left of this is a mummification scene with excerpts from Chapter 151 of the Book of the Dead (contribution by Seyfried in this volume, fig. 9). The deceased, lying on a lion-shaped bier, is being attended to by the sky-god Horus and the funerary deity Anubis. Below him are the four canopic jars (cat. no. 26), the vessels containing his viscera, protected by the mourning goddesses Isis and Nephthys (cat. no. 27 b).

The left section of the papyrus first shows the ibis-headed Thoth, the god of science, supplying the deceased with food and drink. Behind Ankh-ef-en-amun stands an anonymous woman, presumably his wife (fig. on pages 50/51).

A larger space is taken up by the final scene, the Judgement of the Dead (Chapter 125 of the Book of the Dead): On the right, the deceased strides, holding the feather of Maat ("truth, justice") in his hand. In the centre are the weighing scales, in whose pans the goddess Maat is weighed against the heart of the deceased. If the scales remain balanced when the deceased testifies, he becomes a god-like being. If not, the "Devourer" stands ready to inflict punishment, her figure combining elements of a crocodile, lion, and female hippopotamus. Anubis, as the weighing master, works the scales, while on his left Thoth records the result and announces it. Thoth also sits on the scales in the form of a baboon. On the far left, Osiris, the ruler of the underworld, sits enthroned in front of an offering altar, again accompanied by Isis and Nephthys (cf. cat. nos. 21, 23 c, d).

The owner of the papyrus bore a common name that translates as "He lives for (the god) Amun". His titles are "Purification Priest of Amun" and "Scribe of the Recruits of the Temple of Amun". The mention of the god Amun in the name and in

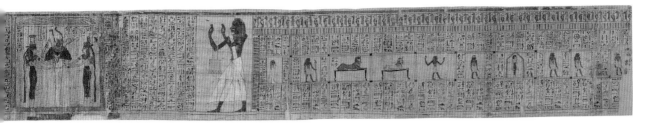

the titles indicates that he originated from Thebes, the most important cult centre of Amun. Also, it would seem that all the papyri of the Book of the Dead dating from the Twenty-first Dynasty, and with a known place of discovery, originate from Thebes. However, since no other objects can be clearly assigned to Ankh-ef-en-amun, the question of his origin is impossible to clarify beyond doubt. ML

Selected Bibliography:
Hase 1833: 137 no. 405; cat. Dresden 1977: 37 f. no. 37, fig. 36–38, cover illustration, front; cat. Bonn 2012: 38, 40, 43 f., 47–70, Plate A–C; cat. Dresden 2014: 170 f.; cat. Chemnitz 2017: 32–34 fig. 4–8, 48 fig. 19

Literature:
cat. London 2010; Hornung 1993b; Niwiński 1989

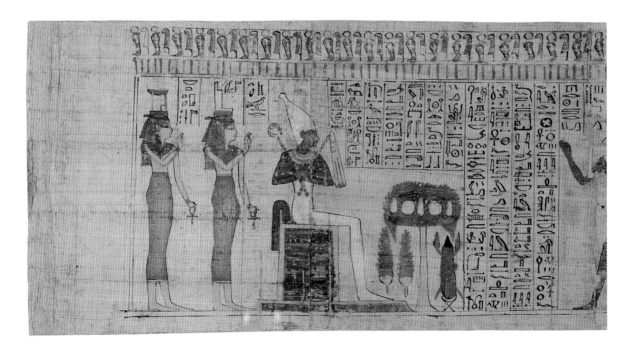

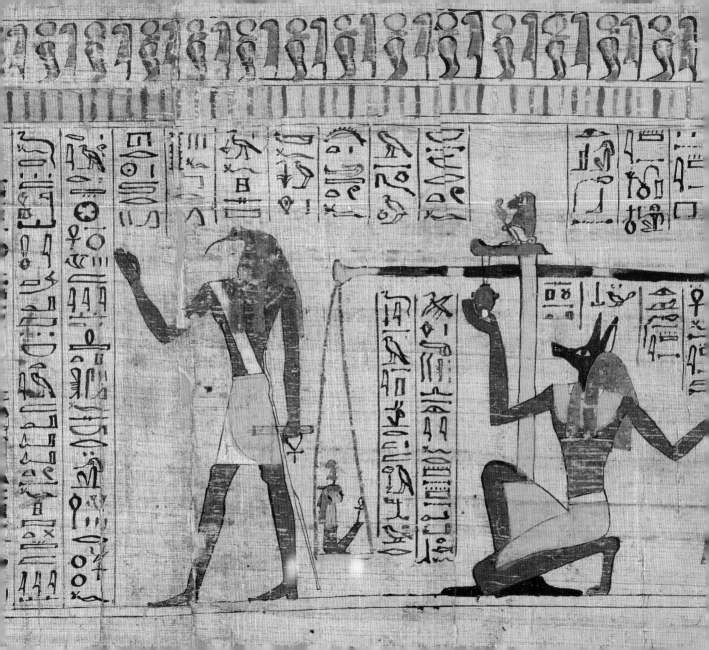

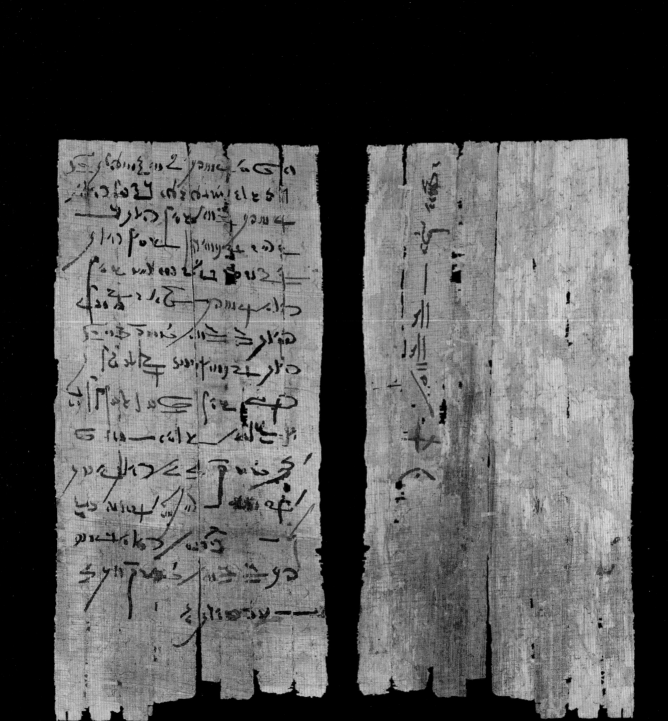

Papyrus with the »Book of Breathing« and writing utensils

(a) Middle Roman Period, second century CE;
(b) New Kingdom, c. 1539–1077 BCE;
(c) Late Period, 664–332 BCE

(a) Papyrus, ink; (b) Wood; (c) Faience
(a) H. 22, W. 11 cm; (b) H. 1.7, W. 4.4, L. 36.8 cm;
(c) H. 7.6, W. 5, D. 4.1 cm

(a) Findspot: probably Thebes. Purchased from Alessandro Ricci, Florence, in 1831;
(b) acquired from the collection of Otto Magnus von Stackelberg before 1838

Skulpturensammlung, Inv. nos. (a) Aeg 828, (b) Aeg 735, (c) Aeg 659

The slightly damaged papyrus (a) dates from the Roman Period. The text is written in Demotic, a highly abbreviated cursive form of hieroglyphic script used from the seventh century BCE onwards. The 15 lines on the front side and the vertical line on the reverse contain a version of the "Book of Breathing":

Front side:
"May his Ba(-spirit) live forever, may it rejuvenate eternally, Pairy, whom Tshenpamont bore, so that his Ba(-spirit) may follow Osiris,
so that he may be among the favored ones by Osiris,
so that he may receive water upon the offering-table behind Osiris,
so that his Ba(-spirit) may go to heaven,
so that he may breathe on Earth for all eternity,

so that he may praise those who have buried him,
before Osiris, Foremost of the West, the great god,
the Lord of Abydos. 26 years
he spent on the Earth, so that he will be taken (///)
from the winter season and to (///)
the summer season, so that his Ba(-spirit)
may breathe on Earth.
He does everything that he desires."

Reverse: "The Book of Breathing" (as well as some unidentifiable characters at the end).

The Book of Breathing is in the tradition of the Egyptian Book of the Dead (cat. 29) and is one of the prominent funerary texts of the Graeco-Roman Period. It expresses the wish that the spirit of the deceased may live eternally in the afterlife in the company of the gods, being constantly rejuvenated and, among other things, breathing. There were different versions and designations of this text, and they were also placed at different locations on the mummy: on the head, on the feet, or on the chest.

The typical Egyptian writing medium, papyrus, was obtained from the papyrus plant that grew along the Nile. The stalks, cut into strips, were laid crosswise on top of each other and pressed. In the process, the plant sap that emerged adhered the strips together. The resulting sheet was then smoothed with a stone.

The instrument used for writing on papyrus was the stem of a rush plant, which was chewed at the end to separate the fibres, thus forming a brush. The rush and the cakes of black and red ink were placed on a long rectangular scribe's palette (b). It is made of wood and in the upper third it has two round depressions for the inks. The rushes were inserted into a case with a sliding lid; the lid is missing here. Scribe palettes used as grave goods could also be made of more valuable materials, such as ivory, stone, or faience.

30 b

The emergence of the state in Egypt around 3000 BCE was accompanied by the establishment of a functioning administrative apparatus. This required a suitable writing system. It was developed from pictorial symbols, which were used as word signs, sound signs (omitting the vowels), and meaning signs. The Egyptians called their script *medu netjer* "(script of) the words of the gods"; thus, they believed it to be of divine origin. This is also reflected in the Greek term hieroglyph, which is still used today and means "sacred engravings". The god Thoth (c) was considered the inventor of writing. He is sometimes represented as a baboon, but sometimes also as an ibis or as a hybrid being with an ibis head and a human body. A small figurine of Thoth was supposed to help the scribe find the right words and write the hieroglyphs without mistakes. However, only few Egyptians were able to read and write, probably only 1–2 % of the population. MG

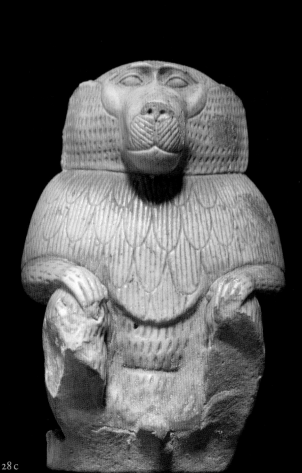

Selected Bibliography:
(a) Hettner 1881: 132 no. 25; cat. Dresden 1998: 27
no. 153; Stadler 2004: 562; Vleeming 2011: 674–678;
Dieleman 2014: 30; (b) Hettner 1881: 137 no. 28;
cat. Dresden 1977: 49 no. 134; cat. Leipzig 1989: no.
240; (c) cat. Dresden 1977: 50 no. 140, fig. 47;
cat. Leipzig 1989: no. 37; cat. Dresden 1993:
22 with fig.

Literature:
(a) cat. London 2008; (b, c) Leach/Tait 2000;
Parkinson et aL. 1995; Schlott 1989

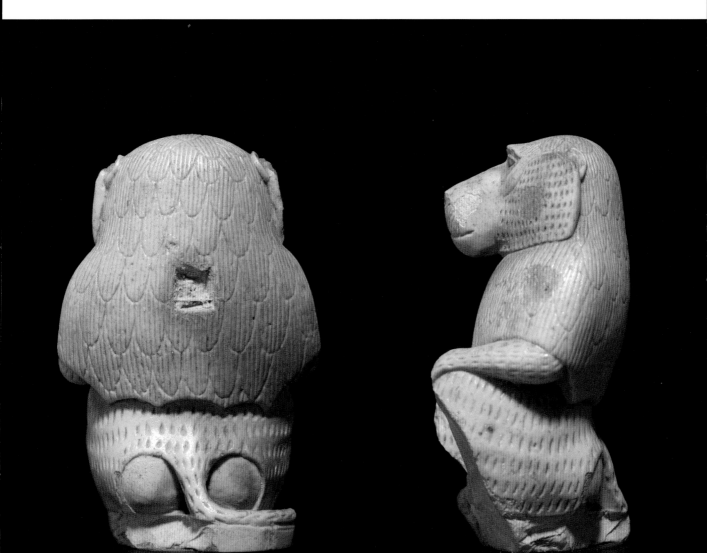

31 c

31 d

31 a

31 b

31

Ceramic vessels

(a) Predynastic Period, Naqada IIC–IID1, c. 3400 BCE;
(b) Predynastic Period, Naqada IIIA2, c. 3150 BCE;
(c, d) New Kingdom, Eighteenth Dynasty,
reign of Amenhotep IV/Akhenaten, c. 1353–1336 BCE

(a, b) Clay; (c, d) Clay, painted
(a) H. 24.2, Diam. 4–12.2 cm; (b) H. 27.8, Diam. 6.2–10.8 cm;
(c) H. 8.6, W. 11.5, D. 3 cm; (d) H. 9.7, W. 9.2, D. 1.8 cm

(a) Findspot: Naqada tomb 1430. Probably donated by William Matthew
Flinders Petrie, London, in 1896; (b) Findspot: Naqada tomb 45. Probably
donated by William Matthew Flinders Petrie, London, in 1896;
(c) Findspot: el-Amarna. Acquired from Georg Steindorff, Leipzig, in 1896;
(d) Findspot: el-Amarna. Donated by the Kühnscherf heirs, Dresden, in 1938

Skulpturensammlung, Inv. nos. (a) ZV 1586, (b) ZV 1557,
(c) ZV 1569, (d) ZV 3466

The tall, black-rimmed, polished ceramic vessel (a) is one of the oldest dated objects in the Dresden Egyptian Collection. The slightly conical body of the vessel extends upwards from a small, flat base and ends in a broad, very slightly protruding rim. These vessels are called Black-topped Ware, or B-Ware for short, and date to the Predynastic Naqada I and II periods. The red B-ware is found mainly in Egypt and Nubia. In addition to the form shown here, bulbous vessels as well as tulip-shaped and slender cups also occur. The finished moulded vessel was coated with ochre and smoothed before drying and probably then placed upside down in the ashes of the potter's kiln. While the strong firing effect produced the typical red colouring, the metallic-looking black lustre in the upper area of the vessel was produced by carbonisation.

The second, cylindrical vessel (b) is an example of Wavy-handled Ware or W-Ware. The surface is well smoothed, but is not polished. A typical feature is the wavy band with depressions, which extends around the circumference in the upper section of the vessel. It has its origin in small wavy handles that were attached to both sides of the vessel. In the course of time, these handles developed into a purely decorative element.

The two ceramic shards of almost equal size (c, d) come from differently decorated vessels. The cobalt blue colour, as well as the floral decoration, are typical of vessels from Akhetaton. The settlement now known as el-Amarna was the capital of Pharaoh Akhenaten. Fragment (a) is decorated with blue leaf garlands, while fragment (b) has closed lotus buds as well as leaf garlands. A band at the top probably contains red pomegranates. This type of decoration is first attested under Amenhotep III, Akhenaten's father; the latest known vessels date from the Nineteenth Dynasty.

The typical blue colour of the paint only came into being during the firing process. Beforehand, aluminium oxide in the form of clay slip enriched with cobalt components was applied to the vessel. This coating was initially transparent to light grey or pink. Only during firing do aluminium and cobalt react with each other to produce the characteristic blue colour.

As early as the fifth millennium BCE, Egypt was already a centre of pottery production. Small clay vessels were mainly deposited in graves as containers, or they were used for ritual purposes, while larger ones were employed in everyday life for storage or transportation.

In Egypt, pottery was produced using marl clay, which contains a high proportion of calcium oxide, and Nile clay. These were often enriched with various organic materials ("temper"). The Nile clay was gathered on the banks of the Nile or along irrigation canals, while the marl clay was obtained from desert valleys (wadis). The clay was mixed with water and kneaded with the feet to expel the air bubbles. Then it was transported to the potter. Vessels could be shaped by hand, and from the Fourth Dynasty onwards there is also evidence of the potter's wheel. After drying, the surface could be coated, smoothed and decorated, e. g. painted. MG

Selected Bibliography:
(a) Bericht 1896/1897: 47; (b) Bericht 1896/1897: 47;
cat. Leipzig 1989: no. 101

Literature:
Bourriau/Nicholson/Rose 2000; Hope 2001;
Loschwitz 2012; Rose 2007

32 a

Stone vessels

(a) Old Kingdom, c. 2590–2118 BCE; (b) Predynastic
Period, Naqada II – Old Kingdom, c. 3600–2118 BCE;
(c) New Kingdom, c. 1539–1077 BCE

(a) Gabbro; (b) Limestone (?), gold; (c) Travertine
(a) H. 11.8, Diam. 9.3 cm; (b) H. 7.7, Diam. 2–5.6 cm;
(c) H. 8.7, Diam. 7.9 cm

Donated by Ernst von Sieglin, Stuttgart, in 1910

Skulpturensammlung, Inv. nos. (a) ZV 2600 E 005,
(b) ZV 2600 E 065, (c) ZV 2600 E 053

The elegant vessel (a) is made of the black hard stone known
as gabbro. From a small, round base, the body of the vessel runs
upwards in a cylindrical form, ending in a narrow, flat rim.

The second vessel (b) is made of a dark limestone (?). From
a small base, the body of the vessel extends upwards in a high
oval shape. Because of the two pierced handles, it is what is
known as a "hanging vase" or vessel with lug handles: a cord
could be run through the gilded handles in order to hang up
the vessel. Such vessels have been documented in Egypt from
the Naqada II period to the Old Kingdom.

The third vessel (c) is made of travertine and has a strongly
bulbous body with a stepped foot, a cylindrical neck, and a
narrow, outwardly curved rim.

Because they are often of small size, these containers are
called ointment vessels. They were probably used to store fra-
grant oils or similar substances, and they also served as grave
goods for the afterlife. The covering was sometimes a flat, disc-
shaped lid. To secure it, the lid was additionally wrapped with
intersecting strips of linen or papyrus and fixed under the lip
of the vessel. Alternatively, a lump of clay or a linen plug could
also be used as a stopper.

The Egyptians had already mastered the art of stone work-
ing by the Predynastic Period. Until the time of the Old King-
dom, the artistic focus was on the production of vessels. These
high-quality stone vessels usually had forms that were vertically
or horizontally oval, spherical, cylindrical, or animal-shaped.
Popular materials were travertine, red breccia, granite, diorite,
gabbro, gneiss, and limestone. The craftsmen experimented
with the material and tested it to its limits. Often, the colour
and grain of the stone was also particularly emphasised and

accentuated. There was an enormous variety of shapes, sizes,
and other material properties. The working process was char-
acterised by a constant striving for perfection, beauty, and
luxury.

Stone was used extensively in funerary and temple archi-
tecture, and in statue production, from the Old Kingdom
onwards, although stone vessel production declined markedly
towards the end of the Old Kingdom, before reaching a second
peak in the New Kingdom. Due to the exchange of goods and
the strong expansion of Egypt into the Mediterranean region
and the Near East, resulting in new cultural contacts, novel
vessel forms appeared in the repertoire. Existing forms were
developed further, and foreign forms were adopted. The most
popular material at this time was travertine, a light-coloured,
soft stone that was easy to carve. It could be worked very
thinly, emphasising its fine, wavy veining and translucency.

The production of stone vessels always required a high
degree of skill and understanding of the material. The outer
shape of the vessel was first created with stone hammers before
the interior was hollowed out in several stages using a crank
(or twist-reverse-twist) stone drill. The drill heads were made
of sandstone, silicified sandstone, or flint, among other mate-
rials. The surface of the vessel was smoothed by means of a
grindstone, and in rare cases also painted. MG

Selected Bibliography:
(a) Pagenstecher 1913: 182, Plate 6 no. 11; cat. Dresden
1977: 55 no. 186, fig. 9; cat. Leipzig 1989: no. 119;
(b) Pagenstecher 1913: 182, Plate 6 no. 12; cat. Dresden
1977: 54 no. 180, fig. 7; cat. Leipzig 1989: no. 110;
cat. Berlin 2002: fig. 74; (c) Pagenstecher 1913: 176,
Plate 2 no. 18; cat. Dresden 1977: 67 no. 217, fig. 45 r.;
cat. Leipzig 1989: no. 140 with fig.

Literature:
Aston 1994; Aston/Harrell/Shaw 2000; El-Khouli
1978

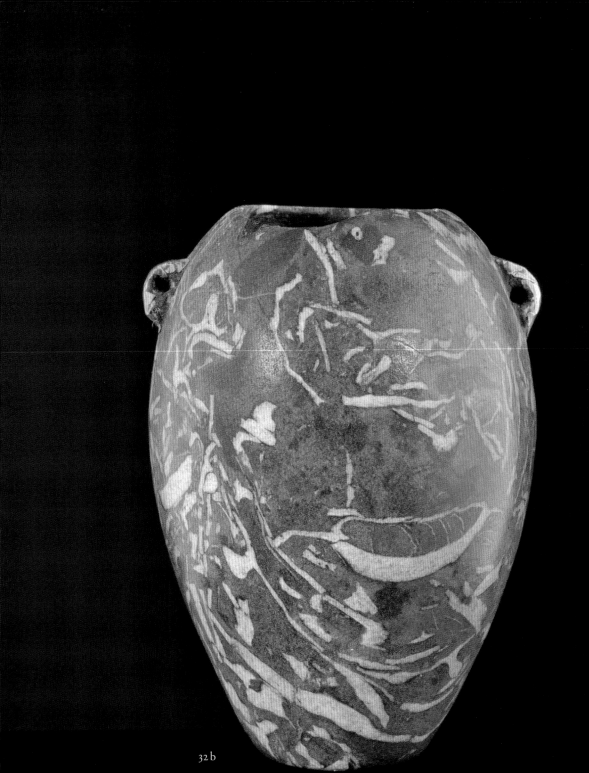

32 b

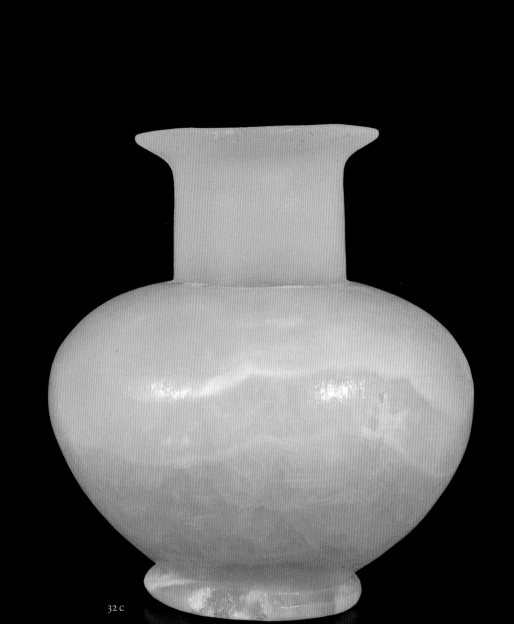

32 c

33 a

33 b

33

Cosmetic utensils

(a) Predynastic Period, Naqada IC–IIIB, c. 3700–3100 BCE;
(b) Predynastic Period, Naqada I, c. 3900–3600 BCE;
(c) New Kingdom, c. 1539–1077 BCE;
(d) presumably Middle Kingdom, c. 1980–1760 BCE;
(e) Graeco–Roman Period (?), 332 BCE–395 CE;
(f) Graeco–Roman Period, 332 BCE–395 CE

(a, b) Greywacke; (c) Travertine; (d) Bronze; (e, f) Bone
(a) H. 7, W. 12.4, D. 0.6 cm; (b) H. 30.1, W. 10.4, D. 2.6 cm;
(c) H. 7.8, Diam. 6.7 cm; (d) H. 21, W. 10.7, D. 1.8 cm;
(e) H. 4.5, W. 4.7, D. 0.2 cm; (f) H. 9.5–12.9, Diam. max. 1.1 cm

(a, b, d) Acquired from Georg Steindorff, Leipzig, in 1896;
(c, e, f) donated by Ernst von Sieglin, Stuttgart, in 1910

Skulpturensammlung, Inv. nos. (a) ZV 1562, (b) ZV 1563, (c) ZV 2600 E 083,
(d) Aeg 827, (e) ZV 2600 K 143, (f) ZV 2600 K 135

Cosmetics played an important role in the life of the Egyptians. Many objects, and also texts, have survived which are concerned with beauty and personal hygiene. Numerous utensils were used for the production and storage of cosmetics, including vessels for ointments, oils, and makeup. The surviving items include mirrors, cosmetic boxes, razors, and tweezers.

Among the earliest documented such utensils are the cosmetic palettes (a, b), which occur exclusively in the Predynastic Period and are mostly made of greywacke. These flat stone discs may be rectangular or rhomboid (b) or have an animal-shaped outline, representing mammals such as the antelope, reptiles, especially the turtle, or even fish (a) or birds. Minerals were probably ground on them to produce eye makeup. In addition to their practical use, such cosmetic palettes probably also had a cultic function. Gods in the temple required special care to maintain their physical perfection. Such palettes are also important for researchers because they are among the earliest objects bearing images and writing in Egypt.

Particularly typical containers for eye makeup are small, bulbous vessels (c) with flat lids and flared feet. These are known as *kohl* pots (from Arabic *kahala* "to anoint, to coat the eyes"). They are made from numerous materials, such as travertine, breccia, obsidian, faience, or wood. From the reign of Thutmose III, *kohl* tubes also emerged. These were originally made from hollow sections of sedge or wood, with one end closed. Several tubes could also be tied together with a ribbon.

One of the most important elite cosmetic utensils was the mirror (d). It usually consisted of a circular, oval, pear-shaped, or lotus-shaped polished disc made of copper, bronze, silver, or gold. At the lower end, a handle made of wood, ivory, metal, also gold, faience or obsidian was fitted on a short spike. The mirror was associated with life and regeneration. Mirrors used as grave goods were supposed to guarantee the eternal youth of the deceased. They were often wrapped inside the mummy bandages directly under the head.

Particular importance was attached to hair care. It is therefore not surprising that combs (e) made of ivory, bone, horn, wood, and occasionally also stone, have been found as grave goods in tombs dating from the Predynastic Period. In addition to simply crafted objects, there were also high-quality combs whose upper and middle parts had incised, relief, or openwork decoration.

From Predynastic times onwards, hairpins (f) made of bone, wood, or ivory were used to fix the hair and create elaborate hairstyles, as is evident from grave goods. The pin sometimes ends in a small knob; small animal figures, such as a monkey or hippopotamus, were also very popular as finials. This type of decoration has been frequently found on objects dating from the Roman Period.

Finally, it should be emphasised that although toiletries and cosmetic utensils are often associated with female personal hygiene, the Ancient Egyptian sources clearly show that there was a comparable use of cosmetics by men. MG

Selected Bibliography:
(a) cat. Leipzig 1989: no. 109; (b) cat. Leipzig 1989: no. 108; (c) cat. Dresden 1977: 56 no. 205; cat. Leipzig 1989: no. 136; cat. Dresden 1993: 30 with fig.; (d) cat. Dresden 1977: 48 f. no. 129, fig. 26; cat. Leipzig 1989: no. 133 with fig.; (e) Pagenstecher 1913: 235, Plate 59 no. 6; (f) Pagenstecher 1913: 235 f., Plate 59; Stutzinger 1995: 176 f., List no. 89, fig. 33, 182, List no. 103, fig. 39

Literature:
cat. Bonn 1996; cat. Hildesheim 2006; cat. Munich 1990; Fletcher 1999; Lilyquist 1979

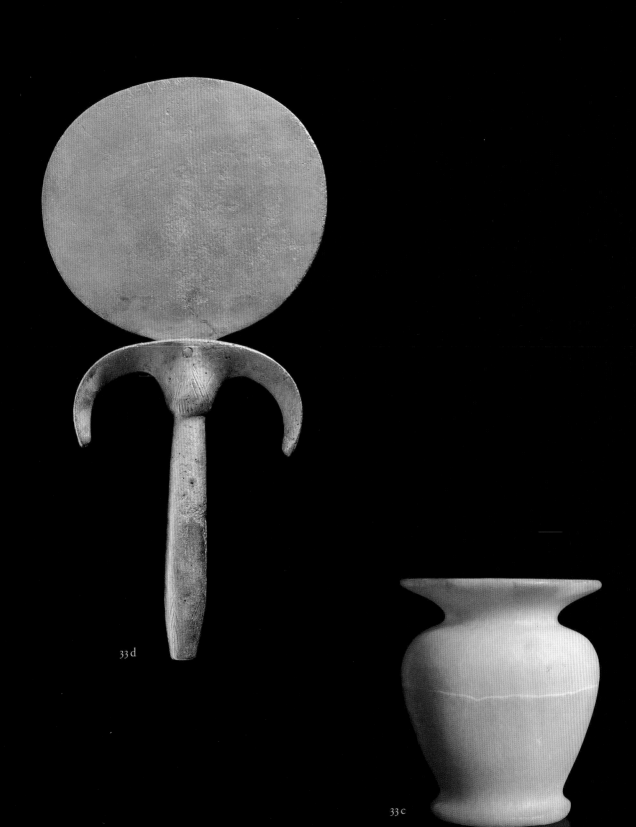

33 d

33 c

33 e

33 f

34 b

34

Jewellery

(a–d) New Kingdom–Late Period, c. 1539–332 BCE;
(e–f) New Kingdom (?), c. 1539–1077 BCE

(a, c–e) Faience; (b) Carnelian, stone, faience; (f) Carnelian
(a) L. 39 cm; (b) L. 19 cm; (c) L. 16 cm; (d) L. 44 cm;
(e) H. 2.3, W. 1.2, D. 2.2, Diam. 1.6 cm; (f) Diam. 1.3, D. 0.3 cm

(a–d, f) Purchased from the estate of Carl Gemming, Nuremberg, in 1881;
(e) purchased from Alessandro Ricci, Florence, in 1831

Skulpturensammlung, Inv. nos. (a) Aeg 137, (b) Aeg 140,
(c) Aeg 142, (d) Aeg 152, (e) Aeg 176, (f) Aeg 124(1)

These four necklaces consist mainly of faience elements of different shapes. They have been threaded in modern times, so that their combination is random or modelled on precedents. In the absence of a find context, it is difficult to date this jewellery. The first necklace (a) contains 19 amulets in the shape of the *djed* pillar. According to Ancient Egyptian belief, this represents the spine of Osiris, the god of the dead (cat. nos. 7 b, 25). It stands for "durability", "stability" and "permanence". Every deceased person hoped to be resurrected as Osiris in the afterlife. The second necklace (b) consists of nine heart pendants, seven made of a dark stone, one of carnelian, and one of blue-green faience. The heart offers protection and is a substitute for the real heart; it symbolises the life force of the deceased and is intended to vouch for him in the Judgement of the Dead (cat. nos. 23 c, d, 25, 29). Eight papyrus stems or columns of different sizes hang from necklace (c). The hieroglyph for papyrus, *wadj*, also signifies "green", "fresh" and "youthful". The papyrus may therefore symbolise the rejuvenation of the deceased in the afterlife (cat. no. 25). The fourth necklace (d) bears 14 of the *udjat* eye pendants that were extremely popular from the Old Kingdom to the Roman Period. The word *udjat* is translated as "intact, healthy, complete". It represents the eye of the god Horus, which was injured in the mythical battle with his uncle Seth and was healed again by the god Thoth (cat. nos. 7, 11 c, 25). In the necklaces (a–c), two tubular beads, each with a round bead set between them, function as intermediate elements. In chain (d), only tubular beads have been used. These beads probably did not originally belong to necklaces, but rather to a bead-net of a mummy (cat. no. 24). Although it was indeed common

for amulets to be joined together with connecting links, the original use of the amulets now on the Dresden necklaces is unknown today.

It was also popular to design the bezels of faience rings (e) as an *udjat* eye. Such rings are characteristic of the New Kingdom and were found en masse in el-Amarna, the capital of Egypt during the reigns of kings Akhenaten to Tutankhamun.

The small rings with a narrow aperture (f), which are called ear, hair, or dress rings, are also interesting. It is unclear whether these rings were put through a hole in the earlobe, were merely attached to the ear lobe at the opening, were used as hair or wig rings to adorn individual locks of hair, or were used as ring brooches to decorate clothing.

Jewellery was omnipresent in the life of the Egyptians, both on the worldly plane and in the afterlife. It was worn not only by women, but also by men and children. Headbands, hair wreaths, and other hair ornaments, collars and necklaces, earrings and finger rings, bracelets and anklets, and ornamental belts, were by no means merely decorative. In addition to neutral shapes (e. g. beads), these items of jewellery also often had figural forms and were intended to ward off evil as amulets and guarantee the wearer vitality, protection, and health in this world, as well as regeneration and resurrection in the afterlife. The colour and other properties of the material often played a role and signified specific things. For example, blue and green stood for renewal and regeneration, red for the sun or blood.

MG

Selected Bibliography:
(a) Hettner 1881: 142 no. 126; cat. Leipzig 1989:
no. 178; cat. Dresden 1993: 37 fig.; (b) Hettner 1881:
137 no. 35, 142 no. 121; cat. Dresden 1977: 64 no. 310;
cat. Leipzig 1989: no. 179; cat. Dresden 1993: 37 fig.;
cat. Dresden 1995: 18 no. 1.01.14; (c) Hettner 1881:
142 no. 116; cat. 1977: 64 no. 306; cat. Leipzig 1989:
no. 180; (d) Hettner 1881: 144 no. 172; cat. Leipzig
1989: no. 176; (e) Hettner 1881: 138 no. 53; cat. Dresden 1977: 53 no. 171; cat. Leipzig 1989: no. 184; (f)
cat. Dresden 1977: 52 no. 165; cat. Leipzig 1989:
no. 188 a

Literature:
Andrews 1990; cat. Berlin 2015; cat. Hildesheim
2006

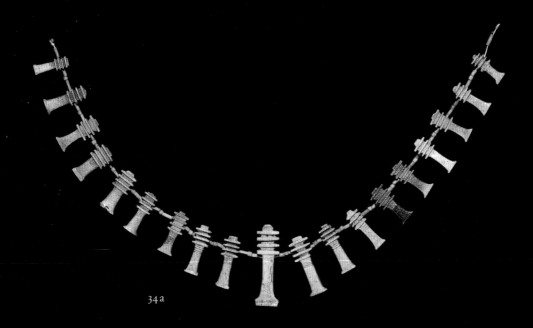

34 a

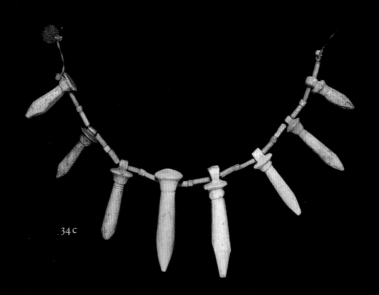

34 c

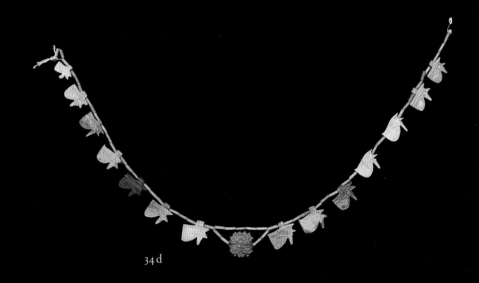

34 d

34 e

34 f

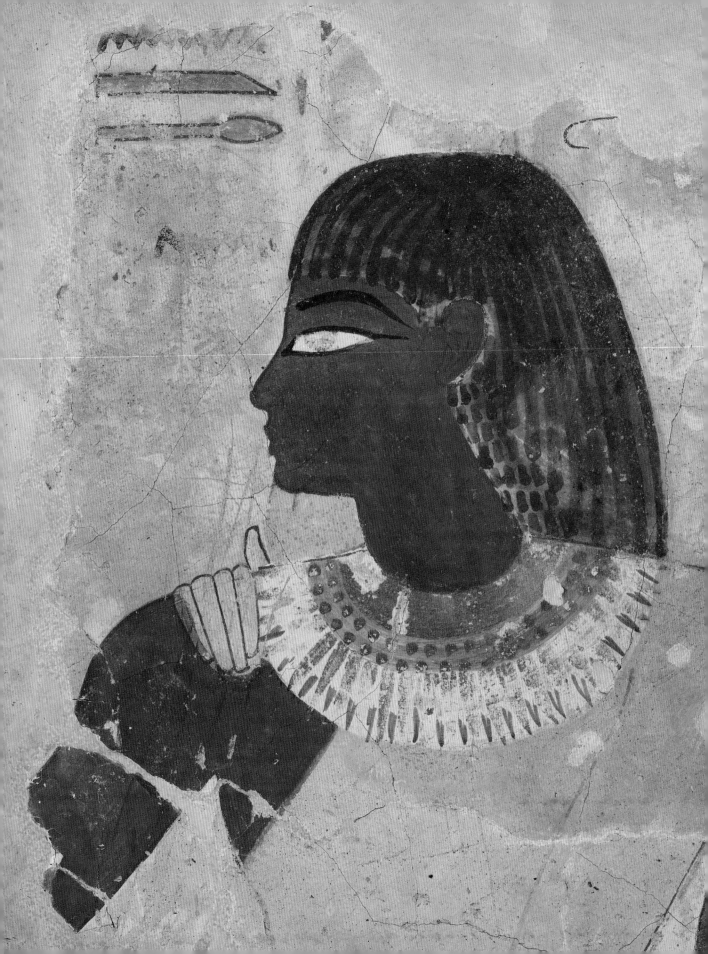

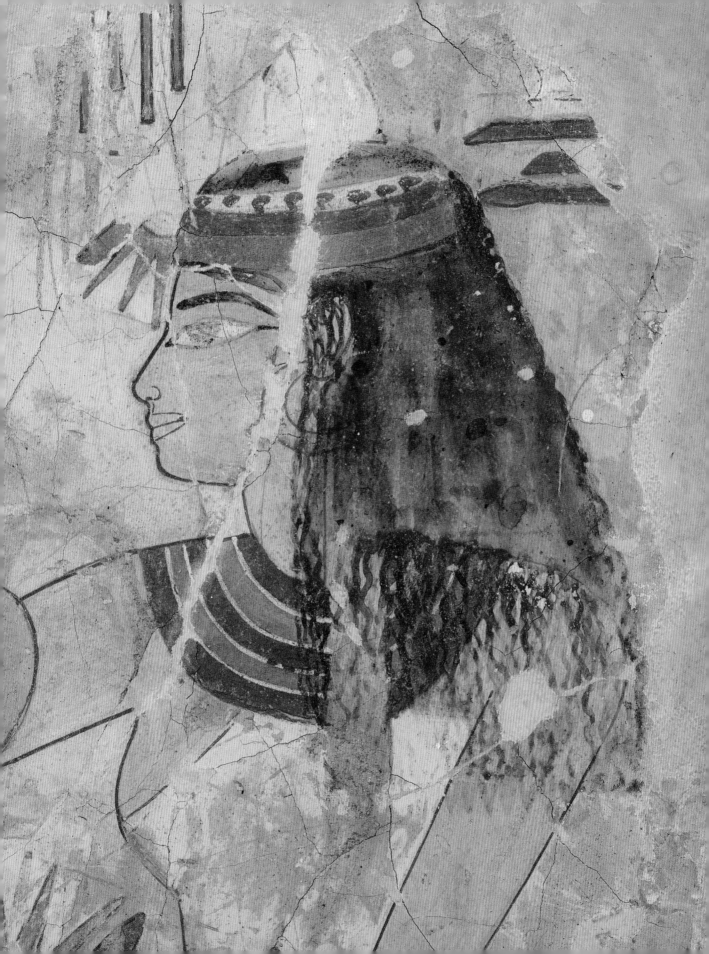

Timeline of
Ancient Egypt

Marc Loth

Only those Dynasties and kings are mentioned that the text listed. The Dates are based on Hornung/Krauss/Warburton 2006: 490–495, for the period before 3rd millennium BCE see also Shaw 2003.

PALEOLITHIC PERIOD	
OR	
OLD STONE AGE	c. 700 000 – 7000 BCE
NEOLITHIC PERIOD	
OR	
NEW STONE AGE	
OR	
PREDYNASTIC PERIOD	c. 6000 – 2900 BCE
Tasian culture	c. 4900 – 4600 BCE
Merimde culture	c. 4400 – 4000 BCE
Badarian culture	c. 4400 – 3800 BCE
Naqada I	c. 3900 – 3600 BCE
Naqada II	c. 3600 – 3300 BCE
Naqada III	c. 3300 – 2950 BCE
Dynasty 0	c. 3000 – 2900 BCE
EARLY DYNASTIC PERIOD	c. 2900 – 2590 BCE
1st Dynasty	c. 2900 – 2730 BCE
OLD KINGDOM	c. 2590 – 2118 BCE
4th Dynasty	c. 2543 – 2436 BCE
5th Dynasty	c. 2435 – 2306 BCE
Userkaf	c. 2435 – 2429 BCE
Sahure	c. 2428 – 2416 BCE
Nyuserre	c. 2402 – 2374 BCE
6th Dynasty	c. 2305 – 2118 BCE
Pepi I	c. 2276 – 2228 BCE
Pepi II	c. 2216 – 2153 BCE

FIRST INTERMEDIATE
PERIOD ——————— c. 2118–1980 BCE

MIDDLE KINGDOM ——————— c. 1980–1760 BCE

11th Dynasty ——————— c. 2080–1940 BCE

12th Dynasty ——————— c. 1939–1760 BCE

SECOND INTERMEDIATE
PERIOD ——————— c. 1759–1539 BCE

NEW KINGDOM ——————— c. 1539–1077 BCE

18th Dynasty ——————— c. 1539–1292 BCE
Thutmose I ——————— c. 1493–1483 BCE
Thutmose III ——————— c. 1479–1425 BCE
Amenhotep III ——————— c. 1390–1353 BCE
Amenhotep IV/
Akhenaten ——————— c. 1353–1336 BCE
Tutankhamun ——————— c. 1334–1324 BCE
Haremhab ——————— c. 1319–1292 BCE

19th Dynasty ——————— c. 1292–1191 BCE

20th Dynasty ——————— c. 1190–1077 BCE
Ramesses III ——————— c. 1187–1157 BCE

THIRD INTERMEDIATE
PERIOD ——————— c. 1077–664 BCE

21st Dynasty ——————— c. 1077–944 BCE

22/23st Dynasty ——————— c. 943–715 BCE

LATE PERIOD ——————— 664–332 BCE

26th Dynasty ——————— 664–525 BCE
Psamtek I ——————— 664–610 BCE

27th Dynasty ——————— 525–404 BCE

30th Dynasty ——————— 380–343 BCE

PTOLEMAIC (GREEK)
PERIOD ——————— 332–30 BCE
Alexander the Great ——————— 332–323 BCE
Ptolemy I ——————— 306/4–283/2 BCE
Ptolemy II ——————— 282–246 BCE

ROMAN PERIOD ——————— 30 BCE–395 CE
Augustus ——————— 30 BCE–14 CE
Claudius ——————— 41–54
Hadrian ——————— 117–138

Map of Egypt
showing location of places
mentioned in the text

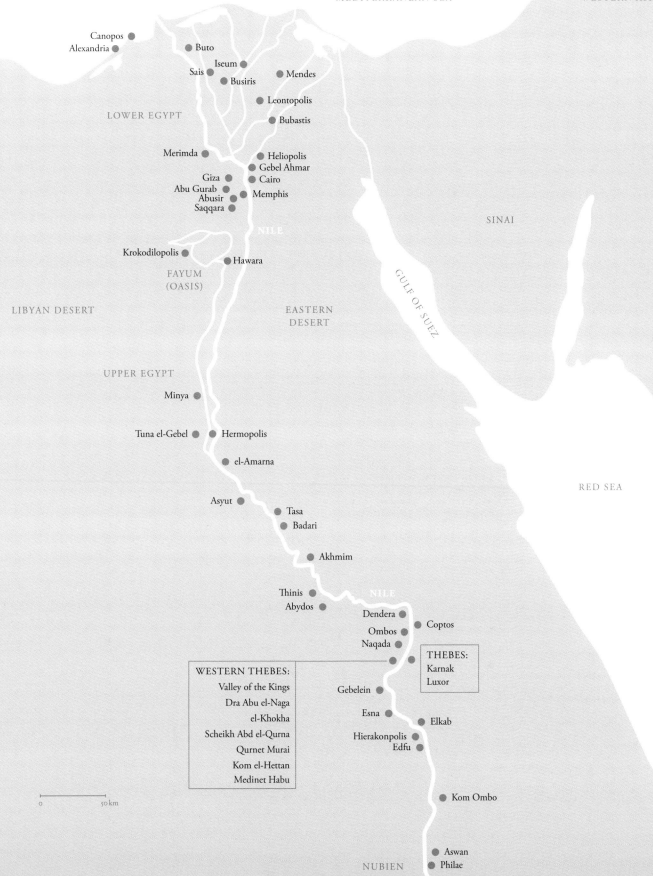

MEDITERRANEAN SEA WESTERN ASIA

Canopos
Alexandria Buto
 Iseum
 Sais Mendes
 Busiris
 Leontopolis
LOWER EGYPT Bubastis

Merimda Heliopolis
 Gebel Ahmar
 Giza Cairo
 Abu Gurab
 Abusir Memphis
 Saqqara

 NILE

Krokodilopolis
 Hawara SINAI
 FAYUM
 (OASIS)

LIBYAN DESERT EASTERN GULF OF SUEZ
 DESERT

UPPER EGYPT

 Minya

Tuna el-Gebel Hermopolis

 el-Amarna
 RED SEA

 Asyut
 Tasa
 Badari

 Akhmim

 Thinis NILE
 Abydos
 Dendera Coptos
 Ombos
 Naqada THEBES:
 Karnak
WESTERN THEBES: Luxor
 Valley of the Kings
 Dra Abu el-Naga
 el-Khokha Gebelein
 Scheikh Abd el-Qurna
 Qurnet Murai Esna
 Kom el-Hettan Elkab
 Medinet Habu Hierakonpolis
 Edfu

0 50 km

 Kom Ombo

 Aswan
NUBIEN Philae

Glossary

Manuela Gander, Marc Loth

Abydos fetish – The Abydos fetish is a sacred object consisting of a pole topped with a beehive-like object, whose symbolic meaning is unknown, adorned with twin plumes. It served as a sign for the Thinis nome (8th nome of Upper Egypt), where Abydos is located, and was later interpreted as a reliquary for the head of the god Osiris.

aegis – In Egyptology, aegis refers to the representation of the head of one or more deities, or of the king, with a crown and a broad collar. The aegis could be combined with other cultic items, such as the *menat*, and was also used as an amulet.

Aegyptiaca – The term Aegyptiaca is generally used for works that deal with, or originate from, Ancient Egypt. Here it is used for Ancient Egyptian (collection) objects.

Amun – Amun, "the hidden one", was the principal deity of Thebes and one of the most important gods of Ancient Egypt. He is usually depicted as a man wearing a crown of two falcon tail feathers. It is probable that he was initially worshipped as a god of the air and a creator deity, but later he became a universal god who also acquired the characteristics of a fertility god, a solar deity, a god of war, and king of the gods.

ankh – The Ancient Egyptian word *ankh* means "to live". It is written with a symbol in the form of a cross whose uppermost bar has the shape of a loop, probably a sandal strap. Gods are often depicted holding the *ankh* in their hand.

Antinous – Antinous (or Antinoös) was a close friend of the Roman Emperor Hadrian (reigned 117–138 CE). He drowned in the Nile in 130 AD and was subsequently deified. Some of the statues of him made in Egyptian style depict him as Osiris.

Anubis – Anubis is a god of the dead, especially the god of mummification. He is usually depicted as an animal displaying features of various canine species, especially the African Gold Wolf and the Black-backed Jackal. This animal is represented lying on a shrine (container for a sacred object), or the figure of the deity combines the animal's head with the body of a man.

aper – see *mankhet*

Apis – Apis is a deity who was worshipped in the form of a live bull. After the death of an Apis, his successor was selected on the basis of certain specific markings. He was regarded as the embodiment of the creator god Ptah. The main centre for the worship of Apis and Ptah was Memphis.

atef – *Atef* is the name of a crown worn especially by the god Osiris, but also by other deities and the king. It consists of the White Crown and two ostrich feathers (see Maat) on either side. It could be supplemented by rams' or bulls' horns, cobras, and the sun disc.

Atum – Atum is a creator god and solar deity (cf. Re) and the father of Shu and Tefnut. He is often depicted as a man with a Double Crown. The main centre of his cult was in Heliopolis.

Autokrator – The Greek title Autokrator, "self-ruler" or "one who rules by himself", could also be applied to Roman Emperors.

Ba – The Ba (or Ba-spirit) is a component of an individual which was believed to detach itself from the corpse after death in order to move freely in heaven and the underworld, but which could also reunite with the corpse. In images, the Ba is shown as a falcon with a human head, and often also human arms.

base line – In Ancient Egyptian two-dimensional pictorial compositions, the images are bordered at the bottom with a horizontal line on which the figures, objects, buildings, bodies of water and mountains stand. This base line also serves to separate the different registers. Subordinate scenes and figures are given their own base lines.

Bastet – Bastet is a goddess of motherhood and also of music, drunkenness, and celebration, but she can also take on aggressive traits. This is reflected in her various forms as a lioness or as a cat. The main centre of her cult was Bubastis.

Benu – Benu is an Egyptian primordial god, usually depicted as a heron. The main place of his worship was Heliopolis. As a god who periodically rejuvenates himself, he is closely related to the main Heliopolitan deity, the sun god (Atum, Re) as well as to Osiris, the god of the dead. Many of Benu's traits were incorporated into the Graeco-Roman legend of the phoenix.

Bes – Bes is a protective god, especially for pregnant women, women in labour, and newborn babies. His ugly face with its outstretched tongue is framed by lion ears and a mane-like full beard; on his head he often wears a plumed crown. His body with its short legs curved in an O-shape is reminiscent of toddlers or people with dwarfism, and he has a lion's tail.

Book of Breathing – The Book of Breathing, which has survived in several versions, is one of the most important funerary texts produced during the Graeco-Roman Period in Egypt. The texts were mostly written in hieratic script (see hieroglyphs) on papyrus and positioned on the mummy. In these texts, deities guarantee the spirit eternal life in the hereafter, rejuvenation, and also breathing.

Book of Caves – Traditionally assigned to the Book of the Dead as Chapter 168, this text is now regarded as an independent composition. In analogy to the twelve hours of the night, it describes the realm of the dead as twelve caves with their associated deities and is called the Book of the Twelve Caves or Book of Caves. It is documented from the New Kingdom until the Ptolemaic Period.

Book of the Dead – The Egyptian Book of the Dead is the modern name for a collection of incantations or spells (called "chapters") relating to the afterlife; in Egyptian it was called the "Book of Going Forth by Day". These were used from the New Kingdom down to the Ptolemaic Period. Many of the approximately 200 chapters derive from older precedents, such as the Coffin Texts. They were intended to enable the deceased to be admitted to the afterlife, as well as warding off dangers and providing the deceased with all comforts. The illustrated texts were often written on papyrus and deposited close to the mummy.

canopic jars – Canopic jars is the name given to containers made of stone, clay, wood or metal for storing and preserving the organs removed during mummification. They typically form a set of four vessels, one for each of the four organs: the liver, lungs, stomach, and intestines.

cartonnage – Cartonnage is the name given to a material made of plaster and glued layers of linen or/ and papyrus that was used for coffins, mummy masks, and trappings on mummies.

cartouche – In Egyptology, a cartouche or royal ring is a hieroglyph representing a circular or oval loop formed by a rope that is knotted at the bottom or side. The cartouche contains the throne name and the birth name of a Pharaoh as well as the names of queens and deities.

Children of Horus – The Four Children (or Sons) of Horus are four gods whose most important task is to protect certain organs of mummies. The human-shaped Imsety protected the liver, the baboon-headed Hapy the lungs, the jackal- or wolf-headed Duamutef cared for the stomach, while the falcon-headed Qebehsenuef was responsible for the intestines. The shape and inscriptions of the vessels containing the organs (canopic jars) often relate to these four gods.

chiton – The chiton was the most important garment in Greek culture. It was used as a tunic or undergarment by women and men, and it was always belted. It could be made short or long and with or without sleeves.

clavi – Clavi is the name given to the coloured stripes on Roman garments, especially the stripes on the tunic reaching from the shoulders to the hem, which originally denoted social rank. In Roman Egypt, they are also found on garments designated as chitons.

Coffin Texts – In the First Intermediate Period and the Middle Kingdom, about 1200 funerary spells were in use, often inscribed on coffins. These texts were used in particular by non-royal persons. Partly provided with illustrations, they contain rituals for the dead and numerous spells to allow the deceased to travel through the afterlife and continue to live there without danger or worry.

commemoration – In Egyptology, the term commemoration is used for the purposeful, long-term – often collective – (bearing in) remembrance of deceased family members, in particular. Even after their death, these individuals continued to be part of a shared network of remembrance and ritual, which was observed especially at their grave but could also take place in the temple or at home.

Coptology – Coptology is the scientific study of the culture of the Egyptian Christians, the Copts. One focus is the study of texts written in a late form of the Egyptian language but with the Coptic alphabet, which consists of Greek letters and some additional hieroglyphic characters.

Demotic – Demotic ("popular script") is the name given to the late Egyptian cursive script (7th century BCE – 5th century CE) based on Egyptian hieroglyphs. It was mainly used to write non-religious texts such as documents, letters, and literary texts. The form of the Egyptian language in Demotic texts is also called Demotic.

Devourer – The Devourer (of the Dead), known as Ammut in Egyptian, is a divine being from the Book of the Dead, mostly depicted with the head of a crocodile or hippopotamus, the forequarters of a lion, and the hindquarters of a female hippopotamus. She devours the dead who have undergone the Judgment of the Dead and been deemed unworthy.

divine beard – A typical feature of gods who take human form is a braided chin beard that tapers slightly downwards and is curled forward at the end. The cross-section is round or oval. Many depictions show it as an artificial beard attached with ribbons. The divine beard can also be worn by the Pharaoh and the deified deceased. Gods may also have other types of beard, e. g. the royal beard in the case of Ptah, or a full beard in the case of Bes.

divine father, beloved of the god – This title was originally bestowed on men who were close to the king by marriage, especially fathers-in-law, and on educators of the crown prince. From the late New Kingdom, however, "divine father, beloved of the god" was also used as a priestly title.

divine wig – Gods and goddesses often wear a long, tripartite wig – two parts lie on either side of the head on the chest, one on the back. The hair is rendered in blue.

djed (pillar) – The *djed* is a divine symbol and a hieroglyph, probably representing a pillar with plant material wrapped round it at the top. It stands for duration and stability and was later identified with the spine of Osiris or with the god Osiris himself.

Double Crown – The Double Crown combines the Red Crown of Lower Egypt and the White Crown of Upper Egypt. It stands for the unified, complete land of Egypt. It is worn by the Pharaoh and certain deities.

Duamutef – see Children of Horus

dynasty – The Egyptians divided their successions of rulers into groups, the decisive criterion being their capital city. In Egyptology, these groups are called dynasties. The division into 31 dynasties used today is based on the history book written by the Egyptian priest Manetho (3rd century BCE) and copies of this book made in antiquity.

Elysium – The name used for the abode of the blessed in Greek mythology is also used for Ancient Egyptian concepts of an idyllic afterlife. The Egyptians described this place using expressions such as "Field of Offerings" or "Field of Reeds".

eye of Horus – The left eye (or both eyes) of the god Horus was injured or destroyed by the god Seth, but was healed thanks to divine assistance. In Egyptian, the eye of Horus is therefore called *udjat* or *wedjat* ("healing"). The *udjat* is one of the most important Ancient Egyptian symbols, which can also stand for the moon, the Uraeus, or generally for offerings, and was frequently used as an amulet. Its appearance corresponds to a human eye with an eyebrow and other, presumably animal, elements.

eye of the moon – see eye of Horus

Eye of Re – Various myths speak of the eye of the sun god as an independent being. It is sent out to search, or against enemies, or it stays away out of anger and has to be brought back. Many goddesses are equated with it, such as Tefnut, Sekhmet, Bastet, Wadjet, and Hathor.

faience – Egyptian faience is the name of a quartz ceramic material made in Ancient Egypt. It was made from powdered quartz (sand, quartz pebbles), alkalis (plant ash or sodium bicarbonate), lime, and metal oxides. A firing process produced a glaze that could have different colours depending on the choice of metal oxides. Green and blue faiences were particularly popular.

Geb – Geb is the Egyptian god of the earth. He is the husband of the sky goddess Nut and father of Osiris, Seth, Isis, Nephthys and Horus. He is usually depicted as a man, often with his head surmounted by a goose, the hieroglyph of his name.

Hapy – see Children of Horus and Nile gods

Harendotes – The god Horus is obliged to take up arms against his uncle Set in order to avenge his father, Osiris, and fight for his inheritance, namely rulership over Egypt. This role is expressed in the name Harendotes, which means "Horus, protector of his father".

Harpocrates – Harpocrates is the Greek adaptation of the name of an Ancient Egyptian god, "Horus the Child". This is the infant son of Isis. Isis uses concealment and sorcery to protect him, especially from his uncle Seth and dangerous animals.

Harsiese – The maternal ancestry of the god Horus is emphasised by the name Harsiese, "Horus, son of Isis".

Hathor – The name of the goddess Hathor means "House of Horus" and refers to her role as mother or wife of Horus. However, she has many aspects: for example, she is a sky deity as well as being goddess of foreign lands, the afterlife, women, love, music, and pleasure. As a cow goddess, she was represented as a cow or, more often, only with parts of a cow's body, in particular with a crown made of cow horns and a sun disc. Her most famous temple is in Dendera.

heraldic plants of Upper and Lower Egypt – The heraldic plant for Upper Egypt is a plant that is now called a "lily" but had not yet been identified. The papyrus plant stands for Lower Egypt. If both plants are intertwined, this symbolises the "Unification of the Two Lands" and thus the unity of Egypt.

hieroglyphs – We use the Greek term hieroglyphs ("sacred engravings") for the script used in Ancient Egypt. The Egyptians themselves called their writing "the words of the gods". However, hieroglyphs in the narrower sense are also distinguished from the hieratic and Demotic scripts that developed from them. Hieroglyphs were used from about 3300 BCE until 450 CE.

Horus – The god Horus, often depicted as a falcon, is the son of Osiris and Isis. He is a sky and sun deity and the god of kingship. Important temples dedicated to Horus were located in Hierakonpolis (Egyptian Nekhen) and Edfu.

Horus name – The Horus name is the oldest known form of the Ancient Egyptian royal name and the first of the five traditional names of a Pharaoh. It depicts a falcon, the god Horus, on a representation of a palace. The upper part of the vertically rectangular sign contains the hieroglyphs of the king's name, while in the lower part the palace façade with its projections and recesses can be seen.

Imsety – see Children of Horus

Ipet – Ipet (Ipy, Opet) is a protective deity and goddess of motherhood, whose hippopotamus form also incorporates human, lion, and crocodile features. She was worshipped especially in Thebes and was equated with the goddess Taweret in the New Kingdom.

Isis – The goddess Isis is usually depicted as a woman, often with a throne as a hieroglyph for her name on her head. She is particularly characterised by her marriage to Osiris and her role as mother to Horus, both of whom she protects with her extraordinary magical power. The main cult sites of Isis were Philae and Iseum/Behbet el-Haggar.

Judges of the Dead – Alongside Osiris, the supreme judge, there were 42 other deities who acted as judges or assessors at the Judgement of the Dead. They often hold a knife in their hands with which to punish the condemned, from whom they obtain nourishment. Each of these judges is assigned a place of origin and a negative deed.

Judgement of the Dead – The Ancient Egyptians believed that before being admitted to the afterlife, the deceased had to undergo a trial. Here, the deceased person had to testify, among other things, that he had not done a number of criminal and unethical acts. To do this, his heart was weighed in a balance against the feather of the goddess Maat. If the scales did not remain balanced, the deceased died a second time and was finally annihilated.

Ka – The multifaceted concept of the Ka (or Ka-spirit) is of central significance in the Ancient Egyptian cult of the dead; it was usually the recipient of offerings made to a deceased person. The Ka is a kind of doppelganger and guardian spirit of the individual (and of the gods), which is created along with him. After death, the Egyptians hoped to be united with their Ka, who would ensure their status and their continued association with their family. The hieroglyph and symbol for the Ka is two raised arms.

kantharos – A kantharos is a Greek drinking vessel with a tall pedestal foot, goblet-like bowl, and two high-swung handles.

Khepri – Khepri ("the (self-)creating one") is the god of the rising sun. He is usually shown in the form of a scarab (Egyptian *kheperer*) or a human with a scarab for a head, as the Egyptians attributed similar characteristics to both the sun god and the scarab.

Khonsu – Khons or Khonsu means "traveller". Khonsu is a moon god and is considered the son of Amun and Mut. He is usually shown as a man in a tight robe, with a moon disc on his head, a sidelock of youth, and a crescent-shaped pectoral. In his hands he holds the *djed* pillar and the royal sceptres, the crook and flail. Besides Thebes, Kom Ombo and Edfu were important cult sites of this deity.

kilt – The most important item of clothing for men in Ancient Egypt was a short or long kilt-like garment made of linen and worn around the waist. Women could also wear a kilt when working. Certain forms of kilts are only found on the Pharaoh and the gods.

kohl pots – In Egyptology, containers for cosmetics are also called *kohl* pots. The name is derived from the Arabic word for (black) eye make-up.

lekythos – In Greek antiquity, a lekythos was a vessel for storing fragrant oils. Today, only oil flasks with a slender or squat body, projecting shoulder, narrow neck, and wide lip are so designated.

Maat – Maat is the goddess of world order, justice and truth. She is often depicted as a woman with an ostrich feather on her head. The ostrich feather can also stand alone to represent the goddess.

mankhet – The Egyptian term *mankhet* denotes an amulet in the shape of a tassel that was used as a counterweight to a decorative collar. References to this counterweight as both *menkhet*, "clothing", and *aper*, "equipment", are known. The amulet is therefore also called *aper* by Egyptologists.

Mastaba – The term mastaba derives from the Arabic word for "bench". In Egyptology it is used for tombs whose block-like superstructure has a rectangular base and sloping walls. Mastaba tombs made of bricks or stone were built from the First to the Twelfth Dynasty.

Medusa – In Greek mythology, Medusa is a terrifying figure with a head of hair consisting of snakes. Her gaze turns all living creatures to stone. After being cut off by the hero Perseus, her head can assume a protective function.

menat – The *menat* or *menyet* is part of a neck ornament, namely the counterweight of a broad collar made up of multiple rows of beads, so that it lay on the wearer's back. The *menat* with chains of beads was also used as a musical instrument in the cult of various goddesses. The *menat*, and also the aegis, were used in combination as cult objects and amulets.

menkhet – see *mankhet*

mekes – The cylindrical symbol with swallowtail-shaped ends, which was worn by the king, especially at the Sed festival, and also by gods, is called a *mekes*. In the Late Period, it was interpreted as a document case for holding a deed of inheritance guaranteeing dominion over Egypt.

Min – Min is a god of procreation and fertility. He is depicted as a human being with a crown consisting of two plumes. In his upheld right hand, he holds the sceptre in the form of a flail, and in his left his erect phallus. The main cult sites of Min were Coptos and Akhmim.

model – In Egyptology, the term "model" is used for various types of groups of objects. One type consists of miniature wooden sculptures depicting everyday scenes. These were used as grave goods from the late Old Kingdom to the early Middle Kingdom and were intended to provide for the needs of the deceased in the afterlife.

mummy label – In the Roman Period, small wooden plaques with Greek inscriptions were attached to mummies – these are known as mummy labels. In addition to the name of the deceased person, the inscriptions may contain information on his or her age, occupation, or family.

mummy portrait – Painted mummy portraits do not appear on Egyptian mummies until the Roman Period. These images in Graeco-Roman style were painted on fabric or wood using wax paint or tempera. Even though they appear to show real people of different ages, the question of their actual resemblance to the deceased is still a matter of debate among scholars.

Mut – The goddess Mut (probably "mother") is the wife of the god Amun and mother of Khonsu, the god of the moon. Mut is often depicted in human form, but she sometimes has a lion's head or takes the form of a cat.

Nekhbet – The goddess Nekhbet is the chief deity of Elkab and the patron deity of Upper Egypt. Her counterpart in Lower Egypt is the cobra-headed Wadjet of Buto. Nekhbet is depicted as a vulture, more rarely as a cobra, or as a woman wearing a vulture crown, frequently also with the White Crown.

Nefertem – Nefertem is a youthful god of the lotus flower, perfumes, and ointments. He is often depicted as a child with a lotus blossom on his head, sometimes supplemented by two feathers and two suspended *menats*. He is considered to be the son of Ptah and Sekhmet.

Neith – Neith is the goddess of war and hunting, of creation, of mothers and childbirth, and of the dead. She is goddess of Lower Egypt, with Sais as the main centre of her worship. She is usually depicted as a woman, wearing the Red Crown on her head or with her symbol of crossed arrows in front of a shield, often holding a bow and arrow in her hands. She is regarded as the mother of Sobek and Tutu.

nemes – The *nemes* is a type of crown very often worn by the Pharaoh, more rarely by gods. It takes the form of a headscarf, probably made of linen. The striped structure of the cloth created by artificial folds (pleating) is designed in the cosmic colours of blue and yellow.

Nephthys – The goddess Nephthys ("Mistress of the House") is the sister of Osiris and Isis, and is thus a funerary goddess, in particular. She is the sister-wife of Seth, but is said to have conceived her son Anubis by Osiris. She is usually shown as a woman with the hieroglyph of her name on her head.

New Year's Festival – Among the most important festivals in Ancient Egypt was the New Year Festival(s). A New Year's Festival was celebrated in accordance with astronomical phenomena ("the reappearance of Sirius") around the time when the Nile began to flood. A second New Year's Festival (also known as the "birthday of Re") was usually celebrated on a different day, namely on the first day of the Ancient Egyptian wandering year, which did not have a leap day. Ancient Egyptian festivals included offerings and rituals in temples as well as processions, and the New Year's Festival certainly also involved the exchanging of gifts.

Nile gods – Hapy, the god of the Nile and of water (not the child of Horus), is usually portrayed as a corpulent man with female breasts, a divine beard and wig, and a papyrus plant on his head. A pair of Nile gods can symbolise Upper and Lower Egypt and thus bring about the Unification of the Two Lands. Personifications of the nomes of Egypt are also often depicted as Nile gods.

nome – The administrative districts of Ancient Egypt are called *nomoi* in Greek, hence nomes. A canonical division into 22 Upper Egyptian and 20 Lower Egyptian nomes is found in the so-called "nome processions" on temple walls dating from the Graeco-Roman Period. This does not correspond to the administrative structure of the time, but is based on conditions in the Old Kingdom and religious ideas of the Late Period.

numina – The term numina (singular numen) is used for divine powers or spirits – forces in the natural process – that reside in objects or living beings, and are made perceptible through them.

Nun – Nun is the primeval ocean that existed before the world came into being and from which emerged the first land, the primeval mound, as well as the creator and sun god. It also surrounds the created world and can manifest itself in all waterbodies. In images, Nun is depicted as a man, or as a man with the head of a frog.

Nut – Nut is the Ancient Egyptian sky goddess and wife of the earth god Geb. Her children are Osiris, Isis, Seth, Nephthys, and Horus, as well as the heavenly bodies. She is usually depicted as a woman, sometimes winged, often naked with the sun and stars in her body. She can also be represented in a tree, or as a cow or sow. As for Osiris, she can take on the role of mother for the deceased and be identified with the coffin.

Obelisk – An obelisk is a tall, four-sided pillar, slightly tapering towards the top, with a pyramid-shaped tip. It is a cult object of the sun god. Stone obelisks are found in Sun Temples or in pairs in front of other temples and tombs. Smaller versions of obelisks are also found on various cult objects, for example on animal coffins made of bronze.

Osiris – Osiris is the most important Ancient Egyptian god of the dead. He is usually shown as a human mummy, with the *atef* crown and the sceptres of the Pharaoh (crook and flail). His wife Isis succeeds in bringing Osiris back to life after his murder, and only then does he become ruler of the underworld. His son Horus avenges his death and thus regains his inheritance from Osiris, namely rulership over Egypt. The principal cult centre of Osiris was Abydos.

Papyrus sceptre – A sceptre in the shape of a papyrus plant (*wadj*) already appears in the Early Dynastic Period in representations of the snake goddess Wadjet. From the Old Kingdom onwards, other Lower Egyptian goddesses and queens also wear it, and in the New Kingdom it becomes a general attribute of goddesses. The origin and meaning of this sceptre are uncertain.

Pataikoi – Pataikoi are naked, male, dwarf-like protective deities. They are most closely related to the god Ptah, but there are also some similarities to Bes and Harpocrates. Pataikoi have mainly survived in the form of amulets.

perfume cone – From the New Kingdom onwards, images show people wearing cone-shaped objects on their heads. This "perfume cone" or "unguent cone" was made of wax mixed with fragrant oils and plant essences, which would gradually melt over the wearer's head and clothing. Later, such cones were also included in depictions of deities.

pesesh-kef – The *pesesh-kef* is a cult implement that looks like a fishtail-shaped knife. Such knives were in use in Egypt until the Early Dynastic Period. The name is probably derived from the Egyptian words *pesesh* "to divide, split" and *kef* or *kaf* "flint". The *pesesh-kef* was used in rituals that served to animate mummies and statues, in the ceremony known as the Opening of the Mouth. It was also used as an amulet.

Pharaoh – Pharaoh is the term used today for the Ancient Egyptian king. It derives from the Egyptian word *per-aa*, meaning "big house".

Pharaonic – The term "Pharaonic" is generally used synonymously with "Ancient Egyptian". As an era with no binding definition, it is often used for the period extending from the First Dynasty until the beginning of the Greek Period, although Greek and Roman rulers in Egypt were also called Pharaohs.

pseudo-hieroglyphs – Pseudo-hieroglyphs are inscriptions that are intended to resemble (Egyptian) hieroglyphs, but use imitated or invented characters. Since those who produced them did not know the hieroglyphic writing system, knowledge of it does not enable these inscriptions to be deciphered. Their authors may have been illiterate Ancient Egyptian craftsmen, or ancient or modern artists, mystics, philosophers, or forgers.

Ptah – Ptah is a creator god and god of crafts. He always appears in human form, with a tight cap, tight robe, and royal beard. In his hands he holds the *was* sceptre and the signs for life (*ankh*) and durability (*djed*). Ptah was the chief deity of Memphis and is also identified with Apis, the bull god worshipped there. His wife is Sekhmet, and Nefertem is their son.

Ptah-Sokar-Osiris – From an early date, the Egyptians combined Ptah and Sokar, the chief deity of Memphis and a Memphite god of the dead, to form Ptah-Sokar, and later also with the god of the dead Osiris to form Ptah-Sokar-Osiris.

Pyramid Texts – From the late Fifth Dynasty until the end of the Old Kingdom, pyramids of Egyptian kings and queens were inscribed with texts; these are known as the Pyramid Texts. It is generally assumed that they were recited during funerary rituals. The main themes of the 750 utterances or spells are the care of the deceased, their journey through the afterlife, and their admittance into the realm of the gods. From the Middle Kingdom until the Late Period, these spells were also used by non-royal persons and some were incorporated into the Coffin Texts and the Book of the Dead.

Qebehsenuef – see Children of Horus

Re – Re (or Ra) is a name of the sun and creator god (see Atum), the most important deity of the Ancient Egyptians. He can appear in many forms, often as the sun or a man with an animal head, or as an animal altogether, especially a falcon, ram, or scarab. He travels in his barque across the sky and through the underworld. The main centre of his worship was Heliopolis.

Re-Horakhty – One of the most important names of the sun god was combined from Re and Horakhty (meaning "Horus of the horizon"). This morning sun god usually has a falcon's head, and the main centre of his cult was Heliopolis.

Red Crown – The Red Crown consists of a conical base from which a narrow projection rises at the back, while a wire with a spiral end protrudes upwards at the front. This crown is associated with Lower Egypt and is worn by the Pharaoh and various deities.

royal beard – Numerous images show the Pharaoh with an artificial chin beard. It is slightly wavy, widens towards the bottom and has a rectangular cross-section. This beard is also used for the god Ptah.

sa – The hieroglyph that writes the word *sa* ("protection (spell), amulet") is often called a loop or knot, but is actually a papyrus mat rolled up and tied at the ends. Amulets in the form of *sa* are rare.

scarab – The scarab, or dung beetle (*kheperer* in Egyptian) was associated with the verb *kheper* "to become, to arise, to transform" and Khepri, the god of the rising sun. The scarab is the most important Ancient Egyptian amulet. The heart scarab, inscribed with a certain chapter from the Book of the Dead, is placed on the heart of the mummy and is intended to prevent the heart from testifying against the deceased person at the Judgement of the Dead.

Sed festival – Besides the coronation of a king, the Sed festival was the most important Ancient Egyptian royal festival. It served to revitalise royal power. As a rule, it was celebrated after 30 years of the monarch's reign, and thereafter at intervals of a few years.

Sekhmet – Sekhmet is a goddess of war, but she also wields control over disease and has magical powers. Her name means "the powerful one". She is usually depicted as a woman with the head of a lioness. She was worshipped in Memphis along with her husband Ptah and her son Nefertem.

sema – see Unification of the Two Lands

Serapis – Serapis or Sarapis was a god who was introduced to Egypt in Ptolemaic Period and whose cult spread widely. Serapis combines features of the Egyptian Osiris-Apis and the Greek gods Zeus, Pluto, Dionysus, Poseidon, Asclepius, and Helios. The main centres of his cult in Egypt were Alexandria and Memphis.

Selkis – Selkis (or Serket, Selket) is a goddess whose full name is Serket-hetyt, "(she who) causes the throat to breathe". With her magical powers, she was considered the preserver of life, the goddess of mothers and of the dead, who together with Isis, Nephthys, and Neith protects the deceased and their organs. She is usually depicted as a woman with a scorpion on her head.

Seth – Seth is the god of the desert and foreign lands, of chaos and violence. But he is also considered the lord of Upper Egypt or protector of the sun god. Seth murdered his brother Osiris. Seth is usually depicted as a mythical creature with a long, curved snout, square ears and a vertically rising tail, or as a human being with the head of this animal. The primary centre of his cult was Ombos.

shen ring – The hieroglyph representing a cord arranged in a circle with its ends knotted at the bottom reads *shen* ("ring, circle, circumference"). The shen ring is closely associated with the Pharaoh and was used as a protective sign and amulet. A special form is the cartouche.

Shu – Shu is a god of air and light. He is the son of the creator god Atum, husband of Tefnut, and father of Geb and Nut. He is usually depicted as a man with an ostrich feather on his head, the hieroglyph for his name. His cult centre was Leontopolis.

sidelock of youth – An important element of the Ancient Egyptian hairstyle for children was a fairly long braid on the right side, rolled up at the end, while the rest of the head was shaved or shorn short. The sidelock of youth is also found on child gods and certain priests in Egypt.

sistrum – The sistrum is a rattle-like musical instrument that was used especially in the cult of the gods. Sistrums consist of a handle and a bracket or a chapel- or shrine-shaped frame through which movable bronze rods, some with bronze discs, are inserted.

sky hieroglyph – In iconography and in hieroglyphs, the sky is often depicted as a horizontal or curved blue band. At the ends, short spikes point downwards to form supports for the sky on the earth or on other supporting symbols.

Sobek – Sobek is the Ancient Egyptian crocodile god, rendered as a crocodile or a man with a crocodile head. He is also a god of the Nile and of water. Important sites for the cult of Sobek were Krokodilopolis and Kom Ombo.

Sphinx – A sphinx in the narrower sense is a sculpture depicting a lion's body with a human head or upper body. Ancient Egyptian sphinxes are originally, and most frequently, images of a Pharaoh or queen. Some gods, such as the sun god or Tutu, also take the form of a sphinx. The term sphinx is also used for statues of gods with the body of a lion and the head of another animal, e.g. the ram-headed sphinx.

stela – A stela or memorial stone is a stand-alone monument bearing inscriptions and/or text. They are often vertical slabs with a rounded top edge and are usually made of stone. Some important functional categories of Ancient Egyptian stelae are stelae for the deceased (funerary stelae), for gods (votive stelae), liminal/boundary stelae, donation stelae, and magical stelae (e. g. Horus stelae).

syncretism – In Egyptology, the term syncretism is used for the merging of deities, which is particularly evident in names such as Ptah-Sokar-Osiris, and/or by gods appropriating the functions and features of others, including in images. These relationships, which may be dissolved at any time, can be described as "indwelling" or "fusion", or by a god being named after the image, the appearance, the body, or the Ba of another deity.

Taweret – The name Taweret (in Greek: Thoëris) means "she who is great". It is used for various goddesses depicted as an upright pregnant hippopotamus with the back and tail of a crocodile, the limbs and paws of a lion, a divine wig, and the hands and breasts of a woman. Taweret holds the *sa* sign. She is considered the patron goddess of women during pregnancy, childbirth and lactation.

Tefnut – Tefnut is the daughter of the creator Atum and wife of Shu. Her precise character is unclear (moisture?, fire?). She is also equated with the Eye of Re. She is depicted in human form or as a woman with the head of a lioness. Cult centres of Tefnut were located in Heliopolis and Leontopolis.

Thoth – Thoth is the Ancient Egyptian god of the moon and of knowledge. He was considered the inventor of hieroglyphs. He is often depicted as a man with an ibis head, but also as an ibis or baboon. The main centre of his cult was Hermopolis.

throne name – From the Middle Kingdom onwards, the full title of the Pharaoh consisted of five names. The fourth name is today called the throne name and was the most important name of the reigning king. It is written in a cartouche. The throne name is often preceded by a title, especially "King of Upper and Lower Egypt" or also "Good God".

tit – A specific type of knot amulet is called *tit* or "Blood of Isis" or "Isis knot". Perhaps this was originally a tampon.

Tutu – The god Tutu, Tithoës in Greek, appears mainly on monuments of the Greek and Roman Periods. He is depicted as a striding sphinx or lion and can have many other animal heads, a tail in the shape of a snake, and wings. As the son of the war goddess Neith, his role was to protect against enemies, demons and diseases, and he also delivered oracles.

udjat – see eye of Horus

Unification of the Two Lands – The linking of the heraldic plants of Upper and Lower Egypt with the hieroglyph for union (windpipe and lung, Egyptian *sema*) is read as "Unification of the Two Lands". This symbol is closely associated with the coronation of the king and is often depicted on thrones. The knotting of the plants can be performed by Horus and Seth or by Nile gods.

Uraeus – Uraeus is a goddess in the form of a cobra. This is found, in particular, on the forehead of deities and members of the royal family and protects them by spitting out poison or fire. She can be equated with the goddess Wadjet and the Eye of Re.

shabti – Shabtis are mummy- or human-shaped statuettes that were mostly used as grave goods. Their Egyptian names can be translated by such terms as "answerer" and "substitute". In the afterlife, the shabtis were supposed to perform the work assigned to their owner. The corresponding spell can also be found in the Book of the Dead.

Vestibule – A vestibule is the entrance hall or forecourt of a building.

votive offering – A votive offering is a gift to a deity in connection with a vow – in expectation of, or after receiving, some divine favour. In a broader sense, it is understood to mean any dedicatory gift to a deity.

vulture crown – The vulture crown is a headdress in the shape of a vulture lying on its front with its head erect and its wings pointing down. It was initially worn by vulture goddesses such as Nekhbet and Mut when they were depicted as humans. Later it was used in depictions of queens and other goddesses, and finally deceased women.

wadj – The papyrus stem as a hieroglyph is also read as "green, fresh, young". From the New Kingdom onwards, it was used as an amulet, presumably to bestow youthfulness.

Wadjet – The goddess Wadjet (or Uto) is the main goddess of Buto and is regarded as the matron of Lower Egypt. Her Upper Egyptian partner is Nekhbet of Elkab. Wadjet ("the green one") is usually depicted as a cobra wearing the Red Crown, but sometimes also as a woman with the head of a lioness.

was sceptre – The cultic symbol known as a *was* is shaped like a staff which has the head of an indeterminate animal at the top and is forked at the bottom. It is worn by gods and the Pharaoh as a sign of power, and less frequently by other people. *Was* sceptres were also depicted as the pillars supporting the sky, and they were used as amulets.

Wenennefer – This popular name or epithet of the god Osiris can be translated as "He who exists (continuously) by being perfect".

Wepwawet – This god, whose name means "opener of the ways", is depicted as a – usually standing – canine (jackal or wolf) or as a man with a canine head. He is characterised as a god of the dead and as a god of war who especially protects the king. Important cult sites of Wepwawet were Asyut and Abydos.

White Crown – The White Crown is of conical shape tapering towards the top with a knob-like finial. It is associated with Upper Egypt and is worn by the Pharaoh and deities.

wreath of vindication – After the deceased has been judged innocent at the Judgement of the Dead, he or she receives a wreath from the gods as a symbol of triumph; this can be worn on the head like a crown.

Concordance

Manuela Gander, Marc Loth

The list includes those objects of the
Skulpturensammlung mentioned
in the catalogue as well as in the essays
or illustrated objects.

Inv. no.	cat. no. or essay
Aeg 10	cat. no. 25 ak
Aeg 19	cat. no. 25 ai
Aeg 30	cat. no. 25 ae
Aeg 36	cat. no. 25 ad
Aeg 39	cat. no. 24 b
Aeg 40	cat. no. 25 al
Aeg 102	cat. no. 25 g
Aeg 124(1)	cat. no. 34 f
Aeg 127(2)	cat. no. 25 ax
Aeg 129(3)	cat. no. 25 bc
Aeg 137	cat. no. 34 a
Aeg 137(4)	cat. no. 25 d
Aeg 138(4)	cat. no. 25 h
Aeg 138(8)	cat. no. 25 f
Aeg 138(15)	cat. no. 25 ao
Aeg 140	cat. no. 34 b
Aeg 140(1)	cat. no. 25 a
Aeg 140(4)	cat. no. 25 c
Aeg 140(8)	cat. no. 25 x
Aeg 140(12)	cat. no. 25 ay
Aeg 140(15)	cat. no. 25 z
Aeg 141(1)	cat. no. 25 n
Aeg 141(15)	cat. no. 25 k
Aeg 141(16)	cat. no. 25 m
Aeg 141(17)	cat. no. 25 ap
Aeg 141(20)	cat. no. 25 j
Aeg 141(22)	cat. no. 25 am
Aeg 142	cat. no. 34 c
Aeg 142(3)	cat. no. 25 az
Aeg 142(7)	cat. no. 25 e
Aeg 142(8)	cat. no. 25 i
Aeg 143(7)	cat. no. 25 q
Aeg 152	cat. no. 34 d
Aeg 157(3)	cat. no. 25 aw
Aeg 172	cat. no. 25 b
Aeg 176	cat. no. 34 e
Aeg 181	cat. no. 25 as
Aeg 205	essay Loth, fig. 7
Aeg 214(1)	cat. no. 25 ag
Aeg 214(2)	cat. no. 25 ah
Aeg 228	cat. no. 25 ba
Aeg 232	cat. no. 25 au
Aeg 239(a)	cat. no. 24 c
Aeg 239(b)	cat. no. 24 d
Aeg 245(1)	cat. no. 25 ar
Aeg 245(2)	cat. no. 25 av

Inv. no.	cat. no. or essay
Aeg 245(3)	cat. no. 25 bb
Aeg 262	cat. no. 10 a
Aeg 326	cat. no. 9 b
Aeg 332	cat. no. 9 c
Aeg 335	cat. no. 25 ac
Aeg 337	cat. no. 25 v
Aeg 343	cat. no. 25 o
Aeg 348	cat. no. 25 r
Aeg 370	cat. no. 25 s
Aeg 379	cat. no. 25 t
Aeg 398	cat. no. 28 a
Aeg 406	cat. no. 28 b
Aeg 425	cat. no. 28 c
Aeg 429	essay Loth
Aeg 436	essay Loth
Aeg 460	essay Loth
Aeg 462	cat. no. 27 a
Aeg 463	cat. no. 27 b
Aeg 466	cat. no. 6 b
Aeg 472	essay Seyfried, fig. 7
Aeg 473	cat. no. 7 d
Aeg 481	cat. no. 25 at
Aeg 482	cat. no. 25 u
Aeg 483	cat. no. 9 a
Aeg 487	cat. no. 11 b
Aeg 490	cat. no. 25 aq
Aeg 507	cat. no. 25 y
Aeg 508	cat. no. 25 w
Aeg 530	cat. no. 6 c
Aeg 549	cat. no. 7 c
Aeg 564	cat. no. 25 aa
Aeg 589	cat. no. 25 ab
Aeg 591	cat. no. 6 a
Aeg 613	cat. no. 24 e
Aeg 619	cat. no. 24 f
Aeg 621	cat. no. 24 g
Aeg 626	cat. no. 24 h
Aeg 640	cat. no. 6 d
Aeg 659	cat. no. 30 c
Aeg 664	cat. no. 7 e
Aeg 673	cat. no. 6 e
Aeg 686	cat. no. 7 a
Aeg 690	cat. no. 26 a
Aeg 691	cat. no. 26 b
Aeg 692	cat. no. 26 c
Aeg 693	cat. no. 26 d

Inv. no.	cat. no. or essay	Inv. no.	cat. no. or essay	Inv. no.	cat. no. or essay
Aeg 694	essay Loth	Aeg 773	essay Loth	H1 093/405	essay Loth, fig. 2
Aeg 695	essay Loth	Aeg 775	cat. no. 29	H1 093/406	essay Loth, fig. 2
Aeg 696	essay Loth	Aeg 776	essay Loth	H4 134/40	essay Loth
Aeg 698	essay Loth	Aeg 777	cat. no. 20 a	H4 146/218 a	cat. no. 23 c
Aeg 699	essay Loth	Aeg 778	cat. no. 20 b	H4 146/218 b	cat. no. 23 d
Aeg 700	essay Loth	Aeg 779	essay Loth	H4 146/218 c	cat. no. 23 g
Aeg 701	essay Loth	Aeg 780	cat. no. 19	H4 146/218 d	cat. no. 23 h
Aeg 702	essay Loth	Aeg 781	essay Loth	H4 146/218 e	cat. no. 23 e
Aeg 703	essay Loth	Aeg 782	cat. no. 21	H4 146/218 f	cat. no. 23 f
Aeg 705	essay Loth	Aeg 783	essay Loth	K 1180	essay Loth
Aeg 706	essay Loth	Aeg 784	essay Loth; essay Seyfried, fig. 3	o. Inv. 133	cat. no. 5, fig. 2
Aeg 707	essay Loth	Aeg 785	essay Loth	o. Inv. 161	cat. no. 25 af
Aeg 722	cat. no. 7 b	Aeg 786	essay Loth	o. Inv. 177	cat. no. 25 p
Aeg 726	cat. no. 24 a	Aeg 787	essay Loth	o. Inv. 300	cat. no. 25 l
Aeg 735	cat. no. 30 b	Aeg 788(a–b)	cat. no. 23 a	o. Inv. 307	cat. no. 25 an
Aeg 736	cat. no. 8 a	Aeg 789(1–2)	cat. no. 23 b	ZV 30,15	essay Loth, fig. 8
Aeg 741	essay Loth	Aeg 790	cat. no. 22 j	ZV 1557	cat. no. 31 b
Aeg 742	cat. no. 1 a	Aeg 791	cat. no. 22 a	ZV 1562	cat. no. 33 a
Aeg 743	cat. no. 1 b	Aeg 792	cat. no. 22 b	ZV 1563	cat. no. 33 b
Aeg 744	cat. no. 1 c	Aeg 793	cat. no. 22 c	ZV 1569	cat. no. 31 c
Aeg 745	cat. no. 1 d	Aeg 794	cat. no. 22 d	ZV 1586	cat. no. 31 a
Aeg 746	cat. no. 1 e	Aeg 795	cat. no. 22 e	ZV 2600 B 045	cat. no. 11 a
Aeg 747	cat. no. 1 f	Aeg 796	essay Loth	ZV 2600 B 189	cat. no. 10 b
Aeg 748	essay Loth	Aeg 797	cat. no. 22 f	ZV 2600 B 192	cat. no. 3 b
Aeg 749	cat. no. 14 a	Aeg 798	cat. no. 22 g	ZV 2600 B 202	cat. no. 3 c
Aeg 750	cat. no. 14 b	Aeg 799	cat. no. 22 h	ZV 2600 E 001	cat. no. 13 b
Aeg 751	cat. no. 14 c	Aeg 800	cat. no. 22 i	ZV 2600 E 002	cat. no. 13 a
Aeg 752	essay Loth	Aeg 801	essay Loth	ZV 2600 E 005	cat. no. 32 a
Aeg 753	essay Loth	Aeg 803	essay Loth	ZV 2600 E 053	cat. no. 32 c
Aeg 754	cat. no. 17 a	Aeg 807	essay Loth	ZV 2600 E 065	cat. no. 32 b
Aeg 755	cat. no. 17 b	Aeg 818	cat. no. 8 b	ZV 2600 E 083	cat. no. 33 c
Aeg 756	essay Loth	Aeg 819	cat. no. 11 d	ZV 2600 K 135	cat. no. 33 f
Aeg 757 a	cat. no. 15 a	Aeg 821	essay Seyfried, fig. 4	ZV 2600 K 143	cat. no. 33 e
Aeg 757 b	cat. no. 15 b	Aeg 823	essay Seyfried, fig. 6	ZV 2807	cat. no. 16 a
Aeg 757 c	cat. no. 15 c	Aeg 827	cat. no. 33 d	ZV 3466	cat. no. 31 d
Aeg 758	cat. no. 4	Aeg 828	cat. no. 30 a	ZV 3947	cat. no. 25 aj
Aeg 759	cat. no. 18	ASN 4749	essay Loth, fig. 6	ZV 3963	cat. no. 16 b
Aeg 760	essay Loth, fig. 2	Hm 16	cat. no. 12 a		
Aeg 761	cat. no. 17 c	Hm 17	Kat. 12	present whereabouts unknown	
Aeg 763	essay Loth	Hm 18	cat. no. 12 b	(child mummy)	essay Loth
Aeg 764	essay Loth	Hm 19	essay Loth, fig. 5		
Aeg 765	cat. no. 3 a	Hm 20	essay Loth, fig. 5		
Aeg 766	cat. no. 11 c	Hm 21	essay Loth, fig. 5		
Aeg 767	essay Loth	Hm 22	essay Loth, fig. 5		
Aeg 768	cat. no. 5	Hm 23	essay Loth, fig. 3		
Aeg 769	cat. no. 2				

Bibliography

Albersmeier 2002 – Sabine Albersmeier, *Untersuchungen zu den Frauenstatuen des ptolemäischen Ägypten,* Aegyptiaca Treverensia 10, Mainz 2002

Andrews 1990 – Carol Andrews, *Ancient Egyptian Jewellery,* London 1990

Andrews 1994 – Carol Andrews, *Amulets of Ancient Egypt,* London 1994

Arnold 1997 – Dieter Arnold, *Lexikon der ägyptischen Baukunst,* 2. Ed. Düsseldorf and Zurich 1997

Arnold 2012 – Dorothea Arnold, *Die ägyptische Kunst,* Munich 2012

Arnold/Pischikova 1999 – Dorothea Arnold and Elena Pischikova, "Les Vases de pierre, des produits de luxe aux implications multiples", in: *L'Art égyptien au temps des pyramides*. Paris, Galeries nationales du Grand Palais, 6 avril – 12 juillet 1999, New York, The Metropolitan Museum of Art, 16 septembre 1999 – 9 janvier 2000, Toronto, Musée royal de l'Ontario, 13 février – 22 mai 2000, Paris 1999, 112–118

Arnst 1998 – Caris-Beatrice Arnst, "Vernetzung. Zur Symbolik des Mumiennetzes", in: *Die ägyptische Mumie. Ein Phänomen der Kulturgeschichte. Beiträge eines Workshops am Seminar für Sudanarchäologie und Ägyptologie der Humboldt-Universität zu Berlin (25. und 26. April 1998)*, ed. by Martin Fitzenreiter and Christian E. Loeben, Internet-Beiträge zur Ägyptologie und Sudanarchäologie, 1, Berlin 1998, 79–93

Ashton 2001 – Sally-Ann Ashton, *Ptolemaic Royal Sculpture. The Interaction between Greek and Egyptian Traditions,* BAR International Series, 923, Oxford 2001

Assmann 1991 – Jan Assmann, *Ägypten. Theologie und Frömmigkeit einer frühen Hochkultur,* 2. Ed., Stuttgart, Berlin and Cologne 1991

Assmann 1996 – Jan Assmann, *Ägypten. Eine Sinngeschichte,* Munich and Vienna 1996

Assmann 2002 – Jan Assmann, *Das kulturelle Gedächtnis. Schrift, Erinnerung und politische Identität in frühen Hochkulturen,* 4. Ed., Munich 2002

Assmann 2003 a – Jan Assmann, *Stein und Zeit. Mensch und Gesellschaft im alten Ägypten,* 3. Ed., Darmstadt 2003

Assmann 2003 b – Jan Assmann, *Tod und Jenseits im Alten Ägypten,* Munich 2003

Assmann/Kucharek 2008 – Jan Assmann and Andrea Kucharek, *Ägyptische Religion. Totenliteratur,* Frankfurt am Main and Leipzig 2008

Aston 1994 – Barbara G. Aston, *Ancient Egyptian Stone Vessels. Materials and Forms,* Studien zur Archäologie und Geschichte Altägyptens, 5, Heidelberg 1994

Aston/Harrell/Shaw 2000 – Barbara G. Aston, James A. Harrell and Ian Shaw, "Stone", in: *Ancient Egyptian Materials and Technology*, ed. by Paul T. Nicholson and Ian Shaw, Cambridge 2000, 5–77

Baines/Málek 1980 – John Baines and Jaromir Málek, *Weltatlas der Alten Kulturen Ägypten. Geschichte, Kunst, Lebensformen*, Munich 1980

Bard 1999 – Kathryn A. Bard (ed.), *Encyclopedia of the Archaeology of Ancient Egypt,* London and New York 1999

Becker 1804 – Wilhelm Gottlieb Becker, *Augusteum. Dresden's antike Denkmäler enthaltend* 1. vol., Leipzig 1804

Bericht 1896/1897 – *Bericht über die Verwaltung und Vermehrung der Königlichen Sammlungen für Kunst und Wissenschaft in Dresden während der Jahre 1896 und 1897*

Bierbrier 1997 – Morris L. Bierbrier (ed.), *Portraits and Masks. Burial Customs in Roman Egypt,* London 1997

Bierbrier 2019 – Morris L. Bierbrier, *Who Was Who in Egyptology,* 5. rev. Ed., London 2019

Bissing/Kees 1923 – Friedrich Wilhelm von Bissing and Hermann Kees, *Das Re-Heiligtum des Königs Ne-woser-re (Rathures),* vol. 2. *Die kleine Festdarstellung,* Leipzig 1923

Bissing/Kees 1928 – Friedrich Wilhelm von Bissing and Hermann Kees, *Das Re-Heiligtum des Königs Ne-woser-re (Rathures),* vol. 3. *Die grosse Festdarstellung,* Leipzig 1928

Böhme 2007 – Alexandra Böhme, *Konservierung und Restaurierung einer ägyptischen Skulptur,* Studienbezogenes Praktikum. Unpubl. Paper, Dresden 2007

Bonnet 2000 – Hans Bonnet, *Lexikon der ägyptischen Religionsgeschichte,* 3. Ed., Hamburg 2000

Borbein et al. 2006 – Adolf H. Borbein et al. (ed.), *Johann Joachim Winckelmann. Geschichte der Kunst des Alterthums. Katalog der antiken Denkmäler, Erste Auflage Dresden 1764, Zweite Auflage Wien 1776,* Johann Joachim Winckelmann, Schriften und Nachlaß, 4,2, Mainz 2006

Borg 1998 – Barbara Borg, *"Der zierlichste Anblick der Welt …". Ägyptische Porträtmumien,* Mainz 1998

Bothe 2000 – Rolf Bothe, "Gentz oder Goethe, das ist hier die Frage. Anmerkungen zu Treppenhaus und Festsaal im Weimarer Schloß", in: *Deutsche Baukunst um 1800*, ed. by Reinhard Wegner, Cologne, Weimar and Vienna 2000, 165–190

Bourriau/Nicholson/Rose 2000 – Janine D. Bourriau, Paul T. Nicholson and Pamela J. Rose, "Pottery", in: *Ancient Egyptian Materials and Technology*, ed. by Paul T. Nicholson and Ian Shaw, Cambridge 2000, 121–147

Brophy 2015 – Elisabeth Brophy, *Royal Statues in Egypt 300 BC-AD 220. Context and Function,* Archaeopress Egyptology, 10, Oxford 2015

Bryan 1997 – Betsy M. Bryan, "The Statue Program for the Mortuary Temple of Amenhotep III", in: *The Temple in Ancient Egypt. New Discoveries and Recent Research. Papers from a Colloquium Held at the British Museum Department of Egyptian Antiquities, July 21–22, 1994*, ed. by Stephen Quirke, London 1997, 57–81

Bryan 2010 – Betsy M. Bryan, "Amenhotep III's Legacy in the Temple of Mut", in: *Offerings to the Discerning Eye. An Egyptological Medley in Honor of Jack A. Josephson*, ed. by Sue H. D'Auria, Culture and History of the Ancient Near East, 38, Leiden and Boston 2010, 63–72

Budka/Mekis 2017 – Julia Budka and Tamás Mekis, "The Family of Wah-ib-Re I (TT 414) from Thebes", in: *Ägypten und Levante,* 27 (2017), 219–239

Cantone 2013 – Valentina Cantone, "The Syncretic Portrait. Visual Contaminations in Early Christian Art", in: *The Face of the Dead and the Early Christian World. Proceedings of the International Conferences, Masaryk University, Brno, 18th October 2012*, ed. by Ivan Foletti, Studia Artium Medievalium Brunensia, 1, Rome 2013, 107–122

Cat. Berlin 2002 – Staatliche Kunstsammlungen Dresden and Staatliche Museen zu Berlin, Stiftung Preußischer Kulturbesitz (ed.), *Nach der Flut. Die Dresdener Skulpturensammlung in Berlin*, Begleitbuch zur Ausstellung im Martin-Gropius-Bau Berlin vom 22. November 2002 bis 10. Februar 2003, Leipzig 2002

Cat. Berlin 2015 – Klaus Finneiser et al., *Alltag – Luxus – Schutz. Schmuck im Alten Ägypten*, Sonderschriften der Ägyptischen Sammlung, 3, Berlin 2015

Cat. Bonn 1996 – Christina Regner, *Schminkpaletten*, Bonner Sammlung von Aegyptiaca, 2, Wiesbaden 1996

Cat. Bonn 2004 – Silke Grallert and Isabel Stünkel (ed.), *Ägyptisches Museum. Bonner Sammlung von Aegyptiaca*, Bonn 2004

Cat. Bonn 2012 – Marcus Müller-Roth and Michael Höveler-Müller (ed.), *Grenzen des Totenbuchs. Ägyptische Papyri zwischen Grab und Ritual / Beyond the Book of the Dead. Egyptian Papyri between Tomb and Ritual*, Erschienen anlässlich der Sonderausstellung "Grenzen des Totenbuchs" im Ägyptischen Museum der Universität Bonn vom 1. März bis 20. Mai 2012, Rahden 2012

Cat. Chemnitz 2017 – Staatliches Museum für Archäologie Chemnitz (ed.), *Tod & Ritual. Kultur von Abschied und Erinnerung*, Begleitband zur gleichnamigen Sonderausstellung im Staatlichen Museum für Archäologie Chemnitz vom 16. November 2017 bis 21. Mai 2018, Ausstellungskataloge des Staatlichen Museums für Archäologie Chemnitz, 1, Dresden 2017

Cat. Cleveland 1992 – Arielle P. Kozloff, Betsy M. Bryan and Laurence M. Berman, *Egypt's Dazzling Sun. Amenhotep III and His World*, Cleveland 1992

Cat. Dresden 1889 – Generaldirektion der Königlichen Sammlungen (ed.), *Führer durch die Königlichen Sammlungen zu Dresden*, Dresden 1889

Cat. Dresden 1896 – Generaldirektion der Königlichen Sammlungen (ed.), *Führer durch die Königlichen Sammlungen zu Dresden*, 3. Ed., Dresden 1896

Cat. Dresden 1914 – Generaldirektion der Königlichen Sammlungen für Kunst und Wissenschaft (ed.), *Führer durch die Königlichen Sammlungen zu Dresden*, 12. Ed., Dresden 1914

Cat. Dresden 1920 – Ministerium des Kultus und öffentlichen Unterrichts (ed.), *Führer durch die Staatlichen Sammlungen zu Dresden*, 14. Ed., Dresden 1920

Cat. Dresden 1922 – Ministerium des Kultus und öffentlichen Unterrichts (ed.), *Führer durch die Staatlichen Sammlungen zu Dresden*, 15. Ed., Dresden 1922

Cat. Dresden 1961 – Martin Raumschlüssel and Hans Hoffmann, *Staatliche Kunstsammlungen Dresden. Katalog der verkäuflichen Gipsabgüsse*, [Dresden 1961?]

Cat. Dresden 1977 – Steffen Wenig (ed.), *Ägyptische Altertümer aus der Skulpturensammlung Dresden*, Ausstellung im Albertinum, Dresden 1977

Cat. Dresden 1993 – Gudrun Elsner, *Ägyptische Altertümer der Skulpturensammlung*, Ausstellung im Albertinum zu Dresden 30. Juli 1993 – 24. Juli 1994, Dresden 1993

Cat. Dresden 1995 – Susanne Hahn (ed.), *Herz. Das menschliche Herz – Der herzliche Mensch*, Begleitbuch zur Ausstellung "Herz" vom 5. Oktober 1995 bis 31. März 1996 im Deutschen Hygiene-Museum, Dresden and Basel 1995

Cat. Dresden 1998 – Staatliche Kunstsammlungen Dresden (ed.), *Zurück in Dresden. Eine Ausstellung ehemals vermißter Werke aus Dresdener Museen*, Anläßlich der Ausstellung im Dresdner Schloß – Georgenbau, vom 9. April bis 12. Juli 1998, Eurasburg 1998

Cat. Dresden 2002 – Stiftung Deutsches Hygiene-Museum (ed.), *Mensch und Tier. Eine paradoxe Beziehung*, Begleitbuch zur Ausstellung […] 22. November 2002 bis 10. August 2003, Ostfildern-Ruit 2002

Cat. Dresden 2004 – Joachim Marzahn (ed.), *Könige am Tigris. Assyrische Palastreliefs in Dresden*, Katalogbuch zur Ausstellung der Skulpturensammlung im Albertinum, Dresden, 20. März – 29. September 2004, ed. by Skulpturensammlung, Staatliche Kunstsammlungen Dresden, in Zusammenarbeit mit dem Vorderasiatischen Museum Berlin, Staatliche Museen zu Berlin – Preußischer Kulturbesitz, Mainz 2004

Cat. Dresden 2011 – Kordelia Knoll, Christiane Vorster and Moritz Woelk, *Staatliche Kunstsammlungen Dresden, Skulpturensammlung – Katalog der antiken Bildwerke, 2. Idealskulptur der römischen Kaiserzeit*, 2 vols., Munich 2011

Cat. Dresden 2014 – Staatliche Kunstsammlungen Dresden and Kunstsammlung Nordrhein-Westfalen, Düsseldorf (ed.), *Paul Klee. Die Reise nach Ägypten 1928/29*, Publikation anlässlich der Ausstellung "Nach Ägypten! Die Reisen von Max Slevogt und Paul Klee", Dresden 2014

Cat. Dresden 2018 – Catherine Nichols (ed.), *Shine on me. Wir und die Sonne*, Begleitband zur gleichnamigen Ausstellung in Dresden 28. September 2018 – 18. August 2019, Göttingen 2018

Cat. Dresden 2020a – Staatliche Kunstsammlungen Dresden, Stephan Koja (ed.), *Glanzstücke. Gemäldegalerie Alte Meister, Skulpturensammlung bis 1800*, Dresden 2020

Cat. Dresden 2020b – Staatliche Kunstsammlungen Dresden, Stephan Koja (ed.), *Skulpturensammlung bis 1800*, Dresden 2020

Cat. Frankfurt 1993 – Vera von Droste zu Hülshoff et al., *Liebighaus – Museum alter Plastik, Ägyptische Kunstwerke, vol. 3. Skulptur, Malerei, Papyri und Särge*, Melsungen 1993

Cat. Frankfurt 1999 – Klaus Parlasca and Hellmut Seemann (ed.), *Augenblicke. Mumienporträts und ägyptische Grabkunst aus römischer Zeit*, Eine Ausstellung der Schirn-Kunsthalle Frankfurt, 30. Januar bis 11. April 1999, Frankfurt am Main and Munich 1999

Cat. Fribourg 2010 – Christian Herrmann and Thomas Staubli, *1001 Amulett. Altägyptischer Zauber, monotheistische Talismane, säkulare Magie*, Fribourg/ Switzerland and Stuttgart 2010

Cat. Grenoble 2018 – Florence Gombert-Meurice and Frédéric Payraudeau (ed.), *Servir les dieux d'Égypte. Divines adoratrices, chanteuses et prêtres d'Amon à Thèbes*, Paris 2018

Cat. Hildesheim 2006 – Katja Lembke and Bettina Schmitz (ed.), *Schönheit im Alten Ägypten. Sehnsucht nach Vollkommenheit*, Hildesheim, Roemer- und Pelizaeus-Museum, and Karlsruhe, Badisches Landesmuseum, Hildesheim 2006

Cat. Leipzig 1989 – Elke Blumenthal et al., *Ägyptische Kunst aus der Skulpturensammlung der Staatlichen Kunstsammlungen Dresden*, Ausstellungszentrum Kroch-Haus, Universität Leipzig, Leipzig 1989

Cat. London 2008 – François-René Herbin, *Books of Breathing and Related Texts*, Catalogue of the Books of the Dead and Other Religious Texts in the British Museum, 4, London 2008

Cat. London 2010 – John H. Taylor, *Journey through the Afterlife. Ancient Egyptian Book of the Dead,* London 2010

Cat. Munich 1990 – Sylvia Schoske, *Schönheit – Abglanz der Göttlichkeit. Kosmetik im Alten Ägypten,* Munich 1990

Cat. Munich 2010 – Sylvia Schoske and Alfred Grimm, *Friedrich Wilhelm Freiherr von Bissing. Ägyptologe – Mäzen – Sammler,* Recherchen zu Aegyptiaca in München, Studien zur Erwerbungsgeschichte der Sammlung, 5, Munich 2010

Cat. New York 2015 – Edward Bleiberg, Yekatarina Barbash and Lisa Bruno, *Soulful Creatures. Animal Mummies in Ancient Egypt,* New York, Minneapolis and London 2013

Cat. Paris 2004 a – Marie-France Aubert and Roberta Cortopassi, *Portraits funéraires de l'Égypte romaine,* vol. 1. *Masques en stuc,* Musée du Louvre, Département des Antiquités égyptiennes, Catalogue, Paris 2004

Cat. Paris 2004 b – Annie Gasse, *Les stèles d'Horus sur les crocodiles,* Musée du Louvre, Département des Antiquités égyptiennes, Catalogue, Paris 2004

Cat. Paris/Ottawa/Vienna 1994 – *Ägyptomanie. Ägypten in der europäischen Kunst 1730–1930,* Paris, Ottawa, Vienna and Milan 1994

Cat. Rome 1996 – Loredana Sist, *Museo Barraco. Arte egizia,* Quaderno, 2, Rome 1996

Cat. Stuttgart 2007 – Landesmuseum Württemberg (ed.), *Ägyptische Mumien. Unsterblichkeit im Land der Pharaonen,* Große Landesausstellung vom 6. Oktober 2007 bis 24. März 2008, Stuttgart and Mainz 2007

Cat. Zurich 2008 – Elena Mango, Joachim Marzahn and Christoph Uehlinger, *Könige am Tigris – Medien assyrischer Herrschaft,* Begleitbuch zur Ausstellung […] in der Archäologischen Sammlung der Universität Zürich, 18. April bis 31. August 2008, Zurich 2008

Corcoran 1995 – Lorelei H. Corcoran, *Portrait Mummies from Roman Egypt (I – IV Century A. D.) with a Catalogue of Portrait Mummies in Egyptian Museums,* Studies in Ancient Oriental Civilization, 56, Chicago 1995

Davies 1933 – Norman de Garis Davies, *The Tombs of Menkheperrasonb, Amenmosĕ, and Another (Nos 86, 112, 42, 226),* The Theban Tombs Series, 5, London 1933

Davies/Macadam 1957 – Norman de Garis Davies and M. F. L[aming] Macadam, *A Corpus of Inscribed Egyptian Funerary Cones,* part 1, Oxford 1957

Della Valle 1674 – Pietro della Valle, *Eines vornehmen Roemischen Patritii Reiß-Beschreibung in unterschiedliche Theile der Welt …,* Geneva 1674

Deutscher Museumsbund 2021 – Deutscher Museumsbund e. V. (ed.), *Leitfaden. Umgang mit menschlichen Überresten in Museen und Sammlungen,* Berlin 2021

Díaz Hernández 2014–2015 – Roberto A. Díaz Hernández, "Zur Entstehung des ägyptischen Museums in Deutschland. Von der fürstlichen Kunstkammer zum Ägyptischen Museumssaal", in: *Curiositas,* 14–15 (2014–2015), 59–75

Dibley/Lipkin 2009 – Gary Dibley and Bron Lipkin, *A Compendium of Egyptian Funerary Cones,* London 2009

Dieleman 2014 – Jacco Dieleman, "Scribal Routine in Two Demotic Documents for Breathing. Papyri Vienna D 12017 and 12019", in: *Gehilfe des Thot. Festschrift für Karl-Theodor Zauzich zu seinem 75. Geburtstag,* ed. by Sandra Lippert, Luisa and Martin Andreas Stadler, Wiesbaden 2014, 29–42

Dijk 2001 – Jacobus van Dijk, "Ptah", in: *The Oxford Encyclopedia of Ancient Egypt* vol. 3, ed. by Donald B. Redford, Oxford 2001, 74–76

Dodson/Ikram 2008 – Aidon Dodson and Salima Ikram, *The Tomb in Ancient Egypt. Royal and Private Sepulchres from Early Dynastic Period to the Romans,* London 2008

Donadoni 2004 – Sergio Donadoni (ed.), *Der Mensch des Alten Ägypten,* Essen 2004

Doxiadis 1995 – Euphrosyne Doxiadis, *The Mysterious Fayum Portraits. Faces from Ancient Egypt,* London 1995

Dubiel 2011 – Ulrike Dubiel, "Pharao – Gott – Wächter. Sphingen im Alten Ägypten", in: *Wege der Sphinx. Monster zwischen Orient und Okzident,* Eine Ausstellung der Abguss-Sammlung Antiker Plastik des Instituts für Klassische Archäologie der Freien Universität Berlin, ed. by Lorenz Winkler-Horaček, Rahden 2011, 5–38

Ebers – Georg Ebers, "Bemerkenswerthes Neues, welches sich aus dem Studium der Gemming'schen Sammlung (im japanischen Palais zu Dresden) ergiebt", in: *Zeitschrift für Ägyptische Sprache und Alterthumskunde,* 19 (1881), 66–70

El-Khouli 1978 – Ali Abdel-Rahman Hassanain El-Khouli, *Egyptian Stone Vessels. Predynastic Period to Dynasty III. Typology and Analysis,* 3 vols., Mainz 1978

El-Sayed 1976 – Ramadan El-Sayed, "A propos du titre ḥrp-ḥwwt", in: *Revue d'Égyptologie,* 26 (1976), 97–110

Enking 1939 – Ragna Enking, *Der "Apis-Altar" Johann Melchior Dinglingers. Ein Beitrag zur Auseinandersetzung des Abendlandes mit dem alten Ägypten,* Glückstadt, Hamburg and New York 1939

Fischer 1994 – Jutta Fischer, Griechisch-römische Terrakotten aus Ägypten. Die Sammlungen Sieglin und Schreiber. Dresden, Leipzig, Stuttgart, Tübingen, Tübinger Studien zur Archäologie und Kunstgeschichte, 14, Tübingen 1994

Fitzenreiter 2013 – Martin Fitzenreiter, *Tierkulte im pharaonischen Ägypten,* Ägyptologie und Kulturwissenschaft, 5, Munich 2013

Fletcher 1999 – Joann Fletcher, *Oils and Perfumes of Ancient Egypt,* New York 1999

Gander/Loth 2019 – Manuela Gander and Marc Loth, "Die ägyptischen Bestände der Skulpturensammlung Dresden. Geschichte und Perspektiven", in: *Amun,* 21, no. 58 (2019), 46–51

Gertzen 2017 – Thomas Gertzen, *Einführung in die Wissenschaftsgeschichte der Ägyptologie,* Einführungen und Quellentexte zur Ägyptologie, 10, Berlin 2017

Girgensohn 1893 – Joseph Girgensohn, "Stackelberg, Otto Magnus Freiherr von", in: *Allgemeine Deutsche Biographie* 35 (1893), 340–353 (https://www.deutsche-biographie.de/pnd118798359.html #adbcontent [accessed 23 April 2022])

Grimm 1974 – Günter Grimm, *Die römischen Mumienmasken aus Ägypten,* Wiesbaden 1974

Harpur 1985 – Yvonne Harpur, "The Identity and Position of Relief Fragments in Museums and Private Collections", in: *Journal of Egyptian Archaeology,* 71 (1985), 27–42

Harpur 1987 – Yvonne Harpur, *Decoration in Egyptian Tombs of the Old Kingdom. Studies in Orientation and Scene Content,* London and New York 1987

Hartwig 2013 – Melinda Hartwig (ed.), *The Tomb Chapel of Menna (TT 69). The Art, Culture, and Science of Painting in an Egyptian Tomb,* American Research Center in Egypt Conservation Series, 5, Cairo and New York 2013

Hartwig 2015 – Melinda K. Hartwig (ed.), *A Companion to Ancient Egyptian Art,* Chichester 2015

Hase 1833 – Heinrich Hase, *Verzeichniss der alten und neuen Bildwerke und übrigen Alterthümer in den Sälen der Kgl. Antikensammlung zu Dresden,* 3., rev. Ed., Dresden 1833

Hase 1839 – Heinrich Hase, *Verzeichniss der alten und neuen Bildwerke und übrigen Alterthümer in den Sälen der Kgl. Antiken-Sammlung zu Dresden,* 5. Ed., Dresden 1839

Hausmann 1979 – Franz Josef Hausmann, "Eine vergessene Berühmtheit des 18. Jahrhunderts. Der Graf Caylus, Gelehrter und Literat" in: *Deutsche Vierteljahresschrift für Literaturwissenschaft und Geistesgeschichte,* 53 (1979), 191–209

Heinrich 2017 – Monique Heinrich, *Ägyptische Wandmalereifragmente im Albertinum Dresden (Inv.-Nr. Aeg 757a–c). Recherchen zu Objekt- und Restaurierungsgeschichte, Dokumentation von Bestand und Erfassen der Zustandsphänomene*, unpubl. paper, Dresden 2017

Heinrich 2020 – Monique Heinrich, "Ägyptische Wandmalereifragmente aus einem Grab in Theben", in: *Restaurierte Meisterwerke zur Wiedereröffnung der Sempergalerie*, ed. by Staatliche Kunstsammlungen Dresden, Stephanie Exner, Marlies Giebe and Stephan Koja, Dresden 2020, 138–143

Herrmann 1915 – Paul Herrmann, *Kgl. Skulpturen-sammlung-Dresden. Verzeichnis der antiken Original-Bildwerke,* Dresden 1915

Herrmann 1925 – Paul Herrmann, *Verzeichnis der antiken Originalbildwerke der Staatlichen Skulpturensammlung zu Dresden*, 2. Ed., Berlin and Dresden 1925

Hettner 1869 – Hermann Hettner, *Die Bildwerke der Königlichen Antikensammlung zu Dresden*, 2., rev. Ed., Dresden 1869

Hettner 1881 – Hermann Hettner, *Die Bildwerke der Königlichen Antikensammlung zu Dresden*, 4. Ed., Dresden 1881

Hill 2000 – Marsha Hill, *Ancient Egyptian Royal Bronzes, with Special Attention to the Kneeling Pose*, Dissertation, New York 2000.

Hölscher 2015 – Tonio Hölscher, *Klassische Archäologie. Grundwissen*, 4., rev. and ext. Ed., Darmstadt 2015

Hölzl 2001 – Regina Hölzl, "Stelae", in: *The Oxford Encyclopedia of Ancient Egypt*, vol. 3, ed. by Donald B. Redford, Oxford 2001, 319–324

Hope 2001 – Colin A. Hope, *Egyptian Pottery*, Shire Egyptology, 5, 2. Ed., Buckinghamshire 2001

Hornung 1993 a – Erik Hornung, *Geist der Pharaonenzeit*, 2. Ed., Munich 1993

Hornung 1993 b – Erik Hornung, *Das Totenbuch der Ägypter*, Munich and Zurich 1993

Hornung 2005 – Erik Hornung, *Der Eine und die Vielen. Altägyptische Götterwelt*, 6., rev. and ext. Ed., Darmstadt 2005

Hornung/Krauss/Warburton 2006 – Erik Hornung, Rolf Krauss and David Warburton (ed.), *Ancient Egyptian Chronology*, Handbook of Oriental Studies, 1, The Near and Middle East, 83, Leiden and Boston 2006

Ikram 2015 – Salima Ikram (ed.), *Divine Creatures. Animal Mummies in Ancient Egypt*, Cairo and New York 2015

Ikram/Dodson 1998 – Salima Ikram and Aidan Dodson, *The Mummy in Ancient Egypt. Equipping the Dead for Eternity*, Cairo 1998

Irmscher 1978 – Johannes Irmscher (ed.), *Lexikon der Antike*, 3. Ed., Leipzig 1978

Jansen-Winkeln 2014 – Karl Jansen-Winkeln, Inschriften der Spätzeit, part 4. Die 26. Dynastie, vol. 1. Psametik I.–Psametik III., Wiesbaden 2014

Kaiser 1956 – Werner Kaiser, "Zu den Sonnenheiligtümern der 5. Dynastie", in: *Mitteilungen des Deutschen Archäologischen Instituts Kairo*, 14 (1956), 104–116

Kaiser 1971 – Werner Kaiser, "Die kleine Hebseddarstellung im Sonnenheiligtum des Neuserre", in: *Beiträge zur Ägyptischen Bauforschung und Altertumskunde*, 12 (1971), 87–105

Kammerzell 1986 – Frank Kammerzell, "Zeichenverstümmelung", in: *LÄ* vol. 6, Wiesbaden 1986, 1359–1361

Kaper 2003 – Olaf E. Kaper, *The Egyptian God Tutu. A Study of the Sphinx-God and Master of Demons with a Corpus of Monuments,* Orientalia Lovaniensia Analecta, 119, Leuven, Paris and Dudley 2003

Kater-Sibbes/Vermaseren 1975/77 – G. J. F. Kater-Sibbes and M. J. Vermaseren, *Apis*, 3 vols., Études préliminaires aux religions orientales dans l'Empire Romain, 48, Leiden 1975 and 1977

Kemp 1989 – Barry J. Kemp, *Ancient Egypt. Anatomy of a Civilization*, London and New York 1989

Kubisch 2000 – Sabine Kubisch, "Die Stelen der 1. Zwischenzeit aus Gebelein", in: *Mitteilungen des Deutschen Archäologischen Instituts Abteilung Kairo*, 56 (2000), 240–265

Laube 2012 – Ingrid Laube, Expedition Ernst von Sieglin. Skulptur des Hellenismus und der Kaiserzeit aus Ägypten. Die Sammlungen in Dresden, Stuttgart und Tübingen, Munich 2012

LÄ – Wolfgang Helck, Eberhard Otto and Wolfhart Westendorf (ed.), *Lexikon der Ägyptologie*, vol. 1–7, Wiesbaden 1975–1992

Leach/Tait 2000 – Bridget Leach and John Tait, "Papyrus", in: *Ancient Egyptian Materials and Technology*, ed. by Paul T. Nicholson and Ian Shaw, Cambridge 2000, 227–253

Leitz 2014 – Christian Leitz, "Geographische Soubassementtexte aus griechisch-römischer Zeit. Eine Hauptquelle altägyptischer Kulttopographie", in: *Altägyptische Enzyklopädien. Die Soubassements in den Tempeln der griechisch-römischen Zeit*, vol. 1, ed. by Alexa Rickert and Bettina Ventker, Soubassementstudien, 1, Studien zur spätägyptischen Religion, 7, Wiesbaden 2014, 69–126

Leplat 1733 – Raymond Leplat, *Recueil des marbres antiques qui se trouvent dans la Galerie du Roi de Pologne a Dresden*, Dresden 1733

Lilyquist 1979 – Christine Lilyquist, *Ancient Egyptian Mirrors from the Earliest Times through the Middle Kingdom*, Münchner Ägyptologische Studien, 27, Munich 1979

Lipsius 1798 – Johann Gottfried Lipsius, *Beschreibung der Churfürstlichen Antiken-Galerie in Dresden, zum Theil nach hinterlassenen Papieren Herrn Johann Friedrich Wacker's*, Dresden 1798

Lloyd 2010 – Alan B. Lloyd (ed.), *A Companion to Ancient Egypt*, Chichester 2010

Lösch 1837 – J. Chr. Ernst Lösch, *Die ägyptischen Mumien. Aus der Ostergabe für das Jahr 1837 besonders abgedruckt und mit zwei Blättern lithographirter Abbildungen von ägyptischen Alterthümern aus der Sammlung des Herrn von Gemming in Nürnberg vermehrt*, Nuremberg 1837

Loschwitz 2012 – Nina Loschwitz, "Amarnazeitliche Keramikbemalung mit Kobaltblau", in: *Im Licht von Amarna. 100 Jahre Fund der Nofretete*, ed. by Friederike Seyfried, ex.-cat. Berlin, Ägyptisches Museum und Papyrussammlung, Berlin 2012, 132–135

Malek et al. 1999 a – Jaromir Malek et al., *Topographical Bibliography of Ancient Egyptian Hieroglyphic Texts, Reliefs, and Paintings,* vol. 8. *Objects of Provenance not Known*, part 1. *Royal Statues. Private Statues (Predynastic to Dynasty XVII)*, Oxford 1999

Malek et al. 1999 b – Jaromir Malek et al., *Topographical Bibliography of Ancient Egyptian Hieroglyphic Texts, Reliefs, and Paintings,* vol. 8. *Objects of Provenance not Known*, part 2. *Private Statues (Dynasty XVIII to the Roman Period). Statues of Deities*, Oxford 1999

Malek et al. 2007 – Jaromir Malek et al., *Topographical Bibliography of Ancient Egyptian Hieroglyphic Texts, Reliefs, and Paintings,* vol. 8. *Objects of Provenance not Known*, part 3. *Stelae (Early Dynastic Period to Dynasty XVII)*, Oxford 2007

Malek et al. 2012 – Jaromir Malek et al., *Topographical Bibliography of Ancient Egyptian Hieroglyphic Texts, Reliefs, and Paintings,* vol. 8. *Objects of Provenance not Known*, part 4. *Stelae (Dynasty XVIII to the Roman Period) 803-044-050 to 803-099-990*, Oxford 2012

Manley 2018 – Bill Manley, *Egyptian Art*, London [2018]

Mendoza 2008 – Barbara Mendoza, *Bronze Priests of Ancient Egypt from the Middle Kingdom to the Graeco-Roman Period*, BAR International Series, 1866, Oxford 2008

Milde 2012 – Henk Milde, "Shabtis", in: *UCLA Encyclopedia of Egyptology*, ed. by Willeke Wendrich, Los Angeles 2012 (https://escholarship.org/uc/item/6cx744kk [accessed: 23. 4. 2022])

Morenz 1984 – Siegfried Morenz, *Gott und Mensch im alten Ägypten*, 2., ex. Ed., Leipzig 1984

Müller 1965 – Hans Wolfgang Müller, "Löwenskulpturen in der Ägyptischen Sammlung des Bayerischen Staates", in: *Münchner Jahrbuch der bildenden Kunst*, 3, Folge 16 (1965), 7–46

Müller 2017 – Asja Müller, "Provenancing Roman Period Mummy Masks. Workshop Groups and Distribution Areas", in: *Egypt 2015. Perspectives of Research. Proceedings of the Seventh European Conference of Egyptologists, 2nd-7th June 2015, Zagreb, Croatia*, ed. by Mladen Tomorad and Joanna Popielska-Grzybowska, London 2017, 127–145

Müller 2020 – Birgit Müller, "Die Porträtmumie einer Frau – von Schäden, die durch Restaurierungen entstehen", in: *Restaurierte Meisterwerke zur Wiedereröffnung der Sempergalerie*, ed. by Staatliche Kunstsammlungen Dresden, Stephanie Exner, Marlies Giebe and Stephan Koja, Dresden 2020, 134–137

Müller 2021 – Asja Müller, *Ägyptens schöne Gesichter. Die Mumienmasken der römischen Kaiserzeit und ihre Funktion im Totenritual*, Archäologische Forschungen, 39, Wiesbaden 2021

Müller-Winkler 1987 – Claudia Müller-Winkler, *Die ägyptischen Objekt-Amulette. Mit Publikation der Sammlung des Biblischen Instituts der Universität Freiburg Schweiz, ehemals Sammlung Fouad S. Matouk*, Orbis Biblicus et Orientalis Series Archaeologica, 5, Fribourg/Switzerland and Göttingen 1987

Niwiński 1989 – Andrzey Niwiński, *Studies on the Illustrated Theban Funerary Papyri of the 11th and 10th Centuries B.C.*, Orbis Biblicus et Orientalis 8, Fribourg/Switzerland and Göttingen 1989

Nuzzolo 2018 – Massimiliano Nuzzolo, *The Fifth Dynasty Sun Temples. Kingship, Architecture and Religion in Third Millennium BC Egypt*, Prague 2018

Pagenstecher 1913 – Rudolf Pagenstecher, *Die griechisch-ägyptische Sammlung Ernst von Sieglin, 3. Teil. Die Gefäße in Stein und Ton, Knochenschnitzereien*, Expedition Ernst von Sieglin, Ausgrabungen in Alexandria, 2, Leipzig 1913

Pagenstecher 1923 – Rudolf Pagenstecher, *Die griechisch-ägyptische Sammlung Ernst von Sieglin, 1. Teil. Malerei und Plastik*, Erster Teil (A), Expedition Ernst von Sieglin, Ausgrabungen in Alexandria, 2, Leipzig 1923

Parkison et al. 1995 – Richard H. Parkinson et al., *Papyrus*, London 1995

Parlasca 1966 – Klaus Parlasca, *Mumienporträts und verwandte Denkmäler*, Wiesbaden 1966

Petrie 1914 – W. M. Flinders Petrie, *Amulets. Illustrated by the Egyptian Collection in University College, London*, London 1914

Petrie/Murray 1952 – Hilda Flinders Petrie and Margaret A. Murray, *Seven Memphite Tomb Chapels*, British School of Egyptian Archaeology, 65, London 1952

Pfister 2013 – Eva Pfister, "Die Horusstelen", in: *Kemet*, 22, Heft 1 (2013), 31–33

Pink 2014 – Johanna Pink, *Geschichte Ägyptens. Von der Spätantike bis zur Gegenwart*, Munich 2014

Porter/Moss 1960 – Bertha Porter and Rosalind L. B. Moss, *Topographical Bibliography of Ancient Egyptian Hieroglyphic Texts, Reliefs, and Paintings*, vol. 1. *The Theban Necropolis*, part 1. *Private Tombs*, 2., rev. and augmented Ed., Oxford 1960

Porter/Moss 1981 – Bertha Porter and Rosalind L. B. Moss, *Topographical Bibliography of Ancient Egyptian Hieroglyphic Texts, Reliefs, and Paintings*, vol. 3. *Memphis*, part 2. *Ṣaqqâra to Dahshur*, 2., rev. and augmented Ed., Oxford 1981

Quack 2006 – Joachim Friedrich Quack, "Die Horus-Stelen und ihr Bildprogramm", in: *Ägypten. Ein Tempel der Tiere*, Begleitbuch zur gleichnamigen Ausstellung im Zoologischen Garten Berlin, ed. by Veit Vaelske et al., Berlin 2006, 107–109

Quaegebeur 1990 – Jan Quaegebeur, "Les Rois Saites amateurs du vin", in: *Ancient Society*, 21 (1990), 241–271

Quirke 1996 – Stephen Quirke, *Altägyptische Religion*, Stuttgart 1996

Quirke/Spencer 1992 – Stephen Quirke and Jeffrey Spencer, *The British Museum Book of Ancient Egypt*, London 1992

Raven 1978–1979 – Maarten J. Raven, "Papyrus-Sheats and Ptah-Sokar-Osiris Statues", in: *Oudheidkundige Mededelingen uit het Rijksmuseum von Oudheden te Leiden*, 59–60 (1978–1979), 251–296

Raven 1982 – Maarten J. Raven, "Corn-Mummies", in: *Oudheidkundige Mededelingen uit het Rijksmuseum von Oudheden te Leiden*, 63 (1982), 7–38

Reinecke 1996 – Walter F. Reinecke, "Carl August Reinhardt – Kaufmann, Philologe, Sammler, Konsul", in: *Mitteilungen aus der Arbeit am Wörterbuch der ägyptischen Sprache*, 5 (1996), 13–59

Riggs 2014 – Christina Riggs, *Ancient Egyptian Art and Architecture. A Very Short Introduction*, Oxford 2014

Robins 2000 – Gay Robins, *The Art of Ancient Egypt*, London 2000

Rocheblave 1889 – Samuel Rocheblave, *Essai sur le Comte de Caylus*, Paris 1889

Roeder 1956 – Günther Roeder, *Ägyptische Bronzefiguren*, Mitteilungen aus der Ägyptischen Sammlung, 6, Berlin 1956

Rose 2007 – Pamela J. Rose, *The Eighteenth Dynasty Pottery Corpus from Amarna*, Egypt Exploration Society Excavation Memoir, 83, London 2007

Rother 1994 – Wolfgang Rother, *Der Kunsttempel an der Brühlschen Terrasse. Das Akademie- und Ausstellungsgebäude von Constantin Lipsius in Dresden*, Dresden and Basel 1994

Salvoldi 2018 – Daniele Salvoldi, *From Siena to Nubia. Alessandro Ricci in Egypt and Sudan, 1817–22*, Cairo and New York 2018

Schlott 1989 – Adelheid Schlott, *Schrift und Schreiber im Alten Ägypten*, Munich 1989

Schneider 1977 – Hans Schneider, *Shabtis. An Introduction to the History of Ancient Egyptian Funerary Statuettes with a Catalogue of the Collection of Shabtis in the National Museum of Antiquities at Leiden*, 3 vols., Leiden 1977

Schneider 1996 – Thomas Schneider, *Lexikon der Pharaonen*, Rev. Ed., Munich 1996

Schneider 2010 – Thomas Schneider, *Die 101 wichtigsten Fragen. Das Alte Ägypten*, Munich 2010

Schulz 1992 – Regine Schulz, Die Entwicklung und Bedeutung des kuboiden Statuentypus. Eine Untersuchung zu den sogenannten "Würfelhockern", 2 vols., Hildesheimer Ägyptologische Beiträge, 33, Hildesheim 1992

Schulz/Seidel 1997 – Regine Schulz and Matthias Seidel (ed.), *Die Welt der Pharaonen*, Cologne 1997

Sharawi/Harpur 1988 – Galal Sharawi and Yvonne Harpur, "The Identity and Position of Relief Fragments in Museums and Private Collections. Reliefs from Various Tombs in Saqqâra", in: *Journal of Egyptian Archaeology*, 74 (1988), 57–67

Shaw 2003 – Ian Shaw (ed.), *The Oxford History of Ancient Egypt*, Oxford 2003

Shaw 2007 – Ian Shaw, *Das alte Ägypten. Eine kleine Einführung*, Stuttgart 2007

Stadler 2004 – Martin R. Stadler, "Fünf neue funeräre Kurztexte (Papyri Britisches Museum EA 10121, 10198, 10415, 10421a, b, 10426a) und eine Zwischenbilanz zu dieser Textgruppe", in: *Res serva verum gaudium. Festschrift für Karl-Theodor Zauzich zum 65. Geburtstag am 8. Juni 2004*, ed. by Friedhelm Hoffmann and Heinz-Josef Thissen, Leuven 2004, 551–571

Stanwick 2002 – Paul Edmund Stanwick, *Portraits of the Ptolemies. Greek Kings as Egyptian Pharaohs*, Austin 2002

Steinla 1893 – »Steinla, Moritz«, in: *Allgemeine Deutsche Biographie*, 35 (1893), 741 (https://www.deutsche-biographie.de/pnd117258709.html#adbcontent [accessed: 23 April 2022])

Sternberg-El Hotabi 1999 – Heike Sternberg-El Hotabi, *Untersuchungen zur Überlieferungsgeschichte der Horusstelen. Ein Beitrag zur Religionsgeschichte Ägyptens im 1. Jahrtausend v. Chr.*, 2 parts, Ägyptologische Abhandlungen 62, Wiesbaden 1999

Strecker/Heinrich 2007 – Carolina Strecker and Peter Heinrich, "Eine innovative Restaurierung – Eine neuartige Präsentation. Das altägyptische Perlennetz aus El-Hibe", in: *Ägyptische Mumien. Unsterblichkeit im Land der Pharaonen*, Große Landesausstellung 6. Oktober 2007 bis 24. März 2008, ed. by Landesmuseum Württemberg, Stuttgart, Stuttgart and Mainz 2007, 217–226

Stutzinger 1995 – Dagmar Stutzinger, "Römische Haarnadeln mit Frauenbüste", in: *Bonner Jahrbücher*, 195 (1995), 135–208

Syndram 1989a – Dirk Syndram, "Interieurs im ägyptischen Stil. Englische und deutsche Innendekorationen im Frühklassizismus", in: *Kunst & Antiquitäten*, Heft 6, 1989, 38–45

Syndram 1989b – Dirk Syndram, "Die 'Urzeit' als Avantgarde. Italienische und französische Interieurs im Frühklassizismus", in: *Kunst & Antiquitäten*, Heft 3, 1989, 48–57

Syndram 1990 – Dirk Syndram, *Ägypten-Faszinationen. Untersuchungen zum Ägyptenbild im europäischen Klassizismus bis 1800*, Frankfurt am Main, Bern, New York, Paris 1990

Syndram 1999 – Dirk Syndram, *Die Ägyptenrezeption unter August dem Starken. Der "Apis-Altar" Johann Melchior Dinglingers*, Mainz 1999

Syndram/Schöner 2014 – Dirk Syndram and Jörg Schöner, *August der Starke und sein Großmogul*, Munich 2014

Tattko 2014 – Jan Tattko, "Quellenübersicht zu den *mr*-Kanälen, *ww*- und *phw*-Gebieten", in: *Altägyptische Enzyklopädien. Die Soubassements in den Tempeln der griechisch-römischen Zeit*, vol. 1, ed. by Alexa Rickert and Bettina Ventker, Soubassementstudien, 1, Studien zur spätägyptischen Religion, 7, Wiesbaden 2014, 154–223

Taylor 2001 – John H. Taylor, *Death and the Afterlife in Ancient Egypt*, London 2001

Taylor 2003 – John H. Taylor, "Theban Coffins from the Twenty-Second to the Twenty-Sixth Dynasty. Dating and Synthesis of Development", in: *The Theban Necropolis. Past, Present and Future*, ed. by Nigel Strudwick and John H. Taylor, London 2003, 95–121

Thiel 2020 – Reiner Thiel, "Die assyrischen Palastreliefs der Dresdner Skulpturensammlung", in: *Restaurierte Meisterwerke zur Wiedereröffnung der Sempergalerie*, ed. by Staatliche Kunstsammlungen Dresden, Stephanie Exner, Marlies Giebe and Stephan Koja, Dresden 2020, 130–133

Tomoum 2005 – Nadja Samir Tomoum, *The Sculptor's Models of the Late and Ptolemaic Periods. A Study of the Type and Function of a Group of Ancient Egyptian Artefacts*, Cairo 2005

Treu 1898 – Georg Treu, "Erwerbungen der Antikensammlungen in Deutschland. 1896. I. Dresden. A. Skulpturen", in: *Archäologischer Anzeiger*, 1898, 52–59

Vleeming 2011 – S[ven] P[eter] Vleeming, *Demotic and Greek-Demotic Mummy Labels and other Short Texts Gathered from many Publications (Short Texts II 278 – 1200)*, A. *Texts*, Studia Demotica, 9 (A), Leuven, Paris and Walpole 2011

Von Beckerath 1999 Jürgen von Beckerath, *Handbuch der ägyptischen Königsnamen*, Münchner Ägyptologische Studien, 49, 2., rev. and etx. Ed., Mainz 1999

Von Watzdorf 1962 – Erna von Watzdorf, *Johann Melchior Dinglinger. Der Goldschmied des deutschen Barock*, Berlin 1962, vol. 1, Berlin 1962

Voß 2004 – Susanne Voß, *Untersuchungen zu den Sonnenheiligtümern der 5. Dynastie. Bedeutung und Funktion eines singulären Tempeltyps im Alten Reich*, Dissertation, Hamburg 2004

Watzinger 1927 – Carl Watzinger, *Die griechisch-ägyptische Sammlung Ernst von Sieglin*, vol. 1. *Malerei und Plastik*, part 2 (B), 2 vols., Expedition Ernst von Sieglin, Ausgrabungen in Alexandria, 2, Leipzig 1927

Weinlig 1782–1787 – Christian Traugott Weinlig, *Briefe aus Rom*, 3 vols., Dresden 1782–1787

Weiß 2012 – Katja Weiß, *Ägyptische Tier- und Götterbronzen aus Unterägypten. Untersuchungen zu Typus, Ikonographie und Funktion sowie der Bedeutung innerhalb der Kulturkontakte zu Griechenland*, 2 parts, Ägypten und Altes Testament, 81, Wiesbaden 2012

Wetzig 2017 – Saskia Wetzig, "Das Dresdener 'Mumien-Projekt'. Einblicke – Durchblicke – Ausblicke", in: *Dresdener Kunstblätter*, 61, 2 (2017), 6–15

Wilkinson 2017 – Richard H. Wilkinson, *The Complete Gods and Goddesses of Ancient Egypt*, London 2017

Winckelmann 1825 – Johann Winckelmann, "Nachricht von einer Mumie in dem königlichen Kabinet der Altertümer in Dresden", in: *Johann Winckelmanns sämtliche Werke. Einzige vollständige Ausgabe*, vol. 1, ed. by Joseph Eiselein, Donauöschingen 1825, 108–117

Wittwer 2004 – Samuel Wittwer, *Die Galerie der Meißner Tiere. Die Menagerie Augusts des Starken für das Japanische Palais*, Munich 2004

Yoyotte 1980 – Jean Yoyotte, "Un Monumental Litanie de granit. Les Sekhmet d'Aménophis III et la conjuration permanente de la Déesse dangereuse", in: *Bulletin de la Société Française d'Égyptologie*, 87–88 (1980), 46–75

Zenihiro 2009 – Kento Zenihiro, *The Complete Funerary Cones*, Tokyo 2009

Zesch et al. 2020 – Stephanie Zesch et al., "Decorated Bodies for Eternal Life. A Multidisciplinary Study of Late Roman Period Stucco-Shrouded Portrait Mummies from Saqqara (Egypt)", in: *PLoS ONE*, 15(11) (2020), e0240900 (https://doi.org/10.1371/journal.pone.0240900 [accessed: 23 April 2022])

Zschoche 1988 – Herrmann Zschoche, "Der Spezialfreund. Caspar David Friedrich und der Bildhauer Christan Gottlieb Kühn", in: *Sächsische Heimatblätter*, 34, Heft 2 (1988), 53–61

https://saebi.isgv.de/liste-aller-artikel [accessed: 23 April 2022]

http://sith.huma-num.fr/karnak/1747 [accessed: 23 April 2022]

About this Publication

Editors
Staatliche Kunstsammlungen Dresden,
Stephan Koja, Saskia Wetzig
Postfach 12 05 51
01006 Dresden
Telephone: +49 (0)351 - 49 14 2000
besucherservice@skd.museum
www.skd.museum

© 2022 Sandstein Verlag, Dresden
Goetheallee 6, 01309 Dresden

Authors
Manuela Gander (MG)
Marc Loth (ML)
Stephanie Panzer (SP)
Wilfried Rosendahl (WR)
Stephanie Zesch (SZ)
Albert Zink (AZ)

Editing
Una Giesecke, Sandstein Verlag

Translation
Jacqueline Todd; Geraldine Schuckelt

Layout
Annett Stoy, Sandstein Verlag

Typo and Reprography
Katharina Stark, Jana Neumann,
Sandstein Verlag

Printing and binding
FINIDR s.r.o., Český Těšín

Typeface
Adobe Garamond Pro

Paper
GardaMatt Art, 170 g/m²

Picture Credits

Seyfried: Fig. 1 © Hervé Champollion / akg-images;
Figs. 2; 8 © Marc Loth; Fig. 3 © Skulpturen-
sammlung, Staatliche Kunstsammlungen Dresden,
photo: Wilhelm Grahl; Fig. 5 © Manuela Gander

Syndram: Figs. 1; 2 © Grünes Gewölbe, Staatliche
Kunstsammlungen Dresden, photo: Dirk Weber;
Fig. 3 © Grünes Gewölbe, Staatliche Kunstsammlu-
ngen Dresden, photo: Jürgen Karpinski; Fig. 4
© SLUB Dresden / Hist.misc.A.9-2,2; Fig. 5
© Porzellansammlung, Staatliche Kunstsammlu-
ngen Dresden, photo: Herbert Jäger; Fig. 6;
© Porzellansammlung, Staatliche Kunstsammlu-
ngen Dresden, photo: Adrian Sauer; Figs. 7; 8
© Muzeum Pałacu Króla Jana III w Wilanowie.
photo: Wojciech Holnicki; Fig. 9 © SLUB Dresden /
Geogr.C.106-1; Fig. 10 © Rogers Fund, transferred
from the Library; Fig. 11 © Christie's Images /
Bridgeman Images

Loth: Fig. 1 © Skulpturensammlung, Staatliche
Kunstsammlungen Dresden, photo: David
Brandt; Figs. 2; 3 © SLUB Dresden / Digitale
Sammlungen; Fig. 4 Zentralbibliothek Zürich,
NR 72 | G, https://doi.org/10.3931/e-rara-56694 /
Public Domain Mark; Fig. 5 © SLUB Dresden /
Deutsche Fotothek, photo: Hermann Krone;
Fig. 9 © Skulpturensammlung, Staatliche
Kunstsammlungen Dresden, photo: Jürgen Lange;
Fig. 10 © Marc Loth

Catalogue: Cat. 5 fig. 1 © SLUB Dresden / Digitale
Sammlungen; Cat. 19 figs. 1; 2; 4; 5; 6 a; 6 b
© Skulpturensammlung, Staatliche Kunstsamm-
lungen Dresden, © German Mummy Project,
Reiss-Engelhorn-Museen Mannheim; Fig. 3
© Skulpturensammlung, Staatliche Kunstsammlu-
ngen Dresden; Cat. 20 figs. 1–6 © Skulpturen-
sammlung, Staatliche Kunstsammlungen Dresden,
© German Mummy Project, Reiss-Engelhorn-
Museen Mannheim; Cover and cat. 21; Cat. 22 b;
22 e; 22 j © Skulpturensammlung, Staatliche
Kunstsammlungen Dresden, photo: Wilhelm
Grahl; Cat. 22 c © Skulpturensammlung, Staatliche
Kunstsammlungen Dresden, photo: Gerhard
Murza; Cat. 22 f © Skulpturensammlung, Staat-
liche Kunstsammlungen Dresden, photo: Peter
Friedrich; Cat. 22 g; 22 h; 22 i © Skulpturensamml-
ung, Staatliche Kunstsammlungen Dresden,
photo: Reinhard Seurig / Hans-Jürgen Genzel

Appendix: p. 177: Map templates Quirke/Spencer
1992: 10; Ikram/Dodson 1998: 313 Map IA – C

All other pictures © Skulpturensammlung,
Staatliche Kunstsammlungen Dresden, photo:
Hans-Peter Klut / Elke Estel

The Deutsche Nationalbibliothek lists
this publication in the Deutsche National-
bibliographie; detailed bibliographic
information can be found on the internet
at http://dnb.dnb.de

www.sandstein-verlag.de
ISBN 978-3-95498-699-6